WOMEN IN GERMAN YEARBOOK 6

Feminist Studies and German Culture

Edited by

Jeanette Clausen
Helen Cafferty

UNIVERSITY
PRESS OF
AMERICA

Lanham • New York • London

Copyright © 1991 by
University Press of America®, Inc.
4720 Boston Way
Lanham, Maryland 20706

3 Henrietta Street
London WC2E 8LU England

All rights reserved
Printed in the United States of America
British Cataloging in Publication Information Available

Co-published by arrangement with
The Coalition of Women in German

0-8191-8126-9 (alk paper)
0-8191-8127-7 (pbk alk paper)

LC 85-642607

The paper used in this publication meets the minimum requirements of American National Standard for Information Sciences—Permanence of Paper for Printed Library Materials, ANSI Z39.48–1984.

ACKNOWLEDGMENTS

The following individuals reviewed manuscripts submitted to the Women in German Yearbook between November 1988 and May 1990. We thank them for their advice and assistance.

Leslie A. Adelson, The Ohio State University
Evelyn T. Beck, University of Maryland, College Park
Gisela Brinker-Gabler, SUNY Binghamton
Donald Daviau, University of California, Riverside
Sandra Frieden, University of Houston
Sara Friedrichsmeyer, University of Cincinnati
Katherine Goodman, Brown University
Marjanne Goozé, University of Georgia
Sabine Hake, University of Pittsburgh
Barbara Hyams, Boston University
Ruth-Ellen Boetcher Joeres, University of Minnesota, Minneapolis
Richard L. Johnson, Indiana University-Purdue University, Fort Wayne
Anna K. Kuhn, University of California, Davis
Sara Lennox, University of Massachusetts, Amherst
Dagmar C. G. Lorenz, The Ohio State University
Kathleen O'Connor, Bowdoin College
Linda S. Pickle, Westminster College
Luise F. Pusch, Hannover, West Germany
Ricarda Schmidt, University of Sheffield, Great Britain
Marc Silberman, University of Wisconsin, Madison
Linda Kraus Worley, University of Kentucky

Special thanks to Victoria M. Kingsbury for manuscript preparation and to MaryEllen Shea for technical assistance.

For support of their work on *Women in German Yearbook 6,* the editors thank the Office of the Dean of Faculty of Bowdoin College and the Modern Foreign Languages Department of Indiana University-Purdue University at Fort Wayne.

Publication of *Women in German Yearbook 5* (1989) was funded in part by a small grant from the Indiana University President's Council on the Humanities.

TABLE OF CONTENTS

Acknowledgments iii

Preface vii

Dagmar C. G. Lorenz. "Hoffentlich werde ich taugen." Zu Situation und Kontext von Brigitte Schwaiger/Eva Deutsch *Die Galizianerin*. 1
 The article explores the situation, post-Holocaust Viennese society and rising anti-Semitism in Waldheim-Austria, and the background against which Schwaiger, an established mainstream Austrian author, writes the life history of Deutsch, a Holocaust survivor from Silesia whose native language is Yiddish. The relationship between interviewer and informant is analyzed as one of exploitation of a marginalized woman by a privileged one. Problems of ethics and authenticity are discussed and the question is raised whether Schwaiger exploits Deutsch for economic and ideological reasons, or whether the stereotypes and misrepresentations are the result of unnoticed cultural, intellectual, and linguistic barriers. (DCGL) (In German)

Sabine Wilke. "Rückhaltlose Subjektivität." Subjektwerdung, Gesellschafts- und Geschlechtsbewußtsein bei Christa Wolf 27
 The essay seeks to orient Wolf's contribution to the problem of subjectivity and gender within the philosophical and theoretical tradition. Two models of subjectivity, both emerging out of German Idealist thought, are discussed as theoretical framework for this text: Schelling's idea of an absolute subject versus Hegel's concept of synthetically constructed individuals. The essay intends to show that Wolf avoids the pitfalls of traditional thinking about subjectivity by having Kassandra undergo a learning process that leads her from an essentialist model of the female subject to an acceptance of a dialogic form of individuality incorporating the presence of other voices. Instead of shedding other (patriarchal) inscriptions to reveal an authentic self, she finally accepts the challenge of working towards a socially relevant form of subjectivity constituted by intersubjective processes. (SW) (In German)

Elaine Martin. Patriarchy, Memory, and the Third Reich in the Autobiographical Novels of Eva Zeller
 Eva Zeller is best known for her two autobiographical works, *Solange ich denken kann* (1981), which centers on the author's troubled relationship with her domineering father, and *Nein und Amen* (1985), which focuses on a love relationship doomed by the war. Both relationships are portrayed against

the backdrop of ever-encroaching Nazi policies. Zeller investigates not only the difficulties of adolescence, here intensified by the additional stress of National Socialism and a world war, but also the possible connections between patriarchal values and attitudes, sexism, and the rise of fascist and totalitarian states. (EM)

Tineke Ritmeester. Heterosexism, Misogyny, and Mother-Hatred in Rilke Scholarship: The Case of Sophie Rilke-Entz (1851-1931) 63

This article examines from a feminist perspective the prevailing misogynistic view of Sophie Rilke-Entz. It discusses the themes of mother hatred and heterosexism and analyzes motherhood, marriage, divorce, and domestic violence against the socio-historical background. The author speculates about the role of Rilke's father, who has been virtually ignored by scholars. Finally, she presents evidence that, whereas Rilke in many ways had an unexceptional family background, his mother was an independent and emancipated woman. (TR)

Richard W. McCormick. Productive Tensions: Teaching Films by German Women and Feminist Film Theory 83

German women filmmakers and feminist film theorists have been productive in different "realms" since the 1970s. Courses focusing on the two can be productive as well. After briefly discussing the political consequences of such courses, I sketch the historical development of filmmaking by women in West Germany from the mid-1970s to the early 1980s. Then I trace a shift in feminist film theory (predominantly Anglo-American, although influenced by French theory) from the 1970s to the 1980s. Finally, I discuss some comparable developments over the course of the 1980s in German films by women. (RWM)

Hildegard M. Nickel. Women in the GDR: Will Renewal Pass Them By? 99

Hildegard Nickel summarizes positive and negative effects of 40 years of GDR socialism on women in her country. She critiques traditional GDR "studies of women" and calls for new research in women's studies. (JC)

Helen Cafferty and Jeanette Clausen. Feminist *Germanistik* after Unification. A Postscript from the Editors. 109

About the Authors 113

Notice to Contributors 115

PREFACE

In our postscript to the last volume of the WIG Yearbook, we discussed the importance of keeping our journal open to a wide range of feminist approaches and theoretical orientations, in order to meet the needs of WIG members at various kinds of institutions and at different stages in their thinking about feminist criticism and teaching. The articles in the present volume represent a mix of theoretical and practical criticism, and reflect elements of WIG members' diverse interests and energies.

Of the five regular contributions, three deal with works by contemporary writers. Dagmar Lorenz's article on *Die Galizianerin* discusses Austrian/German anti-Semitism as an unacknowledged factor in the problematic power relations between Brigitte Schwaiger and her documentary subject Eva Deutsch. Her paper raises important theoretical questions that we hope will stimulate much further thought and debate. Sabine Wilke's article sheds new light on Christa Wolf's evolving model of subjectivity in *Kassandra*. Elaine Martin introduces a largely neglected author, Eva Zeller, whose autobiographical novels bear comparison with those of Christa Wolf, Ingeborg Drewitz, and other women who have written autobiographically about the Third Reich. In an approach to the canon, Tineke Ritmeester provides a corrective reading of Rilke criticism and suggests alternative ways of understanding the poet's relationship to his mother, Sophie Rilke-Entz. Finally, Rick McCormick's article provides useful information for teaching women's films: he reviews the tensions between feminist film theory and feminist filmmaking, and suggests how to approach them productively in the classroom.

Because of the rapid and intense changes taking place in both Germanys, and especially in the GDR, we felt it was important to include a contribution by a GDR scholar. Sociologist Hildegard Nickel of Humboldt University is only one of many GDR researchers who are now beginning to formulate feminist analyses of women's situation in the GDR and to articulate their goals for women's studies. We discuss some likely implications of *die Wende* for feminist Germanists in our contribution concluding the volume.

With this volume of the WIG Yearbook, Helen Cafferty ends her term as coeditor. At this writing, she has left for a semester's research leave in Berlin

and Greifswald. We welcome the new coeditor, Sara Friedrichsmeyer of the University of Cincinnati.

Helen Cafferty
Jeanette Clausen

September 1990

"Hoffentlich werde ich taugen." Zu Situation und Kontext von Brigitte Schwaiger/Eva Deutsch Die Galizianerin

Dagmar C.G. Lorenz

In dem Gedicht "Angely, ma belle" deutet die 1949 geborene Brigitte Schwaiger das Problem an, das sie, eine der prominentesten österreichischen Gegenwartsautorinnen, in verschiedenen Werken beschäftigt: die Schwierigkeit, im postmodernen Österreich, dem Österreich nach dem Holocaust, sich vor dem Hintergrund der Vergangenheit als österreichische Intellektuelle zu definieren.

>Urgroßmutter,
>die einen Juden geboren hat,
>der meine Mutter zeugte,
>die mich gebar.
>
>Angely, ich möchte dich etwas fragen.
>Wohin geh ich, wenn du mich drängst?
>Lauf ich voraus,
>um nicht zu spüren: mein Blutgedicht.
>
>Für dich.
>Sie haben dich umgebracht.
>Die von meiner Seite haben uns auf unserer Seite
>einfach umgebracht. (*Mit einem möcht' ich leben* 40)

Die Vergangenheit zu leugnen oder zu ignorieren ist moralisch nicht möglich. Schwaiger entscheidet sich zu einer Haltung, die sich am ehesten als "Mit-Opfer-Sein" bezeichnen läßt. Sie nähert sich der Nazivergangenheit von der Perspektive einer Frau, die unterdrückt worden wäre und unter den Auswirkungen der potientellen Unterdrückung leidet. Über Nationalsozialismus und Rassismus hinaus postuliert sie eine Solidarität von Frauen. Wie das zitierte Gedicht setzt sich Schwaigers z.T. autobiographischer Roman *Lange Abwesenheit* (1980) aus einer persönlichen Betroffenheit auf die für die 70er und 80er Jahre charakteristische Weise mit dem toten Vater auseinander. Von den Söhnen und Töchtern, die der Beziehung ihrer Eltern zum Naziregime nachforschten, waren wenige so gründlich wie Niklas Frank in *Der Vater,* eine Verdammung des Nazivaters. Die meisten Autoren stellen politisch indifferente kleine Leute dar, deren Versagen höchstens Mangel an

Engagement war, z.B. Handkes Mutter in *Wunschloses Unglück.* Schutting, Plessen und Schwaiger selbst entdeckten faschistoide Züge an den Eltern, aber zögerten, sie als Nazis zu bezeichnen. Selbst Gauch, der Sohn von Himmlers Adjutanten, betont die Unschuld seines Vaters an kriminelle Handlungen. Broder kommentiert:

> Man hat lieber einen Nazi zum Vater als gar keinen ... Das vierte Gebot—Du sollst Vater und Mutter ehren—, für das es bezeichnenderweise kein Pendant zum Schutze der Kinder vor den Eltern gibt, ist an die Stelle der Einsicht getreten, daß die Bewältigung der nationalen Vergangenheit nicht vor der Wohnküche, in der man selber großgeworden ist, haltmachen kann; daß man sich nicht nur abstrakt vom System distanzieren muß, sondern auch von denen, die es getragen haben—und wenn es die eigenen Eltern sind (*Spiegel* 167).

Daß dies selbst bei guten Absichten nicht geschah und vielleicht nicht möglich war, registriert Ruth Beckermann, die in Wien geborene Tochter von Holocaustüberlebenden, in ihrer Abrechnung mit dem Land, in dem sie aufwuchs, Österreich. Sie schildert die Enttäuschung österreichischer Juden, die erfuhren, daß die unter progressiven Intellektuellen gepflegte marxistische Rhetorik Holocaustopfer nicht miteinschloß.

> Zum einen mußten wir gegen das tiefsitzende Vorurteil ankämpfen, alle Juden seien reich, zum anderen wollten wir Mitleid und Sympathie. Und die bekamen wir nur, wenn wir uns der antifaschistischen Ideologie anpaßten, die von *Opfern des Faschismus* sprach, und insgeheim hofften, die anderen würden auch ein wenig an die Juden denken, wenn sie gegen Faschismus schrien" (*Unzugehörig* 125).

Die Art, in der Schwaiger den Vater, der Weltanschauung nach einen Altfaschisten, gegen den Liebhaber ihrer Protagonistin, einen Holocaustüberlebenden, ausspielt, bestätigt Beckermanns Analyse. Da weder der Vater, ein ehemaliger Offizier, Arzt, Antisemit und Haustyrann, noch der Jude, ein Mann im Alter des Vaters, der Protagonistin die Liebe und Anerkennung geben, die sie von ihnen verlangt und für die sie sie umwirbt, distanziert sie sich von beiden unter Selbstmitleid und Ressentiment. Nahegelegt wird, daß beide Repräsentanten der älteren Generation, auch wenn der eine auf der Seite der Täter, der andere auf der der Opfer war, aus demselben Holz geschnitzt sind. Auf privater Ebene sind sie der nachgeborenen Frau gleich unbehaglich. Mit der Erleichterung über den Tod des Vaters erledigt sich für die Protagonistin auch das andere Problem, der Liebhaber. Die Hinterlassenschaft beider alter Männer, Schuld und Scham, wird annulliert.

In ihrer Analyse von Henisch, Schwaiger und Reichardt rechnet Regine Kecht *Lange Abwesenheit* unter die "faschistischen Familienidyllen", die seit Ende der 70er Jahre in großer Zahl veröffentlicht werden. Schwaigers Gleichsetzung des Holocaustüberlebenden mit ihrem Vater scheint denjenigen

ihrer Generation entgegenzukommen, die die Vergangenheit abtun, oft ohne die Geschichte, von der sie angeblich zu viel gehört haben, wirklich zu kennen.

Derselbe Rückzug ins Private, Emotionale, von wo kein Ausblick auf historische und soziale Vorgänge möglich ist, ist auch für *Die Galizianerin* bezeichnend, ein Text mit Holocaustthematik. Zu der Problematik des Themas tritt die der Genese. Das umfangreiche Prosawerk gibt sich als mündliche Historiographie. Mehr noch, die Titelseite, die Eva Deutsch neben Brigitte Schwaiger als Verfasserin nennt—dagegen heißt es auf dem Buchrücken "Brigitte Schwaiger: Eva Deutsch Die Galizianerin"--suggeriert die Zusammenarbeit zweier an Inhalt und Textgestaltung gleichermaßen beteiligter Partnerinnen. Nirgends ist aber klar, welchen Anteil die eine Frau, welchen die andere, an der Gestaltung des Interviews hatte. Folglich ist Deutsch verunsichert, ein Umstand, den Schwaiger zur Kenntnis nimmt, ohne Abhilfe zu schaffen. "Hoffentlich werde ich taugen. Weil ich doch nicht weiß, wohin Sie steuern. Gnädige Frau . . ." (7).

Die Tendenzen von *Lange Abwesenheit* und *Die Galizianerin* gleichen einander so sehr, daß Zweifel an der Authentizität von Schwaigers Eva Deutsch aufkommen müssen. An der Oberfläche entspricht der Text den Interessen der Autorin Schwaiger—Abrechnung mit der Generation der Väter, weibliche Solidarität gegen das Patriarchat über die Kulturgrenzen hinaus.[1] Unterschwellige, diesen Rahmen sprengende Tendenzen reflektieren möglicherweise Deutschs Intentionen: Trauer und Erinnerung an die ostjüdische Kultur und ein Bekenntnis zum Judentum über den Holocaust hinaus, Bewältigungsarbeit, wie sie unter anderem seit der Sklavenbefreiung die mündliche Historiographie in den USA leistet.[2]

Der Aufzeichnung von Erinnerungen an historische Ereignisse und den Lebensgeschichten Überlebender von Massenmorden, z.B. der Armeniermassaker 1915-22 und des Holocaust, werden akademische und kommunale Projekten gewidmet.[3] Das Medium neuerer Aufzeichnungen sind Film und Videokassetten, z.B. in Beckermanns Geschichte und Zeitgeschichte integrierenden Interview in "Wien Retour" mit Franz Weintraub/West und "Die papierene Brücke", eine Filmstudie über eine Reise nach Rumänien und Jugoslawien, der Vergangenheit von Beckermanns Familie nach. Angehörige der jüdischen Gemeinden Rumäniens, Schauspieler in Herman Wouks "War and Remembrance" in dem Kulissen-Theresienstadt und die Eltern der Filmemacherin werden in Interviews vorgestellt. Beckermann ist sichtbar, ohne ihr jeweiliges Gegenüber oder das Gespräch zu dominieren. Der Respekt, den sie ihren Informanten erweist, begünstigt Kooperation. Eben dies nennt Thomson (209) die Voraussetzung für Interviewsituationen, die, wie alle soziale Kommunikationen, Konventionen unterliegen.

Daphne Patai entwickelt eine feministische Theorie mündlicher Historiographie im Zusammenhang mit ihren Interviews mit brasilianischen Frauen, der ihr Bewußtsein des kulturellen und ökonomischen Abstands zwischen sich, einer weißen US-Amerikanerin, und ihren Informantinnen zugrunde liegt. Patai betont, daß gerade feministische und/oder sozialistische Forscher, denen gesellschaftliche Transformation ein Anliegen ist, die ihrer Forschung zugrundeliegenden Prinzipien kritisch zu hinterfragen hätten. Da das Ziel feministischer Forschung nicht nur "Wahrheitssuche" oder beruflicher Erfolg sein könne, hätten Feministinnen darauf zu achten, daß ihre Forschungsmethoden oder zu eng gefaßte ethische Begriffe nicht die Strukturen der Ungleichheit reproduzieren. Die Interviewpartnerinnen in die Rolle dienstbarer Forschungsobjekte zu versetzen heiße nichts anderes, als die bestehenden gesellschaftlichen Strukturen zu bestätigen (7). Die Befragerin benutze die Befragte immer für ihr eigenes Projekt, selbst wenn für die Letztere das Interview subjektiv befriedigend sein mag. Ökonomisch befindet sich die ihre Lebensgeschichte erzählende Frau im Besitze von Rohmaterial, ohne welches die Forscherin keinen Text hervorbringen kann. In der Rolle des Produktionsmittelbesitzers gestaltet die Erzählerin das Erzählte zur Ware. Mit intellektueller Integrität, so meint Patai, könne aus Ausbeuterin und Ausgebeuteter Mitarbeiterinnen werden. Information darüber, wie die Interviews zustandekamen und durchgeführt wurden, hält Patai für essentiell. Darüberhinaus—und gerade diese Information wäre im Falle Schwaigers notwendig—begründet sie die Wahl der betreffenden Informantin und artikuliert ihre eigenen Gefühle (4–8). Patai betrachtet die von ihr angefertigten Tonbänder und Texte als den Treffpunkt zweier Subjektivitäten: "theirs and mine, their cultural assumptions and mine, their memories and my questions, their sense of self and my own, their hesitations and my encouraging words or gestures" (2).

Soziale und historische Faktoren machen Schwaigers Projekt, die Lebensgeschichte einer Holocaustüberlebenden, problematisch. Als einer 1948 in Westdeutschland geborenen und in der BRD aufgewachsenen Nichtjüdin wurde mir erst als Studentin in den USA 1970–74 in Seminaren von Professoren, die, hätte es den Holocaust nicht gegeben, meine Nachbarn gewesen wären, und als Germanistin und Kollegin von Exilanten und Holocaustüberlebenden deutlich, daß in der BRD und, wie Ruth Beckermann ausführt, mehr noch in Österreich, die emotionalen und intellektuellen Voraussetzungen für eine so öffentliche und zugleich intime Konfrontation wie Schwaiger sie unternimmt, fehlen. In beiden Ländern ist die nationalsozialistische Vergangenheit über meine Generation hinaus, wie ich im Kontakt mit Studenten aus Deutschland und Österreich und auf meinen häufigen Besuchen in beiden Ländern erfahren habe, nicht bewältigt worden, auch wenn mittlerweile der Holocaust Teil des Kurrikulums an Schulen geworden ist. Während meiner Schulzeit in den 50er und 60er Jahren wurde

nicht einmal der Versuch dazu unternommen. Mit dem kulturellen Abstand einer naturalisierten Amerikanerin sind mir heute Vorfälle und Sachverhalte bewußt, die ich, integriert in die bundesdeutsche Gesellschaft, nicht einmal als faschistisch hätte einordnen können. Weniger die alt- und neonazistische Presse als die Körpersprache der Kultur vermittelten der Generation nach dem Holocaust sexistische, rassistische und antisemitische Strukturen, die so sehr ein Teil meiner Identität und der der meisten mir Gleichaltrigen wurden, daß ich sie erst nach einer beträchtlichen räumlichen, intellektuellen und emotionalen Trennung erkennen konnte. Angesichts der gegenwärtigen antisemitischen Aktivitäten in Europa und dem Zunehmen autoritärer Tendenzen, auch in dem seiner Vereinigung entgegensehenden Deutschland, geht es nicht an, daß Naziverbrecher und -mitläufer sowie die von ihnen indoktrinierten jüngeren Generationen sich als Opfer der Geschichte darstellen und rezipieren lassen. Wie aber ausbrechen aus der eisernen Umklammerung der eigenen Sozialisierung? Schwaiger scheint einen Versuch unternommen zu haben, aus dem keine Alternative zulassenden Diskurs ihrer Gruppe auszubrechen. Ihre Bemühung um Deutschs Geschichte deutet es an. Ein Grund für ihr Scheitern ist die deutsch-österreichische Konvention, nach der sozial Schwächere nicht zu Wort kommen oder, wenn sie reden, nicht beim Wort genommen werden.

In der österreichischen Geschichtsforschung spielt die Verfolgung der Juden keine Rolle. "Das beredte Schweigen über die Mitschuld der Österreicher reicht also von der Zementierung der Opfer-Legende (mit zeitweiliger Subsumierung der Juden unter die *Opfer für ein freies Österreich*), der Entfremdung und Irrealisierung der Ereignisse, über die Darstellung einer Katastrophe ohne Täter und Opfer bis zur Umkehrung der historischen Täter- und Opferrolle und zur Rückkehr zu den gewohnten Feindbildern".[4] "Österreicher und Juden werden beide als Opfer der deutschen Aggression dargestellt", beschreibt die 1951 in Wien geborene Ruth Beckermann die Situation in ihrem Geburtsland. Darin gleiche Österreich der DDR, daß es sich ebenfalls selbst von historischer Schuld freigesprochen habe.[5] Die "Volksgemeinschaft" sei sich jedoch einig gewesen, "daß die Verhältnisse, die durch die Ermordung und Vertreibung der Juden geschaffen worden waren, beibehalten werden sollten" (*Unzugehörig* 58). Bereits Bundeskanzler Figl wollte die Anwesenheit von Juden nur als "Österreicher, nicht als Juden" tolerieren (65). Personen, die sich den Besitz von Juden angeeignet hatten, organisierten 1948 den "Verband der Rückstellungsbetroffenen", um die Rückgabe zu verhindern (91).

Angesichts dieser historischen Fakten kann die Beziehung zwischen einer in Österreich marginalisierten polnischen Holocaustüberlebenden und einer etablierten deutsch-österreichischen Autorin, aus deren Werk überdies die Assoziation ihrer Familie mit dem Faschismus hervorgeht, nicht unbefangen sein.[6] Klassen-, Bildungs- und Altersunterschiede und die Zugehörigkeit zu

verschiedenen ethnischen Gruppen können auch in weniger komplexen Situationen einem Interview hinderlich sein.[7] Die kulturellen und sprachlichen Barrieren zwischen Schwaiger und Deutsch sind nicht geringer als zwischen Patai und den Brasilianerinnen. Deutschs und Schwaigers Beziehung scheint vor allem aus Deutschs Suche nach einem Autor, Schwaigers Suche nach einer Geschichte zu resultieren.[8] Deutschs Geschichte ist Aufzeichnung und Veröffentlichung wert und hätte möglicherweise eher in Mitarbeit mit einem deutsch- oder österreichisch-jüdischen Autor oder Autorin zu einem Buch werden können, das dem zu Berichtenden gerecht wird.

Die Dialogstruktur setzt Schwaiger und Deutsch in eine hierarchische Beziehung. Elias Canetti charakterisiert Frage-und-Antwort Situationen als Dominanz- und Unterwerfungsrituale:

> Alles Fragen ist ein Eindringen. Wo es als Mittel der Macht geübt wird, schneidet es wie ein Messer in den Leib des Gefragten . . . Die Wirkung der Fragen auf den Fragenden ist eine Hebung seines Machtgefühls; sie geben ihm Lust, noch mehr und mehr zu stellen. Der Antwortende unterwirft sich um so mehr, je häufiger er den Fragen nachgibt. Die Freiheit der Person liegt zum guten Teil in einem Schutz vor Fragen. Die stärkste Tyrannei ist es, die sich die stärkste Frage erlaubt (317-8).

Die von älteren Historiographen entworfenen Interviewstrukturen sind in Canettis Sinn Machtspiele. Nach Willa K. Baum ist ein Interview kein Dialog, da das Ziel das Einholen von Information sei (32). So scheint Schwaiger ihre Rolle Deutsch gegenüber beschrieben zu haben, so Deutsch sie zu akzeptieren:

> "Gnädige Frau, Sie sollen von mir herausziehen, was Sie glauben, daß wichtig wäre. Weil, ich tu sonst den Faden verlieren. Mein Mann hat immer gesagt: das nimmt ka Ende mit dir ich brauch ka Radio, ka Fernsehen" (66-7).

Baum schlägt vor, von den Befragten vor dem Interview Fragebögen über Eltern, Hintergrund, Familiengeschichte, nationale und kommunale Ereignisse, Kriege und Naturkatastrophen ausfüllen zu lassen. Schwaiger verfährt nach diesem Muster und gibt Deutsch Schreibarbeiten auf, auf die diese folgendermaßen reagiert: "Sehr geehrte gnädige Frau! Wie besprochen, so auch getan: also ich schreibe. Fehler . . . Leichter zwar geredet als auf Papier zu geben . . ." (49)

In dem Bewußtsein, daß Interviewsituationen bestehende Machtverhältnisse reproduzieren, reflektiert Patai die ihrer Arbeit zugrundeliegenden Prinzipien. Eine solche kritische Perspektive ist in *Die Galizianerin* nicht einmal angedeutet. Die Berechtigung, Deutsch im Sinne ihres Projekts zu befragen, setzt Schwaiger voraus. Im Gegensatz zu Patai bleibt Schwaiger als

Subjekt ausgeklammert. Patai definiert ihre Texte als von einer Ausländerin gesammelt, herausgegeben und übersetzt—und dabei doch erkennbar als Produkte der befragten Individuen (9). Sie definiert ihre Intention—darzustellen, wie ihre Informantinnen ihr Leben wahrnehmen (2)—und die Textgestaltung. Sie ahmt den regionalen Sprachhabitus ihrer Sprecherinnen im Englischen nicht nach, um Zugeständnisse an exotische Erwartungshaltungen und die Suggestion von Klassenunterschieden zu vermeiden, die der Durchschnittsleser mit der Abweichung von der Norm assoziiert. Sie wählt deshalb eine Übersetzung ins Standardenglische.[9]

Schwaiger dagegen schafft für Deutsch eine Sprachform, die an das jüdische Deutsch antisemitischer Autoren, z.B. Raabe, Freytag, Dinter, Veit Harlans Film "Jud Süß" und Streichers Stürmer erinnert, ein die Sprecherin als verächtliche Exotin charakterisierendes Idiom. Es bleibt jedoch dahingestellt, ob Deutsch nicht tatsächlich Jiddisch, Schwaiger zuliebe mit einem vorwiegend germanischen Wortschatz, verwendet. Sollte Deutsch, ohne daß es Schwaiger als solches erkannte, Jiddisch gesprochen haben, so hätte *Die Galizianerin* in jiddischer Sprache, also mit hebräischen Buchstaben und der jiddischen Grammatik entsprechend aufgezeichnet werden müssen. Zur deutschen Wiedergabe wäre—wie im Falle anderer Fremdsprachen—eine Übersetzung ins Hochdeutsche angebracht.

So aber steht das Werk in einer Sprachform, die in Deutschland und Österreich die negativsten Konnotationen hat. Gilman erläutert, daß bereits Jiddisch als eine Art Pidgin—also minderwertig—angesehen wurde. Das noch nicht akzentfreie Deutsch emanzipierter jüdischer Bürger wurde als *mauscheln* zum Charakteristikum des "komischen Juden" (*Jewish Self-Hatred* 155). Freilich beruht Judenhaß auf mehr als einer nur sprachlichen Differenz, aber auch diese trägt dazu bei, daß Juden als grundsätzlich anders wahrgenommen wurden. "The Jews spoke differently—especially the Eastern Jews. The Germans associated the image of the Eastern Jews and the *Jargon* spoken by them with the image of the Eastern (now Communist) barbarian and treated the Eastern Jews as subhuman" (355).

Obwohl Patais Informantinnen, wie Deutsch mit Schwaiger, aus freien Stücken mitarbeiten, fühlt sich Patai nicht von Verantwortung freigesprochen. Eine Frau, die ihre Lebensgeschichte erzählt, selbst wenn sie eine *Persona* schafft, entblößt sich und gibt sich der kritischen Analyse preis. Befragende gehen eine Verpflichtung ein, da sie zu Enthüllungen einladen, die die Befragten von sich aus nicht machen würden. In diesem Sinne sei mündliche Historiographie Verführung—für die Zuhörerin und die Sprecherin (8). Der stillschweigenden Voraussetzung der frühen feministischen Kritik, daß die Ausbeutung der Frauen von Männern ausgehe, ist entgegenzuhalten, daß alle sozialen, kulturellen und ethnischen Unterschiede für Männer und Frauen

gelten. Androzentrismus marginalisiert Frauen aller Gruppen, ohne daß eine Solidarität über die Gruppierungsgrenzen hinaus besteht. In Mitteleuropa gilt spätestens seit der Aufklärung der weiße, christlich sozialisierte Mann als "Normalmensch". Frauen und Kinder von Minderheiten sind vom Standpunkt dieses "normalen" Menschentums doppelt marginalisiert. Die Ausbeutung doppelt marginalisierter Frauen durch Männer *und* Frauen der privilegierten Gruppen ist gang und gäbe.

Eva Deutsch kommt als Individuum und historische Person aus einer Situation doppelter Marginalisierung. Die Habsburgmonarchie, ihre emotionale Heimat, war ein Vielvölkerstaat, dessen Desintegration Ende des 1. Weltkriegs durch die Gründung von Nationalstaaten besiegelt wurde. In diesen wurden Juden, Sinti und Roma zunehmend diffamiert und verfolgt, da sie auf kein Staatsgebiet als "angestammte Heimat" verweisen konnten und aufgrund kultureller, religiöser und, wie von Rassisten behauptet wurde, rassischer, Besonderheit für unassimilierbar galten.[10]

In Mitteleuropa schien die Assimilation der Juden nach der bürgerlichen Gleichberechtigung um die Jahrhundertwende vollzogen—gerade als Frauen durch das "allgemeine Wahlrecht" jede Möglichkeit zur politischen Mitbestimmung verloren. Ebendann trieben Pogrome in Rußland und Polen strenggläubige und sozialistische osteuropäische Juden, die sich in Sprache (Jiddisch), Kleidung und Sitten von den sogenannten "Westjuden" unterschieden, nach Westeuropa und in die USA. In Deutschland und Österreich—hier vor allem im 2. Bezirk Wiens, der Leopoldstadt—entstanden Einwanderungszentren (Roth 8). Möglicherweise um nicht mit den unassimilierten Immigranten assoziiert zu werden, distanzierte sich die jüdische Mittelklasse von den Ostjuden, wie z.B. Freud und Schnitzler. Karl Kraus empfahl völlige Integration: Taufe und Heirat mit Nichtjuden[11] und tadelte an seinen journalistischen Gegnern jeden Anklang an das in Wien verbreitete jüdische Deutsch. Aufgrund ihres oft ungeklärten Einwandererstatus und ihrer wirtschaftlichen Notlage fielen die osteuropäischen Juden, ihrer Sprache wegen leicht als "Ausländer" identifizierbar, als erste den von den Nazis veranstalteten Deportationen zum Opfer.

Derzeitig richten sich Rassismus und Fremdenhaß in Deutschland und Österreich gegen Arbeiter aus dem Mittelmeerraum, die auf dieselbe Weise stereotypisiert werden wie vor dem Holocaust die Juden. Daneben gibt es weiterhin das Feindbild "des Juden", obwohl die jüdische Minderheit nur 0,1% beträgt. Die jüdische Gemeinde in Wien, die größte Österreichs, repräsentiert den Rest einer ehemals heterogenen jüdischen Bevölkerung. Sie war, wie die Berliner jüdische Gemeinde, als Provisorium intendiert und besteht vorwiegend aus nach 1945 als *Displaced Persons* nach Wien verschlagenen Osteuropäern. Wie in Wien lebende Juden darlegen, hat sich die Situation

zwischen Juden und Nichtjuden nicht normalisiert (cf. Beckermann, Seelich, Sichrovsky). Der Diplomat Hans Thalberg führt aus, ein gedanklicher und gefühlsmäßiger Graben trenne ihn von dem Land und den Leuten, denen er sich in seiner Jugend zugehörig fühlte (213ff.). Die historischen Friedhöfe in der Seegasse und am Währinger Gürtel müssen zum Schutz vor Wandalismus unter Verschluß gehalten werden. Die Synagoge wird als Ziel von Anschlägen Tag und Nacht polizeilich überwacht. 1982, in dem Jahr, in dem *Die Galizianerin* veröffentlicht wurde, gab es Serien von Bombenattentaten auf die Schöps-Kaufhäuser. Waldheims Wahlkampagne, betrieben mit dem Goebbels-Slogan "Nun erst recht", sein Wahlsieg, nachdem seine Nazivergangenheit bekannt wurde, machte die Polarisierung endgültig. Antisemitische Äußerungen in den Medien sind wieder salonfähig geworden.[12] Obwohl für Hazel Rosenstrauch, ein "jüdisch-kommunistisch-wienerisches Emigrantenkind", die BRD kein ideales Land ist, zieht sie es vor, dort zu leben statt in "Österreich, für mich das antisemitischste aller Länder" (341).

In diesem Umkreis entstand *Die Galizianerin*. Der Titel des Werks ist generisch und bezeichnet Herkunftsland und Geschlecht. "In Österreich fällt das Wort *Jude* in den Bereich der Schimpfwörter", führt Beckermann aus (*Unzugehörig* 20). Wieviel mehr das Wort *Galizianerin*. Im Deutschen sind, besonders für die ältere Generation, die durch "Galizien" evozierten Vorstellungen aus dem Nazikontext die denkbar schlechtesten. Galizien bezeichnete in antisemitischen Texten und Filmen, z.B. "Der ewige Jude" (1940), ein Land fern aller Kultur, korrumpiert durch eine große jüdische Minorität, von den Nazis als eine als von Osten her drohende Menschenflut dargestellt, die mit Epidemien oder Schädlingen wie Ratten und Läusen verglichen wurde,[13] ein Feindbild, das die osteuropäischen Juden der Leopoldstadt für die Wiener verkörperten.

In den 80er Jahren diesen stigmatisierenden Terminus als Buchtitel zu verwenden, der in zweiter Linie Assoziationen an den beinahe erfolgreichen Versuch der Nazis, das Judentum zu vernichten erweckt, scheint nicht ratsam. Falls Schwaiger eine Aufwertung beabsichtigen sollte, hätte sie wissen müssen, daß sie das Risiko eingeht, mißverstanden zu werden. Bereits das Österreichische Institut für politische Bildung fürchtete im Mai 1979 Krawalle bei der Fernsehausstrahlung der Hollywood-Serie "Holocaust" und veranstaltete vorbereitende Seminare und verschickte Materialien zur Abwehr antisemitischer und neonazistischer Angriffe.

Auf den ersten Blick gibt sich *Die Galizianerin* als Deutschs Memoir, da ausschließlich durch eine als Deutsch identifizierte Erzählerin berichtet wird. Interviews und schriftliche Unterlagen werden nicht dokumentiert, Schwaigers Rolle als Interviewer und Editor nicht definiert. Das Fehlen solcher Dokumentation verweist *Die Galizianerin* in das Reich der Fiktion mit

Schwaiger als Autorin, wie der Buchrücken nahelegt. Aber auch als Roman läßt der Text, eine recht genau chronologisch organisierte, spannend erzählte Lebensgeschichte aus der Zeit des Holocaust, Fragen offen, zumal es Eva Deutsch in Wien wirklich gibt. Der Form—Deutschs Sprache ist fremdartig genug gestaltet, um exotisch zu wirken, deutsch genug, um von Österreichern verstanden zu werden—und dem Inhalt nach—es werden jüdische Gebräuche für jüdische Leser redundant dargestellt—richtet sich der Text an eine nichtjüdische Leserschaft. Die Anwesenheit zweier Personae, der Erzählerin Deutsch und der Zuhörerin, verleihen dem Werk einen dialogischen Charakter.

Aus der Art wie Deutsch ihre Gesprächs- und Korrespondenzpartnerin anredet, geht hervor, daß Schwaiger keinen Versuch unternommen hat, den von ihr Informantin angesetzten Rangunterschied aufzuheben. Schwaiger forscht, sammelt und ortet, bleibt aber, da der Text ihrer Kommentare und Fragen nicht veröffentlicht ist, unsichtbar. Dagegen steht die alte, ehrerbietige Jüdin mit ihren grammatischen Fehlern, ihrem Dialekt, den erinnerten Demütigungen einschließlich der Vergewaltigung durch einen Nichtjuden, und ihrer problematischen Nachkriegsexistenz im Flutlicht. Das nämliche Verhältnis verewigt Alfred Hrdlickas Mahnmal an der Albertina in Wien. Aufrecht stellt es in weißem Marmor die österreichischen Widerstandskämpfer dar, in Bronze, auf dem Boden ausgestreckt, mit Bart, Kaftan und Paies, einen alten Juden. Beckermann interpretiert:

> Was immer dieses Denkmal den Wienern sagen will, mir sagt es: Im Staube seid ihr gelegen. Auf dem Bauch seid ihr gekrochen. Und das ist unser Bild von euch. Fünfzig Jahre danach formen wir euch nach diesem Bild. Als frommen Alten. Das rührt ans Herz und rückt die Opfer in angenehme Distanz: suggeriert es doch, die Juden seien ein seniles, altersschwaches Volk, dessen natürlicher Tod bevorstand" (*Unzugehörig* 13).

Die Galizianerin ist ein spannungsvoller Text, in dem gegenläufige Intentionen aufeinanderprallen und verschiedene *Personae* entworfen werden. Zwar redet Deutsch Schwaiger ehrfürchtig an, aber ihre Willfährigkeit ist nicht ohne Feindseligkeit, z.B. "Madame, wann Sie zu sehr anstrengt die Geschichte, schnappen Sie frische Luft! Essen Sie gut. Ein Medikament ist erlaubt zu nehmen, wann Sie sind nervös!" (49) Leser könnten schließen, daß Deutsch auf die Art einfacher Menschen eloquent, aber des Schreibens nicht mächtig ist. Schwaiger scheint sie zur Disziplin anzuhalten, ihr eine Stimme zu verleihen—doch was für eine Stimme? Der stigmatisierende Jargon, durch den Schwaiger Deutsch charakterisiert, verstärkt den Eindruck sprachlicher Impotenz und reduziert Deutsch zum antisemitischen Klischee. Daß Deutsch sich misrepräsentiert fühlt, deutet der Sarkasmus ihrer Höflichkeitsformeln an, die ähnlich wie Paul Celans formvollendete Ansprachen bei der Entgegennahme literarischer Preise die Zuhörer gleichzeitig umwerben und verspotten

(*Ausgewählte Gedichte* 133-148), oder der Epilog von Erich Frieds "Arden muß sterben", geschrieben für die Hamburger Staatsoper.

Deutsch sieht ihre Lebensgeschichte verbunden mit der Kultur des Habsburgerreichs, von dem noch Elias Canetti, Joseph Roth und Manès Sperber ihre Identität ableiten. Im Gegensatz zum Titel stellt sie sich im Text spezifisch vor, als "Polin, Jüdin, Patriotin vom Kaiser Franz Josef und seine Völker", als Nachkommin eines Vaters und Großvaters der k. u. k. Monarchie, denen "der Kaiser der halbe Gott" war (*Galizianerin* 11). Sie schreibt ein Requiem auf die Kulturen, deren Kind sie ist: die kaiserlich-österreichische und die ostjüdische und evoziert das Verlorene. "Gnädige Frau, mir ist von meiner Familie zurückgeblieben nicht einmal a Bild" (110). Sie nennt Tote und Verschollene ihres großen Familien- und Bekanntenkreises.[14] Ihre Genauigkeit läuft dem Titel zuwider, der einen Typ, nicht ein Individuum ankündigt. "Ich heiße weltlich Eva, aber de facto bin ich Chawa" (14). Deutsch betrauert den Untergang der Welt ihrer Jugend, bezeugt Verfolgung und Massenmord, klagt die Mörder und ihre Helfer an und leistet ein Bekenntnis zu ihrer Herkunft und ihrem Namen—zu sich selbst.

Deutsch ist polyglott, wie viele Menschen aus dem Raum der Donaumonarchie, mit Jiddisch als Muttersprache. Dazu spricht sie, wie aus den Episoden hervorgeht, in denen sie sich als Polin tarnt, akzentfrei Polnisch—eine Seltenheit bei osteuropäischen Juden—, Russisch und Slowakisch (147). Ihrer eigenen Aussage nach beherrscht sie Deutsch am wenigsten. Sie hat aber Sprachgefühl und ist sich der Wirkung von Texten bewußt, wie die als Schreibproben eingeschobenen Passagen andeuten. Sie ist auch dem Sprachgestus gegenüber empfindlich. Z.B. merkt sie über den deutschen Soldaten, der sich ihr gegenüber primitiv ausdrückt, an: "Er hat geglaubt, er muß verdreht reden. Er hat sicherlich gut deutsch gesprochen, aber er hat sich bemüht, damit wir ihn verstehen sollen ... Ja, sagt er, Krieg nix gut, nix gut!" (65)

Die deutsche Sprache ist für Deutsch die Sprache der Nazis: "SS fangt an zu suchen. Juden! Wo sind Juden! Sind hier Juden? Auf deutsch natürlich. Ein SS kann doch nicht anders reden als deutsch" (93). Solche Erlebnisse mögen einen Block hervorgerufen haben, was nichts Ungewöhnliches wäre. Es gibt Menschen, die nach dem Holocaust ihre deutsche Muttersprache ablegten. Ein kompetenter Herausgeber hätte Deutschs Sprachproblem beilegen können. Bei Schwaiger dagegen verschmelzen Idiom und Person zu einer fiktiven organischen Einheit, Deutschs Sprache signalisiert eine spezifisch jüdische Mangelerscheinung und bedeutet mehr als eine jeden fremdsprachigen Einwanderer konfrontierende Schwierigkeit. Aus Akzent und Syntax wird die Persona einer einfachen jüdischen Frau, einer weisen Märchengroßmutter oder Hexe konstruiert.[15] Im Widerstreit mit dieser Persona äußert sich oft eine modernere, unkonventionelle Eva Deutsch.

Deutsch war bei der Invasion Polens fünfzehn Jahre alt und hat keine abgeschlossene Schulausbildung da seit der Kristallnacht November 1938, auf den von Deutschland kontrollierten Gebieten Juden vom öffentlichen Schulunterricht ausgeschlossen waren. An akademischem Wissen ist sie Schwaiger unterlegen. Der Eindruck des Bildungsgefälles wird durch den Altersunterschied und die kulturellen Barrieren verstärkt. Da Deutschs Kultur Forschungsobjekt, Schwaigers Ort der Forschung ist, kann Deutschs vom Judentum informierter Diskurs nicht gegen den Schwaigers ankommen, dessen Vorrangstellung sich aus der Beherrschung der deutschen Hochsprache und der Kenntnis des traditionellen österreichischen Bildungsguts ableitet.

Aus den Fragen Schwaigers, soweit sie sich aus dem Text erschließen lassen, geht hervor, daß diese praktisch nichts über das osteuropäische Judentum weiß und dasselbe bei ihren Lesern voraussetzt.[16] Die Digressionen über die jüdische Kultur wirken museal, da sie als Vignetten isoliert eingestreut sind, ebenso wie unbeholfene Metaphern und Redensarten—das häufige "Gottes willen" (*Galizianerin* 8, 213, 217, 221 u.a.), apologetische Floskeln, z.B. "mein Mann . . . , er soll mir verzeihen . . ." (199) die Bildlichkeit der Parabel, "Der abgebrochene Zweig" (49ff.), die für sich genommen befremdlich wirkt, aber doch Teil jener Erzähltradition ist, der auch das Märchen von Haga Zusa angehört, mit dem Beckermann "Die papierene Brücke" (9) einleitet. All dies fällt im deutschen, nicht aber im jiddischen Kontext, merkwürdig auf. Deutsch bemüht sich sogar, jiddische Wortspiele zu erklären. (116) Auch ihre Syntax fällt aus dem Rahmen, z.B. die Inversionen, ein integraler Teil des Jiddischen: "Sagt er, nojo . . . Sag ich, was heißt", "Komm ich auf die Straße, schau mir an die Stadt" (8, 26). Dem Exotismus, hervorgerufen durch eine auffällige Widergabe dessen, was in einer anderen Sprache der Normalfall ist, widersprechen Stellen, an denen sich Deutsch als eine kompetente Frau mit politischen und sozialen Interessen herausstellt, der auch westliche Musik und Kunst keineswegs fremd sind.

Deutsch, die als junges Mädchen zionistische Neigungen hatte, scheint über die Situation der Juden und die Politik der Nazis besser informiert als manche großstädtischen Holocaustopfer, die noch auf den Rechtsstaat vertrauten, als das Recht längst beseitigt war. Sie erwähnt, daß ihr der Plan der Nazis, die Juden auf Madagaskar zu internieren, bekannt war. "Ich wäre nicht nur mit zwei Füße, mit hundert Füße, verstehen Sie, gelaufen nach Madagaskar, meinetwegen zum Teufel, nur weg von da" (9). Ebenso gern wäre sie nach Palästina oder in die UdSSR ausgewandert. Von Anfang an scheint ihr klar, daß Hitler die Juden umbringen will (10-11) und die Pogrome offiziell organisiert waren: "Weil das primitive Volk hat das nicht veranlassen können. Das hat müssen durch Köpfe gehen" (44-45).

Dieser erstaunliche Grad an Einsicht stellt Deutsch auf eine Stufe z.B. mit Lion Feuchtwanger, der 1932 die Konsequenzen zog und emigrierte. Der Eindruck entsteht, daß man mit ein wenig gesundem Menschenverstand über die Ziele Hitlers und seiner Partei hätte Bescheid wissen und entsprechend handeln können. Tatsächlich mögen diese Erkenntnisse im Rückblick gewonnen worden sein. Etwaige emotionale Hemmungen, ihr Wissen in die Tat umzusetzen, weist Deutsch zurück. Über Menschen, die, obwohl sie einen Ausweg hatten, im Lande blieben, heißt es: "Die waren wahrscheinlich verblödet" (53, 9). Deutsch billigt die Entscheidung ihrer Verwandten, in die Sowjetunion weitergefahren zu sein. Eine so rigorose Einstellung der Emigration, eine solche Klarsicht dem Nationalsozialismus gegenüber, besaßen die wenigsten Europäer. Typischer war, besonders bei österreichischen und deutschen Juden, ein durch übergroße Heimatliebe motivierter Zukunftsoptimismus. Deutsch, ein halbes Kind, soll gewußt haben, was die meisten Erwachsenen nicht wußten.

Auf diese Weise bestätigt der literarische Charakter Deutsch eine Lieblingsthese der Naziapologeten. Wenn ein Kind die Wahrheit hat wissen können, hätte ein jeder die Wahrheit wissen können. Nichtwissen scheint verantwortungslos, ermordet zu werden, wenn man bleibt, wo man immerhin Staatsbürger ist, als selbstverschuldet. Wenn Deutschs Familie hätte auswandern können, hätte ein jeder auswandern können. Wenn es doch Juden gab, die ein zu nahes Exil in Reichweite der Nazis vorzogen, mußten sie dafür besondere Gründe haben. Bei Deutschs Eltern sind es materielle Überlegungen. Obwohl die Überlebens- und Bildungschancen in der UdSSR angeblich besser gewesen wären, bleiben sie in Polen und hoffen auf die Hilfe ihrer Verwandten.

Diese Vorstellungen bestätigen bekannte antisemitische Vorstellungen: Zum einen, daß eine Affinität zwischen Bolschewismus und Judentum besteht, die Deutsch selbst von sich weist—daher die angebliche Bereitschaft der Sowjets, den Juden zu helfen, die, wie ein Blick auf den Stalinismus belegt, reine Fiktion ist (20), zum anderen, daß Juden produktive Arbeit scheuen und sich in einem kapitalistischen Land vorzugsweise von anderen unterstützen lassen.

Die in *Die Galizianerin* am Judentum geübte Kulturkritik gewinnt durch den Kontext, den Holocaust, einen üblen Beigeschmack. Deutsch exponiert die Misogynie des Ostjudentums Schwaiger, der Angehörigen einer ebenso misogynen und traditionell antisemitischen Kultur gegenüber. Sie klagt über die von den Vätern arrangierten Ehen: "Die Männer besprechen sich das, und dann macht man eine Verlobung ohne die Braut" (15). Sie erwähnt die Vernachlässigung der Frauenbildung, die körperfeindliche Kleidung und die rigiden Geschlechterrollen (13). Diese Auseinandersetzung Deutschs mit ihrer

Rolle als jüdischer Frau ist ein zentrales Thema, das oberflächlich nichtjüdische Leserinnen zur Identifikation einlädt, z.b. wenn es heißt: "Komisch, ich hätte sollen ein Mann sein. Ich hab immer ein Messer bei mir gehabt", "Ich hab mir das nicht verkraften können, daß ich kein Bub bin" (79, 124), oder Deutsch anführt, sie habe sich schon vor dem Krieg von ihrer Kultur betrogen gefühlt, da ihr Berufs- und Liebeswahl versagt waren—sie wäre gern Religionslehrerin geworden, darf jedoch als Mädchen nicht Talmud lernen und beneidet die Töchter eines assimilierten Anwalts, von denen die dritte die Advokatur ihres Vaters übernimmt und ledig bleibt: "Und mir ist eingefallen, Gottes willen! So ein Mensch könnte ich werden!" (122) Deutsch betont wiederholt ihre Entfremdung von den von Männern diktierten Werten.[17]

Unerwähnt bleibt, daß die Flucht aus diesem Kulturkreis für Deutsch weder möglich war noch eine Alternative geboten hätte. Die Unterdrückung der Frau ist allen westlichen Kulturen und den sie prägenden Hauptreligionen, Judentum, Christentum und Islam, gemein. Selbst in sozialistischen, vor allem aber faschistischen Ländern wurden Frauen unterdrückt. Darüberhinaus bestand seit dem Sieg des Nationalsozialismus für europäische Juden keinerlei Möglichkeit zur Assimilation. Im Gegenteil, auch wer sich, einschließlich Taufe, assimiliert hatte, wurde als Jude behandelt und recht- und staatenlos gemacht. In einer Diskussion zwischen einer Jüdin und einer Österreicherin ist im Kontext des Holocaust die Frauenfeindlichkeit des Judentums irrelevant und trivial, wenn nicht zugleich auf die Benachteiligung der Frauen und Juden im Austrofaschismus und im Österreich der Nachkriegszeit hingewiesen wird.

Deutsch ist vor allem das Opfer der Deutschen während und nach dem Holocaust und erst sekundär Opfer ihrer frauenfeindlichen Kultur, der Quelle ihres nicht unbeträchtlichen Selbstbewußtseins und ihrer kulturellen Identität. Nüchtern basiert Deutsch, die nach der Trennung von den Eltern für ihre Brüder sorgt, ihre Selbsteinschätzung auf Charaktereigenschaften, nicht auf ihren Marktwert als Frau. Sie hält sich Männern, auch solchen in Autoritätsrollen, für überlegen. Deutschs Anekdoten belegen, daß in ihrer Kultur trotz der ungleichen Behandlung Zusammenarbeit und Solidarität zwischen den Geschlechtern existieren—und Liebe. Die Nazis dagegen rotteten ihre Familie aus und planten ihren Untergang—den Untergang aller Juden.

Warum kritisiert eine jüdische Frau, eine Holocaustüberlebende, jüdisches Brauchtum in einem Text, der von einer österreichischen Nichtjüdin kontrolliert wird? Deutsch braucht als unbekannte Ausländerin Protektion.[18] In einer solchen Situation entsteht kein authentisches Werk. Auch wenn *Die Galizianerin* den Anschein gibt: hier schreibt kein *insider* über die eigene Gruppe wie Alice Walker, die ihre Celie in *The Color Purple,* auch aus dem Jahr 1982, auf *Black English* die Brutalität ihrer vom Machismo geprägten Kultur aufzeigen läßt. Der scheinbare Befreiungsakt in *Die Galizianerin*

unterliegt der Kontrolle einer Autorin, die der Gruppe angehört, von der sich Deutsch freischreiben will. Das Ende von *Die Galizianerin* deutet keine neuen Perspektiven an.

Die Galizianerin macht eine Jüdin zur Kronzeugin gegen jüdische Menschen einer Frau gegenüber, die eine Generation zuvor ihre Todfeindin hätte sein können, jetzt aber Deutschs Geschichte auf dem Büchermarkt vertreibt. Zwischen beiden wird eine Gemeinsamkeit vom Standpunkt der Frau unterstellt, von dem aus die Nazigreuel bagatellisiert werden, indem wiederholt die Unterdrückung der Frau im Judentum, nicht aber die Unterdrückung des Judentums zur Sprache kommt. Schwaiger deutet nicht an, was Deutsch als Jüdin in Deutsch-Österreich erwartet hätte, daß in der Vernichtungspolitik der Nazis jüdische Mütter, kleine Mädchen und Schwangere bei der Ankunft im Vernichtungslager sofort zur Vergasung geschickt wurden.

Dagegen vertritt Deutsch Ansichten, die in der latent antisemitischen deutsch-österreichischen Öffentlichkeit, in der Juden weiterhin Außenseiter und unliebsame Symbole für ein unbegleichbares Schuldkonto sind, verbreitet sind. Deutschs scheinbare Versöhnlichkeit kommt dem Verlangen dieser Öffentlichkeit entgegen, sich von der Vergangenheit loszusagen zu einem Zeitpunkt, zu dem man es noch nicht wagt, sich öffentlich freizusprechen und der Aggression gegen Juden freien Lauf zu lassen. Schwaiger benutzt Deutschs Geschichte und Namen für eine Veröffentlichung in einer Holocaustthemen günstigen Marktsituation. Die Reste des Holocaust werden—diesmal intellektuell—verwertet. Bereits in den 60er Jahren kritisierte Ingeborg Bachmann den Profit gewonnen aus dieser Vergangenheit in *Der Fall Franza*. Zwischen Bachmanns Jordan und Franza, und Deutsch und Schwaiger, gibt es Parallelen.

Deutsch hat das KZ nur von außen gesehen. Ansonsten gleicht ihr Hintergrund dem von Henryk Broders Eltern, die, wie Deutschs Familie, aus Oberschlesien nach Polen flüchteten, in der Hoffnung, nicht eingeholt zu werden. Broder beobachtet:

> Es dauerte lange, bis ich begriff, daß meine Eltern die KZ-Zeit nur physisch, wenn auch knapp, überstanden hatten, daß sie psychisch zerstört, seelisch endgelöst waren, daß sie diese Geschichten immer wieder erzählen mußten, weil sie sonst selbst mit der Zeit nicht geglaubt hätten, was sie erlebt und überlebt hatten (*Spiegel* 85).

Es mag sein, daß Deutsch sich Schwaiger anvertraute, weil sie, wie Broders, wie Fleischmanns Eltern, besessen ist, zu berichten, wie es war. Vielleicht hielt sie Schwaiger für ein geringeres Hindernis als das deutsche und österreichische Verlagswesen. Das Resultat der Schwaiger/Deutschschen Co-

Produktion ist Zeugnis für die Not einer Überlebenden, die nicht für sich sprechen kann, da ihre Stimme von den Mördern und deren Kindern vereinnahmt wurde. Geschichte wird immer von den Stärkeren geschrieben.[19]

So gesehen wäre *Die Galizianerin* ein Roman von der jüdischen Stimme, die so weit manipuliert wird, bis sie Juden diffamiert, die so lange behorcht wird, bis sich etwas Fragwürdiges zu zitieren findet wie die folgenden, die Wahrheit verzerrenden Passagen: ". . . damit sie (die Nazis) sollen ein leichteres Spiel haben mit den Juden, haben sie gebildet den Judenrat, so wie wir haben hier eine jüdische Kultusgemeinde" (74). Es wird suggeriert, alle Judenräte seien Kollaborateure gewesen und die Wiener Kultusgemeinde mit diesen korrupten Judenräten identifiziert—möglicherweise in Assoziation an Werke wie Rainer Werner Fassbinders *Der Müll, die Stadt und der Tod,* in dem, wie in seiner Vorlage, Zwerenz' *Die Erde ist unbewohnbar wie der Mond,* unter dem Anspruch auf Authentizität Juden, Israel und die Frankfurter jüdische Gemeinde diffamiert werden. Die Gleichsetzung der 1848 gegründeten Wiener Kultusgemeinde mit Instanzen, die an den Vernichtungstransporten teilhatten, ist Geschichtsfälschung.[20] Deutschs Ausfall gegen die Judenräte aus einem spezifischen Erinnerungskontext kann keinen Universalitätsanspruch erheben: "mit Knüppel, Stern und Binde, . . . Verbrecher. Jüdische Verbrecher! Der jüdische Polizist hat sein eigenes Volk verraten. Hat nicht geholfen, auch sie deportiert" (74).

Der Druck macht flüchtig Hingeworfenes permanent. Der Tonfall differenziert nicht zwischen emotionaler Perzeption und Faktum, z.B. bei der Charakteristik eines jüdischen Spitzels, bei der sich Deutsch selber verbessert: "Gefährlicher Hund gewesen. Ärger wie die Gestapo. Ärger nicht. A la Gestapo . . . Wann so ein Polizist sich zufällig in einem Auschwitz oder Treblinka oder in Majdanek noch gerettet hat, da muß er haben viel auf dem Gewissen!" (75) Gleich zu Anfang scheint Deutsch zu ahnen, daß sie mißverständlich zitiert werden könnte: "Weil ich doch nicht weiß, wohin Sie steuern. Gnädige Frau, es gibt Leute, die viel hinter die Ohren haben! Denen muß man sehr aufpassen, was man redet. Da weiß man nicht, wo man hinkommt mit der Geschichte" (7).

Im Falle von ehemaligen Naziverfolgten kommen Mißverständnisse vor. Z.B. hat Ilse Aichinger durch ihren Holocaustroman *Die größere Hoffnung* (1948) erfahren, daß eine Autorin ein Risiko eingeht, wenn sie aus der Sicht der Verfolgten schreibt und fühlte sich, wie Celan, zu immer größerer Diskretion gedrängt, um den Mißbrauch ihrer Worte für fremde Zwecke zu verhindern. Deutsch hat sich geöffnet. Der entstandene Text ist ein Dokument des Dilemmas. Obwohl der Text weitgehend Schwaigers aus *Lange Abwesenheit* bekannten Intentionen entspricht, gibt es Ambiguitäten. Deutsch bringt an scheinbar konfliktlosen Themen ihre Position ein, z.B. wenn sie den

Ursprung von Christentum und Judentum als etwas Gemeinsames zwischen sich und Schwaiger diskutiert. Entsprechend der jüdischen Auffassung lehnt sie aber Jesus als Heiland ab. Sie beschreibt ihn als einen zum Märtyrer gemachten Rabbiner, einen Tröster des von Herodes und Rom unterdrückten Volks, einen verzweifelten Juden: "Wissen Sie, in der Not, bevor man soll zugrunde gehen, will man versprechen" (113). Diesen Mann aus ihrem Volk kann Deutsch akzeptieren. Ebenso menschlich interpretiert sie Maria und erfindet ironisch-liebenswürdige Marienlegenden. "Hat die heilige Maria das bewirkt, daß er den Juden a bissel mehr zu essen gegeben hat. Da war der Jesus doch a Jude gewesen, und die heilige Maria auch . . . Hat ja Mirjam geheißen. Und sie hat uns bewirtet" (72). In der scheinbaren Annäherung ist die Abgrenzung entscheidend. Es ist bei Deutsch nicht die Rede von christlich-jüdischer Vereinigung durch Heiraten wie z.B. bei Kraus und Else Lasker-Schüler. Konversion, um ihr Leben zu retten, einen verzweifelten Versuch, den manche zu spät und vergeblich unternahmen, kommt für sie nicht infrage: "Lieber Gaskammer" (115).[21] Die angehängte Versicherung, es genüge, "daß wir beide bei unseren Überzeugungen bleiben und trotzdem uns lieb haben. Gut meinen. Aufrichtig sind. Ich hab mich nicht frohlockend wollen vergasen lassen" (115) erhöht die schon beträchtliche Spannung. Wie kam Deutsch zu dieser emphatischen Aussage? Welche Frage ging voraus? Nicht die Versöhnung, die Gaskammer, dominiert diesen Gedanken.

Deutsch differenziert zwischen persönlicher Religiosität und organisierter Religion. Letztere ist für sie das Christentum, das sie erfahren hat, als sie, um ihr Leben zu retten, als polnische Katholikin verkleidet zur Messe ging, wo von der Kanzel Judenhaß gepredigt wurde. Deutsch kritisiert die autoritären und ethnozentrischen Elemente im Christentum und deren Wirkung auf die Gemüter (138) in der Art wie Marianne Rosenbaum in ihrem Film *Peppermint Frieden*. An das Judentum assoziiert sie aber innige Gefühle. Dieser Wärme, die *Die Galizianerin* stellenweise vermittelt, läuft das Motiv zuwider, die Unterdrückung der Juden durch Juden sei nicht geringer gewesen als die der Juden durch die Nazis. Zur adäquaten Einordnung solcher Äußerungen gehört eine Sichtung des historischen Kontexts wie sie z.B. Edgar Hilsenrath unternimmt, der die Ausbeutung von Juden durch Juden in seinem Ghettoroman *Nacht* als Folge der von den Nazis geschaffenen Strukturen darstellt, ohne daß die Deutschen ins Blickfeld rücken. Die Ausbeutung der Ärmsten durch die Armen und der Frauen durch Männer—ein Kapitalismus, umso radikaler je geringer das Warenangebot—ist die Folge des nazistischen Konzentrationslagerstaats.

Obwohl Deutsch die Diskrimination gegen die Frauen nicht verschweigt, dringt ihre Liebe zum Judentum durch, deutet sie jüdische Alternativen zur Ultraorthodoxie an. "Ich bin schon nicht mehr so vernagelt, wie die Erziehung war, bin jetzt a weltlicher Mensch, aber ich bin noch mehr gläubig. Ich zünde

Kerzen und ich halte Sabbat" (125, 122). Es scheint dagegen im Sinne Schwaigers, die Opfer, jüdische Männer—und gelegentlich Frauen, wie die reiche Jüdin, die die Hilfesuchende abweist und die Jüdin, die Deutschs Mutter, während sie selbst sich rettete, nicht beistand (104, 101)—, als den Nazis ähnlich zu charakterisieren. "Madame, die jüdische Polizei hat mir genommen den Kleinsten . . ." (107). Die Verbrechen der von den Nazis unterdrückten Individuen und Gruppen sind jedoch anders einzuordnen als die Planung und Durchführung des Völkermords durch die deutsche Regierung. In Erzählpartien solchen Inhalts wird Schwaiger immer direkt als "Madame" (104, 107) oder "Gnädige Frau" (101) angeredet, desgleichen in Partien, in denen Nichtjuden ehrenvoll erwähnt werden (85), als seien diese Passagen besonders an Schwaiger gerichtet.

Der historische Zusammenhang, in dem Deutschs Bericht steht, wird nirgends—nicht einmal durch eine Zeittafel am Ende des Buchs—geklärt. Der 2. Weltkrieg stellt sich als allgemeines Erlebnis "Kriegsgreuel" dar, der Holocaust als Teil desselben. Nach der Verantwortlichkeit wird nicht gefragt. Wo immer sich Gelegenheit bietet, wird in *Die Galizianerin* die Beteiligung von Nicht-Deutschen an Grausamkeiten betont, wie um die Deutschen und Deutschösterreicher zu entlasten: "Madame, ich hab so geschrien. Ich habe geglaubt, nur die Deutschen machen. Jetzt hab' ich gesehen Bauern und Zivilisten" (44). Während diese Beobachtungen richtig sein mögen—auch in Claude Lanzmanns "Shoah" kommt der Antisemitismus der polnischen Landbevölkerung zum Ausdruck (250)—werden sie fragwürdig, da sie allzu häufig mit Exkursen über "gute" Deutsche komplementiert werden, z.B. den Offizier, der Deutsch rät, sich zu den Russen abzusetzen, das Ehepaar, das sie warnt, sie beschenkt und ihr einen Christbaum aufbaut (19, 151).

Während Deutsche verharmlost werden, rückt das Judentum seiner Gebräuche und verschiedener negativer Gestalten wegen in ein schlechtes Licht. *Die Galizianerin* liefert Gründe, warum man erleichtert sein sollte, daß diese Kultur kein Faktor im zeitgenössischen Europa mehr ist. Distanzierung von den Opfern ist umso leichter, als der Chassidismus, die den Mitteleuropäern wenigsten nahestehende Form des Judentums, im Zentrum steht. Zudem legt der Text auf verschiedenen Ebenen nahe, daß Juden aus eigenem Versagen oder aufgrund einer kulturellen Schwäche Opfer des Masssenmordes wurden. Die Annahme, es gäbe keine jüdischen Gemeinden, keine Überlebenden, niemanden mehr, der sich kulturell oder religiös als Jude versteht, wird in den Medien und der Literatur oft gemacht—nicht selten von Nichtjuden.[22] Die Existenz jüdischer Gruppen und Individuen zu übergehen, mag dem latenten Wunsch entspringen, der Holocaust möge erfolgreich gewesen sein, so daß man nurmehr Trauerarbeit leisten und vergessen kann.

Deutsch erzählt eine Parabel im lyrischen Ton chassidischer Märchen, die von der inneren Vereinsamung als Resultat der Assimilation und der auf sie folgenden Verfolgung handelt. Ein Mädchen verkleidet sich, um als Fremde nicht aufzufallen, bis sie krank wird. Nur die Stimme Gottes spricht ihr Trost zu und bewahrt sie vor dem Selbstmord. Dasselbe Thema kehrt in dem jiddischen Lied von der Überlebenden, deren Verwandte erschossen oder vergast wurden, wieder auf. "Und so ist der abgebrochene Zweig alt geworden, fast verdorrt sitzt sie in ihrer Wohnung und denkt nach am Zweck ihres Daseins" lautet das wehmütige Fazit (52).

Anders klingt die Stimme der Sprecherin freilich in weniger lyrischen Momenten. Dann hat sie keinen Zweifel an dem Sinn des Überlebens: "Aber es war ka Zeit zu denken. Man muß weiterleben" (221)—nicht zuletzt für einen Auftrag, den Deutsch so formuliert: "Sehen Sie, hat immer Gott geschickt, daß jemand ist zurückgeblieben. Hat der Christ das Mädchen herausgenommen, und dieses Mädel war das Wunder, daß sie soll Zeuge sein, was man gemacht hat" (44). Als eine solche Zeugin agiert Deutsch, obwohl sie gleichzeitig an ihrem Überleben leidet. Sie bezeugt den beinahe gelungenen Völkermord, ihr Überleben und das ihres Volkes.

Der vielfach gebrochene Text, dessen Widersprüchlichkeit sowohl in der historischen Situation angelegt ist—es ist noch immer nicht leicht, über den Holocaust in deutscher Sprache zu schreiben—wie auch in der Autorinnenkonstellation, läßt durch die in ihm angelegten Spannungsfelder ahnen, daß und warum die Versöhnung zwischen den ehemaligen Opfern und Verfolgern und ihrer Kinder kaum möglich ist. Die Galizianerin reproduziert die Ausbeutung und Reifizierung der unterprivilegierten Frau durch die privilegierte—sichtlich haben sich die Verhältnisse nach 1945 nicht grundsätzlich verändert. Durch die Unterdrückung der einen Stimme bricht freilich auch die andere. Die Stimme, die diesen Text kontrolliert, ohne zu reden, kann auf Integrität keinen Anspruch erheben.

Notes

[1] Deutsch über ihren Mann zum Thema Sexualität: "Mein Mann hat gesagt, alle Männer, ein Mann beutelt sich davon ab, hat er gesagt, erledigt! Das kann der beste Ehemann sein. Aber wissen Sie, mich hat das angewidert, wann er das gesagt hat. Ich hab mich geekelt. Aber die Männer sprechen über sich so. Sind sie so veranlagt?" (*Galizianerin* 134)

[2] Gegen Historiker, die die Zerstörung des europäischen Judentums verkündet haben, z.B. Hilberg und Levin, verkündet Deutsch, daß sie in Europa lebt und Jüdin ist. "Hab ich mir gedacht: Der ewiger Jude! Hab sie doch überlebt. Hab sie bitter überlebt. Hab überlebt die Babylonier, hab überlebt die Römer, hab überlebt das Deutsche Reich, das Tausendjährige! Hast es! Gott, mein Gott, was ist geschehen, hab ich gebetet. Zweitausend Jahre! Und habe

gebetet, ich will nicht undankbar sein. Vor Dir, mein Gott, neige ich mein Haupt, sage dreimal: ewig bist Du, Allmächtiger, unser Einziger, Ewiger Gott" (*Galizianerin* 222).

[3] David Henige, *Oral Historiography* (116ff.) zu Methodologie und Ethik bei Interviews mit ehemaligen Sklaven. Paul Thomson, *The Voice of the Past. Oral History* (159) merkt zu den Aufzeichnungen von Donald und Lorna Miller über den Völkermord an den Armeniern und Holocaustprojekte an: "Such memories are as threatening as they are important, and demand very special skills in the listener."

[4] Beckermann stellt die Judenverfolgungen in Wien mit ihren spontanen "Arisierungen" nach dem "Anschluß" dar. Die erste Kritik am Naziregime sei laut geworden, als die Deutschen den unautorisierten Beutezügen Einhalt geboten (*Unzugehörig* 49ff.).

[5] Aber auch fur die BRD beobachten Alexander und Margarete Mitscherlich, daß Erinnerung nur zur Aufrechnung eigener Schuld gegen fremde, zur Rationalisierung von Greueltaten und der Minimalisierung eigener Verantwortung zugelassen wurde.

[6] Fleischmann illustriert an einem fiktiven Gespräch mit ihrer Mutter eben diesen Sachverhalt (246).

[7] Thomson (212-13): "Usually the interviewers, whether professional historians or the married women typically employed for survey work, are middle-class, and in their thirties and forties. Their informants are normally ordinary working-class or middle-class people, and in oral history work often considerably older. Thus to their normal modesty, or even undervaluation of self, may be added the fragility of old age, and a special vulnerability to discomfort or anxiety." "How can the historian beguile himself into the belief that he need only question the natives of a tribe to get at their history?" (2)

[8] Wie Heinz Lunzer, Direktor der Dokumentationsstelle fur Neuere Österreichische Literatur in Wien während des Symposiums über österreichische Gegenwartsliteratur im Mai 1989 in Riverside, California erläuterte, hat sich Eva Deutsch wiederholt mit ihm in Verbindung gesetzt, um Möglichkeiten, ihre Geschichte zu veröffentlichen, zu finden.

[9] Patai charakterisiert die Übersetzung von Regionalismen als "catering to the sense of exoticism and class distance conveyed to the typical reader when speech is presented in 'dialect,' that is, as perceived deviation from a norm" (15). "There is a distance separating the spoken word from the written word that is unsurmountable . . . I have supplied these conventions—punctuation, sentence completion" (16). Baum besteht auf Dokumentation: Dokumente und Tonbänder seien zu bewahren und zugänglich zu machen. Zur Transkription merkt sie an: "If you transcribe you must give a copy of the interview to the narrator for his corrections. This will require further negotiations" (49ff., 52ff.).

[10] Diese Gruppen hatten jahrhundertelang der Assimilation und Missionierung widerstanden. Es sei auf Luthers Hetzschrift hingewiesen, entstanden aus der Frustration, keine Proselyten zu machen, "Von den Juden und ihren Lügen" von 1543 hingewiesen (1860-2029). Christian von Dohms Reformvorschläge und das Toleranzedikt von Joseph II. von Österreich 1782 zielten auf die Eliminierung der Juden durch Assimilierung ab und wurden von jüdischen religiösen Führern mit Vorbehalt rezipiert.

[11] Kraus' oder Weiningers Verleugnung der eigenen Herkunft bezeichnet Theodor Lessing als "jüdischen Selbsthaß."

[12] Eine Analyse der Waldheimkampagne und einen Exkurs zu ihrer Wirkung auf Holocaustüberlebende geben Haslinger und Stone.

[13] Den österreichischen Judenhaß belegt die Geschichte der Wiener Deportationen unter Brunner. Gelegentlich äußerten sich KZ-Überlebende zu der besonderen Brutalität österreichischer Wachmannschaften, z.B. Troller (63) und Winterfeld (376).

[14] (*Galizianerin*, 121ff.) Weintraub in "Wien Retour" (11) zählt während der letzten Aufnahmen wie in einem Totengebet Namen und Verbleib aller Familienmitglieder auf, an die er sich erinnert.

[15] Diesem Image entspricht der Vorspann der rororo-Ausgabe der Galizianerin: "Wache Augen, eine gewisse Schlitzohrigkeit und eine tiefe Gläubigkeit haben die Chawa Frankel als Statistin von Hitlers Welttheater überleben lassen." Nicht weniger problematisch und tendenziös ist der Klappentext dieser Ausgabe.

[16] Die Voraussetzung, daß die Allgemeinheit nichts vom Judentum weiß und keine Quellen verfügbar sind, führte zu naiven Veröffentlichungen wie Hansen, *Unsere Friedrichstädter Juden*, ein Büchlein mit einigen interessanten Photos, dessen Autor von der Annahme ausgeht, daß es keine Juden mehr gibt. Der unterschwellig antisemitische Text kontrastiert "wir" und "die Juden." Der Grund für die wiederholten Grundsatzdebatten und -erklärungen über das Judentum liegt nicht am Fehlen von Information, sondern an der mangelhaften Rezeption des Vorhandenen. In deutscher Sprache und in leicht zugänglichen rororo- und dtv-Ausgaben sind I.B. Singers Werke in den 70er und 80er Jahren erschienen, von denen die meisten unter Chassiden und ostjüdischen Intellektuellen spielen. Von historischen sei nur eine verschwindende Auswahl genannt: Adler, Baeck, Ben-Chorin, Chalfen, Doblin, Sterling, Fleischmann, Zweig.

[17] Z.B. Deutschs Zuneigung zu Mottel, dem Fiedler. Eine Annäherung ihrerseits war ausgeschlossen. Ihr Mann ist Jahrzehnte später auf den Jugendschwarm eifersüchtig (*Galizianerin* 130, 54).

[18] Die Werke jüdischer Autoren werden nach 1945 weniger rezipiert werden als die von Nichtjuden—Böll, Frisch, Dürrenmatt, Grass vis à vis Becker, Hilsenrath, Fried. Auch prominente jüdische Autoren sind oft auf Verlage mit geringer Verbreitung angewiesen, während unbekannte aufgrund der ihnen zur Verfügung stehenden Veröffentlichungsmöglichkeiten meist unbekannt bleiben.

[19] Benjamin 696: führt aus, daß auch Historiker sich immer nur in den Sieger einfühlen. Die jeweils Herrschenden seien die Erben aller, die je gesiegt haben. Die Einfühlung in den Sieger komme den jeweils Herrschenden zugute. Die Kulturgüter seien die Beute der Sieger. Benjamin rät daher den kulturellen Werten gegenüber zur Vorsicht, denn "was er an Kulturgütern überblickt, das ist ihm samt und sonders von einer Abkunft, die er nicht ohne Grauen bedenken kann ... Es ist niemals ein Dokument der Kultur, ohne zugleich ein solches der Barbarei zu sein. Und wie es selbst nicht frei ist von Barbarei, so ist es auch der Prozeß der Überlieferung nicht, in den es von dem einen an den andern gefallen ist."

[20] Weitzmann gibt Aufschluß über die Entwicklung der 1848 entstandenen Kultusgemeinde (121-151).

[21] Z.B. Peter Edel und seine Frau ließen sich 1941 taufen, hatten trotzdem aber den gelben Stern zu tragen und sich zur Deportation einzufinden (225).

[22] Gilman widerlegt Engelmann, der in *Deutschland ohne Juden* behauptet, daß im heutigen Deutschland Juden keine Rolle spielen ("Jüdische Literaten" 270-1): "Da es zweifellos zahlreiche 'Juden' gibt, die eine entscheidende Rolle in der zeitgenössischen deutschen Kultur spielen: was geschah dann mit der Kategorie des 'jüdischen Schriftstellers' in der Nachkriegsdiskussion?" Gilman definiert als jüdischen Schriftsteller jemanden, der als Jude etikettiert wird und auf diese Etikettierung literarisch reagiert. Er nennt Wolf Biermann, Günter Kunert, Stefan Heym, Rose Ausländer, Edgar Hilsenrath und Jurek Becker.

Works Cited

Adler, H.G. *Die Juden in Deutschland.* München: Kösel, 1960.

Aichinger, Ilse. *Die größere Hoffnung.* Amsterdam, Wien: Bermann Fischer, 1948.

Angress, Ruth K. "Lanzmann's Shoah and Its Audience," *Simon Wiesenthal Center Annual* 3 (1986): 249-60.

Bachmann, Ingeborg. *Der Fall Franza.* Frankfurt: Fischer, 1981.

Baeck, Leo. *Von Moses Mendelssohn zu Franz Rosenzweig. Typen jüdischen Selbstverständnisses in den letzten beiden Jahrhunderten.* Stuttgart: Kohlhammer, 1958.

Baum, Willa K. *Oral History.* Nashville: American Association for State and Local History, 1971.

Beckermann, Ruth. *Die Mazzesinsel. Juden in der Wiener Leopoldstadt.* Wien, München: Löcker, 1984.

_____. "Die papierene Brücke." Wien: filmladen, 1987.

_____. *Unzugehörig.* Wien: Löcker, 1989.

_____; Aichholzer, Josef. "Wien Retour." Wien: filmladen, 1983.

Ben-Chorin, Schalom. *Germanica Hebraica. Beiträge zum Verhältnis Deutscher und Juden.* Gerlingen: Bleicher, 1982.

Benjamin, Walter. "Über den Begriff der Geschichte." *Gesammelte Schriften.* Frankfurt: Suhrkamp, 1974.

Brecht, Bertolt. "Furcht und Elend des Dritten Reiches. Die jüdische Frau." *Gesammelte Werke 3,* Stücke 3. Suhrkamp, 1967. 1127–1133.

Broder, Henryk M. "Diese Scheißbilder trage ich mit mir rum." *Der Spiegel* (4. Juli 1987): 166–168.

_____. "Warum ich lieber kein Jude wäre; und wenn schon unbedingt, dann lieber nicht in Deutschland." *Fremd im eigenen Land,* ed. Henryk M. Broder, Michel R. Lang. Frankfurt: Fischer, 1979. 82–102.

Buber, Martin. *Der Jude und sein Judentum. Gesammelte Aufsätze und Reden.* Köln: Melcher, 1963.

_____. *Die Chassidischen Bücher.* Berlin: Schocken, 1927.

_____. *Hundert Chassidische Geschichten.* Berlin: Schocken, 1933.

Buber-Neumann, Margarete. *Als Gefangene bei Stalin und Hitler.* München: Verlag der Zwölf, 1949; Stuttgart: DVA, 1968.

Canetti, Elias. *Masse und Macht.* Frankfurt: Fischer, 1980.

Celan, Paul. "Der Meridian. Rede anläßlich der Verleihung des Georg-Büchner-Preises." *Ausgewählte Gedichte.* Stuttgart: Suhrkamp, 1968 133–48.

Chalfen, Israel. *Paul Celan. Eine Biographie seiner Jugend.* Frankfurt: Insel, 1979.

Döblin, Alfred. *Flucht und Sammlung des Judenvolkes.* Amsterdam: Querido, 1935.

Dohm, Christian von. *Über die bürgerliche Verbesserung der Juden.* Hildesheim, New York: Olms, 1973.

Edel, Peter. *Wenn es ans Leben geht. Meine Geschichte,* vol. 2. Frankfurt: Röderberg, 1979; Verlag der Nation, 1979.

Fassbinder, Rainer Werner. *Die bitteren Tränen der Petra von Kant. Der Müll, die Stadt und der Tod.* 2 Stücke. Frankfurt: Verlag der Autoren, 1980.

Fleischmann, Lea. *Dies ist nicht mein Land. Eine Jüdin verläßt die Bundesrepublik.* Hamburg: Hoffmann & Campe, 1980.

Frank, Niklas. *Der Vater: Eine Abrechnung.* München: Bertelsmann, 1987.

Fried, Erich. *Arden muß sterben.* London: Schott & Co., 1967.

Gauch, Sigfrid. *Vaterspuren.* Königstein: Athenäum, 1979.

Gilman, Sander L. *Jewish Self-Hatred: Anti-Semitism and the Hidden Language of the Jews.* Baltimore and London: Johns Hopkins Press, 1986.

_____. "Jüdische Literaten und deutsche Literatur. Antisemitismus und die verborgene Sprache der Juden am Beispiel von Jurek Becker und Edgar Hilsenrath," *Zeitschrift für deutsche Philologie,* 107/2 (1988), 269–294.

Göhring, Walter. "Materialien zur Bearbeitung des Themas 'Holocaust'. Judenverfolgung im 'Dritten Reich.'" *Österreichisches Institut für politische Bildung* (Mai 1979).

Handke, Peter. *Wunschloses Unglück.* Salzburg: Residenz, 1972.

Hansen, Hermann. *Unsere Friedrichstädter Juden.* Friedrichstadt: Eigenverlag, 1976.

Haslinger, Josef. *Politik der Gefühle. Ein Essay über Österreich.* Darmstadt und Neuwied, Luchterhand: 1987.

Henige, David. *Oral Historiography.* New York: Longman, 1982.

Hilberg, Raul. *The Destruction of the European Jews.* Chicago: Quadrangle, 1961.

Hilsenrath, Edgar. *Nacht.* München: Kindler, 1964; Köln: Literarischer Verlag Braun, 1978.

Kecht, Regine. "Faschistische Familienidyllen: Schatten der Vergangenheit bei Henisch, Schwaiger, Reichardt." *1938. Understanding the Past— Overcoming the Past,* ed. Donald Daviau. Riverside: Ariadne Press, 1990. 323–347.

Lessing, Theodor. *Der jüdische Selbsthaß.* Berlin: Jüdischer Verlag, 1930.

Levin, Nora. *The Holocaust. The Destruction of European Jewry 1933–45.* New York: Schocken, 1973.

Luthers sämmtliche Schriften, vol. 20, ed. Johann Georg Walch. St. Louis: Lutherischer Concordia-Verlag, 1890. 1860–2029.

Magris, Claudio. *Der habsburgische Mythos in der österreichischen Literatur.* Salzburg: Müller, 1966.

Mitscherlich, Alexander und Margarete. *The Inability to Mourn,* tr. Beverley R. Placzek. New York: Grove Press, 1975.

Patai, Daphne. *Brazilian Women Speak.* New Brunswick and London: Rutgers University Press, 1988.

Plessen, Elisabeth. *Mitteilung an den Adel.* Zürich: Benziger, 1976.

Rosenbaum, Marianne S. W. *Peppermint Frieden,* Basis Filmverleih 1982.

Rosenstrauch, Hazel. "Verwurzelt im Nirgendwo," *Fremd im eigenen Land. Juden in der Bundesrepublik,* ed. Henryk M. Broder, Michel R. Lang. Frankfurt: Fischer, 1979, 339-50.

Roth, Joseph. "Juden auf Wanderschaft," *Werke in drei Bänden,* vol. 3. Köln: Kiepenheuer & Witsch, 1956, 625-90.

Schutting, Jutta. *Der Vater.* Salzburg: Residenz, 1980.

Schwaiger, Brigitte; Deutsch, Eva. *Die Galizianerin.* Wien: Zsolnay, 1982; Reinbeck: Rowohlt, 1984; rororo 5461.

Schwaiger, Brigitte. *Lange Abwesenheit.* Wien: Zsolnay, 1980.

_____. *Mit einem möcht' ich leben.* München: Heyne, 1987.

Seelich, Nadja. "Kieselsteine." *cinéart.* Wien: Filmverleih Hans Peter Hofmann, 1982.

Sichrovsky, Peter. *Wir wissen nicht was morgen wird, wir wissen wohl, was gestern war. Junge Juden in Deutschland und Österreich.* Köln: Kiepenheuer & Witsch, 1985.

Singer, Isaac B. *Das Erbe.* München: dtv, 1981.

_____. *Jakob der Knecht.* Reinbeck: rororo, 1965.

_____. *Mein Vater der Rabbi.* Reinbeck: rororo, 1971.

_____. *Schoscha.* München: dtv, 1980.

Sterling, Eleonore. *Ein Jahrhundert jüdischen Lebens.* Frankfurt: EVA, 1967; original: 1935.

Stone, Laurie. "Analyzing Waldheim's Vienna and Freud's High Anxiety." *Voice* (August 12, 1986): 19.

Thalberg, Hans. *Von der Kunst, Österreicher zu sein.* Wien: Böhlau, 1984.

Thomson, Paul. *The Voice of the Past. Oral History.* Oxford, New York: Oxford University Press, 1988.

Troller, Norbert. "Konzentrations-Lager: Hauptlager Auschwitz I." Collection AR 7368. New York: Leo Baeck Institute.

Walker, Alice. *The Color Purple.* New York: Pocket Books, 1982.

Weininger, Otto. *Geschlecht und Charakter: eine prinzipielle Untersuchung.* Wien: Braumüller, 1906.

Weitzmann, Walter. "The Politics of the Viennese Jewish Community, 1890-1914." *Jews, Antisemitism and Culture in Vienna,* ed. Ivar Oxaal, Michael Pollak, Gerhard Botz. London, New York: Routledge and Kegan, 1987, 121-151.

Winterfeld, Hans. "Deutschland: Ein Zeitbild 1926-45. Leidensweg eines deutschen Juden in den ersten 19 Jahren seines Lebens," Manuskript, Yonkers, NY, 1969. Memoir Collection. New York: Leo Baeck Institute.

Zweig, Arnold. *Das ostjüdische Antlitz.* Berlin: Welt, 1920.

"Rückhaltlose Subjektivität":
Subjektwerdung, Gesellschafts- und Geschlechtsbewußtsein bei Christa Wolf

Sabine Wilke

Nachdenken über die Rolle des Subjekts stellt eine der brennendsten Fragen dar im abendländischen Denken. Ich möchte zunächst meine Ausführungen über die Rolle der rückhaltlosen Subjektivität bei Christa Wolf in einen philosophiegeschichtlichen und theoretischen Rahmen einordnen, der meine späteren Fragen an ihr Werk leiten wird und einige grundsätzliche Probleme von allgemeinem Interesse aufwirft. Insbesondere die romantische Philosophie und, in ihrem Nachvollzug, die Frühschriften Hegels widmen sich der Frage nach der Bedingung von Subjektivität aufs Eindringlichste. Die Philosophen Fichte und vor allem Schelling arbeiten bereits in den neunziger Jahren des achtzehnten Jahrhunderts an einer Theorie des Subjekts, deren Ziel es ist, das selbstbewußte Ich darzustellen als ein absolutes und immer schon so vorhandenes.

Dieses absolute Subjekt ist nicht erst durch die Arbeit der Individuation entstanden. Schellings romantisches absolutes Subjekt ist selbstbewußt bereits *bevor* es mit der Welt und anderen Subjekten in Beziehung tritt. Es ist sich seiner selbst bewußt, ohne durch den Spiegel der Reflexion gehen zu müssen. In seiner Schrift "Vom Ich als Princip der Philosophie oder über das Unbedingte im menschlichen Wissen" von 1795 gründet Schelling seine Theorie vom absoluten und unbedingten Ich auf der Idee der reinen Identität wie folgt: "Das Ich läßt sich anders nicht, als bloß insofern es *unbedingt* ist, bestimmen, denn es ist bloß durch seine Unbedingtheit, bloß dadurch, daß es schlechterdings nicht zum *Ding* werden kann, Ich. Es ist also erschöpft, wenn seine Unbedingtheit erschöpft ist. Denn da es bloß durch seine Unbedingtheit ist, so würde es eben dadurch aufgehoben, wenn irgend ein von ihm denkbares Prädikat anders als durch seine Unbedingtheit denkbar wäre . . ." (Schelling 69).

Die Rollenerwartungen, die an uns von außen herangetragen werden und, wie wir heute glauben, unsere persönliche Entwicklung entscheidend mitbestimmen, werden in dieser Konzeption zu bloßen Akzidenzien, die nicht nur marginale Probleme betreffen, sondern sogar das angenommene "authen-

tische" Ich-Bewußtsein, das im Kern des Individuums verborgen liegt, verschleiern und von daher im Prozeß der Selbstfindung abgestreift werden müssen (vgl. Frank 48ff.). Dieses absolute, vor-relationale Subjekt ist natürlich geschlechtsungebunden gedacht und von daher aus heutiger feministischer Perspektive problematisch, da stillschweigend das Männliche als Modell angenommen wird. Anne Herrmann hat im Zusammenhang mit einer Darstellung von Wolfs Subjektkonstitution an Hand eines kleineren Textes darauf aufmerksam gemacht, wie gefährlich nah eine solch androgyne Konzeption von subjektiver Identität dem traditionellen Denken kommt, das sich problemlos am männlichen Paradigma orientiert hat (Herrmann 43ff.). Im Falle von Fichtes und Schellings Philosophie ist das eigentlich umso gravierender, als es sich bei der Romantik um eine Bewegung handelt, in der zum erstenmal Frauen als selbstbewußte Autorinnen und gleichwertige Gesprächspartnerinnen hervortraten. Das weibliche Subjekt ist zudem Thema vieler romantischer Texte und dort durchaus in seiner weiblichen Spezifizität gedacht, wenn man einmal an Schleiermachers hermeneutische Schriften, Friedrich Schlegels Roman *Lucinde* und andere literarische Produkte dieser Zeit denkt.

Ebenso problematisch allerdings gestaltet sich die mit dem frühen Schelling konkurrierende Position Hegels, dessen Subjektphilosophie mit dem Gedanken der dialektischen Aufhebung des Selbstbewußtseins arbeitet. "In der Tat ist das Selbstbewußtsein die Reflexion aus dem Sein der sinnlichen und wahrgenommenen Welt und wesentlich die Rückkehr aus dem *Anderssein* Das Selbstbewußtsein stellt sich hierin als die Bewegung dar, worin dieser Gegensatz aufgehoben und ihm die Gleichheit seiner selbst mit sich wird" (Hegel 138–39). Hegels romantisches Subjekt stellt sich also überhaupt erst her in der Reflexion und wird dadurch aus dem Zustand der Entfremdung geradezu erlöst. Es ist sozusagen diese Bewegung selbst und durchaus nicht einfach absolut vorhanden wie Schellings selbstbewußtes Ich. Allerdings dürfen wir uns unter dem "Anderssein" und der oben erwähnten "Rückkehr aus dem Anderssein" wiederum nicht gesellschaftliche Realitätsprozesse, also objektive Zustände, moralische Vorstellungen, emotionale Verhaltensmuster, von außen an uns herangetragene Werte und dergleichen vorstellen. Das in der reflexiven Bewegung hergestellte Selbstbewußtsein Hegels kehrt aus dem "Anderssein" zurück, weil sich dieses als *Konstruktion* des suchenden Ich entpuppt, also ebenfalls immer schon vorhanden, nur nicht erkannt war.

Hegels selbstbewußtes Subjekt muß zwar einen ganz anderen Prozeß der Subjekt*werdung* durchlaufen als Schellings absolutes Ich, aber letztendlich stellt sich doch heraus, daß das Resultat, nämlich das selbstbewußte Ich, wieder nur aus der Identität seiner selbst geschöpft ist, die sich zwar vorübergehend als Andersheit im Zustand der Entfremdung erfahren hat, die aber in Wirklichkeit immer durchgängig vorhanden war. "Das Selbstbewußtsein", schreibt

Hegel, "stellt sich hierin als die *Bewegung* dar, worin dieser Gegensatz aufgehoben und ihm die *Gleichheit seiner selbst mit sich* wird" (Hegel 139; meine Hervorhebung). Von daher ist auch Hegels Subjektkonstitution ganz homogen gedacht als zu-sich-selbst-kommendes Ich, das die Außenwelt letztendlich nur als Moment des Ich erfährt: "das *Sein* der Meinung, die *Einzelheit* und die ihr entgegengesetzte *Allgemeinheit* der Wahrnehmung sowie das *leere Innere* des Verstandes sind nicht mehr als Wesen, sondern als Momente des Selbtbewußtseins, d.h. als Abstraktion oder Unterschiede, welche *für* das Bewußtsein selbst zugleich nichtig oder keine Unterschiede und rein verschwindende Wesen sind" (Hegel 138).

Die feministische Diskussion verschiedener Subjektmodelle in den letzten Jahren hat doch, meine ich, auf die unterschwellige Gewalt einer solchen synthetischen Position aufmerksam gemacht. Subjektive Identität, nach Jessica Benjamin beispielsweise, stellt sich eher in der *Balance* von Differenz und Identität her, ohne daß das Fremde und Andere in der Identitätsfindung dem Ich einfach einvernommen wird oder, wie Hegel es formulieren würde, "aufgehoben" ist (vgl. Benjamin 81ff.). Das Andere des Subjekts wird hier nicht einfach nivelliert und kurzerhand zu einem Moment des Selbstbewußtseins selbst erklärt. Der Ausdifferenzierungsprozeß des Ich basiert eben nicht auf dem Häuten von fremden Zuschreibungen, wie bei Schelling, oder auf der synthetischen Findung von Selbstbewußtsein durch Aufhebung des Anderen als Moment des Selbstbewußtseins in uns, wie bei Hegel, sondern auf einer *dialogischen* Struktur, die zwischen Fremdem und Eigenem vermittelt und zwar so, daß die Anwesenheit des Anderen in uns konfliktfrei bestehen bleibt. Es geht also bei Jessica Benjamins feministischer Kritik am traditionellen Subjektmodell um die Wiederherstellung der Möglichkeit des Subjekts, mit der Welt und anderen Subjekten in Beziehung zu treten, in einem Austausch zu stehen, ohne gleich die Existenz des Gegenüber als Teil des Ich erklären zu wollen und es dadurch effektiv in seiner Fremdheit zu neutralisieren.

Diese Vorbemerkungen wollte ich meinem Nachdenken über Christa Wolfs Subjektkonstitution im Zusammenhang der Herausbildung von Gesellschafts- und Geschlechtsbewußtsein vorausschicken, da sich Wolf ja intensiv mit der romantischen Philosophie und Poesie sowie mit ausgewählten feministischen Positionen auseinandergesetzt hat. In der Erzählung *Kein Ort. Nirgends* beispielsweise portraitiert sie die Schriftstellerin Karoline von Günderrode als Leserin von Schelling und verknüpft mit dieser Figur die Problematik von absoluter unbedingter Identität. Günderrodes Unbedingtheit im Leben und auch im Schreiben wird sie dann später auch zerstören. Sie ist auf den ganzen Menschen aus, wie sie selbst sagt, und kann ihn nicht finden (vgl. *Kein Ort. Nirgends* 94). Günderrodes Streben nach Vollkommenheit, nach Authentizität im literarischen Ausdruck, stößt bei ihren männlichen Kollegen auf von Furcht gespeistes Unverständnis. Von daher ist es, glaube ich,

hochinteressant, Wolfs Begriff von Subjektivität einmal genauer nachzuzeichnen und die Verbindungslinien zu dem Gesellschafts- und Geschlechtsbewußtsein insbesondere der weiblichen Figuren herauszuarbeiten. Wolf verbindet nämlich in ihren literarischen Texten und Essays den Anspruch auf Individualität mit einer *gesamtgesellschaftlichen* Aufgabe: "Rückhaltlose Subjektivität kann zum Maßstab werden für das, was wir (ungenau, glaube ich) 'objektive Wirklichkeit' nennen—allerdings nur dann, wenn das Subjekt nicht auf leere Selbstbespiegelung angewiesen ist, sondern *aktiven Umgang mit gesellschaftlichen Prozessen hat*" (*Lesen und Schreiben* 212; meine Hervorhebung).

Hier gilt es nun einmal nachzuhaken und zu fragen, wie sich eine solche gesellschaftlich relevante Form von Subjektivität in Wolfs Texten herstellt und inwiefern sie geschlechtsspezifisch gedacht ist. Dazu möchte ich exemplarisch der Entwicklung Kassandras nachgehen, da in diesem Text individuelle Identität, Gesellschaftsbezug sowie Geschlechtsbewußtsein an Hand der Hauptfigur problematisiert werden. Um es mit Wolfs eigenen Worten kurz vorwegzunehmen: "Ich glaube, es muß tatsächlich damit anfangen, daß man sich selber erfährt, sich zuläßt, sich anblickt und das aushält: das wäre eine sehr individuelle Antwort auf die Frage, was können wir machen" ("Documentation" 109–10).

I

Kassandra wird erzählt aus der reflektierenden Perspektive einer Figur, die nach eigener Einschätzung allen diesen drei Momenten—einer individuellen Form von Identität, einer gesellschaftlichen Relevanz, sowie auch der Forderung eines geschlechtsspezifischen Bewußtseins—am Ende ihrer Persönlichkeitsentwicklung gerecht geworden ist. Kassandra ist es ihrer eigenen Meinung nach gelungen, ihre weibliche Subjektivität mit einem relevanten Gesellschaftsbezug in Verbindung zu bringen: "Das Glück, ich selbst zu werden und dadurch den andern nützlicher—ich hab es noch erlebt" (*Kassandra* 15). Das ist vorerst nur von Kassandra selbst behauptet und soll hier analytisch nachgeprüft werden. Sie hat ja einige schwierige Hürden auf dem Weg ihrer Subjektwerdung zu überwinden, denn als Lieblingstochter stehen ihr die "Luxus-Empfindungen der Priamostochter" im Wege zu notwendigen Einsichten über die wahre Natur der Zitadelle (*Kassandra* 59). Sie braucht von daher länger als andere Frauen in Troia, benötigt mehr Energie, um das Bild von sich selbst zu ändern, das andere für sie entworfen haben. Sie unterscheidet dann später diejenigen fremden Zuschreibungen, die dieses Bild von sich selbst, das andere für sie entworfen haben, ausmachen von denjenigen Eigenschaften, die sie "angeboren" nennt: "Erst spät, und mühsam, lernte ich die Eigenschaften, die man an sich kennt, von jenen unterscheiden, die angeboren sind und fast gar nicht zu erkennen" (*Kassandra* 14).

Es geht in Kassandras Fall darum, das Kriterium für die Unterscheidung zwischen angeborenen und herangetragenen Eigenschaften zu finden und damit zur Kenntnis ihres "authentischen" Selbst, wie sie es nennen würde, vorzudringen. Wie wir schon von Wolf gehört haben, muß dieser Prozeß der Selbstfindung "leere Selbstbespiegelung" ausschließen. Die Gefahr dieser leeren Selbstbespiegelung zeigt Wolf an Hand der Figur des griechischen Priesters Panthoos: "Er kannte sich, ertrug sich, wie ich spät bemerkte, schwer und suchte sich zu helfen, indem er für jede Handlung oder Unterlassung einen einzigen Grund nur zuließ: Eigenliebe. Zu tief war er von der Idee durchdrungen, die Einrichtung der Welt verbiete es, zugleich sich selbst und anderen zu nützen" (*Kassandra* 15). Diese Achse von Selbstbespiegelung und Eigenliebe gilt es also zu durchbrechen und das schwierigste nicht zu scheuen, das Bild von sich selbst zu ändern (vgl. *Kassandra* 25).

Obwohl Kassandras bevorzugte Stellung zunächst hinderlich ist für die Entfaltung eines gesellschaftsbewußteren Ich, schaltet sich bald eine andere Eigenschaft ein, die wir schon aus anderen Wolf-Texten kennen—von Nelly in *Kindheitsmuster,* der Günderrode in *Kein Ort. Nirgends* sowie zu einem gewissen Grade auch von Christa T. in dem gleichnamigen Roman. Ich denke an die Gabe der Selbstbeobachtung: "Hat es nicht jetzt schon, dies probate Mittel, mein altes, schon vergeßnes Übel wieder wahrgemacht: da ich, *gespalten in mir selbst,* mir selber zuseh, mich sitzen seh auf diesem verfluchten Griechenwagen, unter meinem Tuch, von Angst geschüttelt" (*Kassandra* 27; meine Hervorhebung). Diese innere Gespaltenheit in eine erlebende und eine beobachtende Persönlichkeit macht Kassandra zu einer hervorragenden Kommentatorin der subtilen Veränderungen, die in ihr selbst vorgehen. Die Gabe der Selbstbeobachtung ist es endlich auch, die Kassandra zu ihrer kritischen Selbstanalyse zwingt und dadurch zu ihrer Selbstfindung beiträgt, denn nach langen inneren Kämpfen ist sie endlich gegen Ende des Textes "bereit, der andre Mensch zu werden, der sich unter Verzweiflung, Schmerz und Trauer schon so lange in mir regte" (*Kassandra* 127).

Die Frage ist nun, handelt es sich hier um ein ursprünglich vorhandenes (essentielles, "authentisches"?) Ich, das durch die gesellschaftlichen Verhältnisse in Troia zugedeckt wurde, oder um eine synthetische Neugestaltung einer anderen, bewußteren Persönlichkeit, oder vielleicht um ein Drittes? Geht es in diesem Text um *Freilegung* essentieller Weiblichkeitsstrukturen, wie so oft in den Texten der deutschen Frauenbewegung bis in die siebziger Jahre hinein thematisiert wurde, oder geht es um ein dialogisch konstruiertes Subjektmodell, von dem wir in der Einleitung gehört haben und das sich erst im Durchgang durch die kritische Selbst- und Gesellschaftsanalyse herstellen muß? Um diese Frage für *Kassandra* beantworten zu können, sind wir auf die Analyse der Textstruktur zurückverwiesen, da uns die Vorgänge in Troia allein aus Kassandras Perspektive dargestellt werden. Ihre Stimme muß als einziger

Garant für Information genügen, da andere Stimmen nur durch den Filter dieser Perspektivität vernehmbar sind, die die gesamte Erzählung kontrolliert (vgl. Stephens 136ff., Köhn 190f., Nicolai 152). Hinzu kommt, daß es sich bei Kassandras erinnerter Reflexion in gewissem Sinne um eine "erwünschte Legende" handelt, die zwar akribisch genau rekonstruiert ist, aber dennoch von Wunschdenken getragen ist: "Dies alles, das Troia meiner Kindheit, existiert nur noch in meinem Kopf", gibt Kassandra zu. "Da will ich es, solang ich Zeit hab, wieder aufbaun, will keinen Stein vergessen, keinen Lichteinfall, kein Gelächter, keinen Schrei" (*Kassandra* 34). Wir sind, glaube ich, wohl beraten mit etwas Skepsis gegenüber den Aussagen Kassandras, die zwar vom moralischen Standpunkt der subjektiven Authentizität aus spricht, deren Perspektive aber nicht in jedem Fall verläßlich sein muß, obwohl der Text auf der anderen Seite wiederum diese Tatsache nicht hinter einem Schild von erzählerischer Objektivität verbirgt.

Die oben aufgeworfenen Fragen nach dem Modell von Kassandras Subjektkonstitution können vielleicht durch einen kleinen Exkurs zu Wolfs Denkmodell der Zivilisationsprozesse ergänzt werden, das einem ähnlichen Muster folgt. Hier verwendet sie die Metapher der Schichten, die die Geschichte der Zivilisation als Aufeinanderfolge von verschieden organisierten Kulturen beschreibt. Die jeweils siegreiche Kultur nimmt in Wolfs Geschichte der Zivilisation Elemente der besiegten—und dadurch "älteren"—Kultur auf und interpretiert sie nach den nun geltenden neuen Regeln um. Die verschiedenen Kulturschichten Troias—die politische Wirklichkeit der Herrschaftsschicht in der Zitadelle, die Welt der einfachen Leute, der Markt als Platz des Austauschs zwischen beiden Schichten, die Höhlengemeinschaft am Skamander—werden im Text zu verschiedenen und miteinander in Konflikt geratenen Interpretationssystemen mit ihrer jeweils ganz spezifischen Hermeneutik mythischer Konstellationen. Apollon beispielsweise erscheint einmal als Sonnengott in der der griechisch-patriarchalischen Tradition folgenden Welt der Zitadelle, die sie ja auch in ihrer Priesterinnenrolle vertritt, und ein andermal wird er interpretiert als Wolfsgott in der der älteren troianischen Auslegung folgenden Welt der Frauen (vgl. *Kassandra* 32-33).

Die gleichzeitige Gegenwart beider Interpretationsmöglichkeiten in ein und derselben troianischen Zivilisation löst dann in Kassandra einen Machtkampf aus zwischen der griechisch-patriarchalischen und der vorpatriarchalischen Überlieferung: Kassandras Mutter Hekabe träumt nämlich kurz vor der Geburt des Paris, "sie gebäre ein Holzscheit, aus dem unzählige brennende Schlangen hervorkrochen. Dies hieß nach der Deutung des Sehers Kalchas: Das Kind, das Hekabe gebären sollte, werde ganz Troia in Brand stecken" (*Kassandra* 57). Dieser patriarchalischen Deutung des griechischen Sehers wird allerdings von Arisbe, einer Nebenfrau Priamos' und Verbindungsfigur zu den Wohnhöhlen am Skamander, deutlich widersprochen:

"Nämlich daß dieses Kind, sagte Arisbe, dazu bestimmt sein könnte, die Schlangengöttin als Hüterin des Feuers in jedem Hause wieder in ihre Rechte einzusetzen" (*Kassandra* 58). Die Tatsache, daß diese Deutung Arisbes, die die vor-patriarchalische Götterwelt wieder ehren will, dann offiziell verboten wird, zeigt, wie weit Troia auf dem Weg zum Patriarchat und damit auch zur Einsetzung patriarchalischer Götter ist und wie sehr man sich bemüht, die vor-patriarchalische Deutungsschicht aus dem Gedächtnis der Troianer zu vertreiben. In den Vorlesungen zu *Kassandra* hat sich Christa Wolf explizit zu diesem Denkmodell der Kulturschichten geäußert und folgende Fragen an ihr Material gestellt: "Welches wären die spezifischen 'minoischen' Züge in Troia? Herrschte mit König Priamos, dessen Name wahrscheinlich im Orient beheimatet ist, ein ägäisch-kleinasiatisches Herrscherhaus über eine gemischte Bevölkerung, die auch indoeuropäische Anteile hat? Was ergäbe sich daraus für die mögliche Konfliktlage, in die Kassandra geraten könnte, vor allem in bezug auf die Religion und Kulte, die nebeneinander bestanden haben müssen?" (*Voraussetzungen* 90) Wolf denkt also Kultur und Zivilisation mit Hilfe dieses Denkmodells der Schichtenabfolge (vgl. Wilke 222ff.).

Auch Wolfs Modell der psychischen Konstitution vom Menschen—und, wie wir mittlerweile aus *Störfall* wissen, auch der evolutionären Entwicklung—folgt dieser Schichtenmetapher. Angst sitzt dabei ganz tief im innersten Kern Kassandras und soll im Subjektwerdungsprozeß freigelegt werden: "Mir kommt der Gedanke, insgeheim verfolge ich die Geschichte meiner Angst. Oder, richtiger, die Geschichte ihrer Entzügelung, noch genauer: ihrer Befreiung. Ja, tatsächlich, auch Angst kann befreit werden, und dabei zeigt sich, sie gehört mit allem und allen Unterdrückten zusammen" (*Kassandra* 41). Angstbefreiung durch Benennung und Beschreibung ihrer Ursachen geht bei Kassandra nun wiederum Hand in Hand mit Selbstreflexivität: "Öffne dein inneres Auge. Schau dich an"; so hilft ihr Arisbe aus der Lethargie eines Anfalls heraus: "Ich fauchte sie an wie eine Katze. Sie ging. Also schaute ich. . . . Ich ließ also Namen zu. . . . Oinone das Miststück. Schmerzte es? Ja. Es schmerzte. Ein winzig kleines Stückchen tauchte ich weiter auf, den Schmerz zu betrachten. Stöhnend ließ ich ihn zu" (*Kassandra* 71-72). Der von Wolf konzipierte Selbstfindungsprozeß Kassandras beschreibt also eine Dialektik von Selbstbeobachtung, Zulassen und Auftauchen. Dieser Prozeß fordert die Herstellung einer geschlechts- und gesellschaftsbewußten Persönlichkeit als *Aufgabe,* ohne die inhärente Gewalt dieses Prozesses zu leugnen. Wolf spricht in ihren Vorlesungen von dem "Schmerz der Subjektwerdung", den Kassandra erfahren muß und über den auch die Autorin selbst sich ihre Hauptfigur anverwandelt (*Voraussetzungen* 89).

Myra Love hat in ihrer Arbeit zu *Christa T.* bereits darauf hingewiesen, daß Wolf die patriarchalische Logik von Identität und Beherrschung, zumindest was die subjektive Identität Christa T.s anbetrifft, effektiv

unterbrechen kann; sie spricht von "the possibility of a new mode of appropriating experience, perception and expression which rejects the patriarchal interconnection of subjectivity and domination (37; vgl. auch Lersch 165, Bergelt 115, Romero 19, Mauser 142f.). Diese neue und nicht gewalttätige Art der Subjektwerdung besteht eben nicht auf der restlosen Aufhebung entfremdeter Ich-Partikel als Momente des Selbstbewußtseins wie die Hegelsche, sondern erarbeitet stattdessen ein kommunikatives und intersubjektives Modell von Subjektivität, in dem Heterogenes zugelassen werden kann in Form einer gewaltlosen Einheit des Vielen, wie sie die Denker der Kritischen Theorie, besonders Theodor Adorno, immer wieder gefordert haben, und zwar so, daß "mit der Hereinnahme des Nicht-Integrierten, Subjektfernen und Sinnlosen . . . ein um so höherer Grad an flexibler und individueller Organisationsleistung notwendig wird" (Wellmer 103; vgl. auch Schmidt 115, Cramer 140ff.) Dies wäre eben eine "neue Form der Subjektivität, die nicht mehr der rigiden Einheit des bürgerlichen Subjekts entspricht, sondern die die flexible Organisationsform einer 'kommunikativ verflüssigten' Ich-Identität aufweist" (Wellmer 104). Und hierzu noch einmal Kassandra: "Daß man Unvereinbares nicht zusammenzwingen soll, darüber hat Hekabe mich früh belehrt, vergebens natürlich" (*Kassandra* 48). Kassandras angelernte Verdrängungsmechanismen sitzen an dieser Stelle noch so tief, daß sie bis kurz vor Ende des troianischen Krieges an diesem Muster festhält: "Meine Vorrechte stellten sich zwischen mich und die allernötigsten Einsichten" (*Kassandra* 62). Diesen Mechanismus lernt sie nur abzustreifen durch wiederholte und schmerzreiche Selbstanalysen wie auch durch ihre positiven Erfahrungen, die sie in der Gemeinschaft am Skamander macht, die ja ebenfalls ein heterogenes Integrationsmodell auf sozialer Ebene ausprobiert.

Die Konfrontation mit dieser anderen Art von Gemeinschaft ist zunächst schmerzreich. Ihr erster Besuch der Wohnhöhlen endet mit Furcht und Schrecken: "Sklavinnen aus dem Palast sah ich unter ihnen, Frauen aus den Ansiedlungen jenseits der Mauern der Zitadelle, auch Parthena die Amme, die vor dem Eingang der Höhle unter der Weide hockte. . . . Marpessa glitt in den Kreis, der meine Ankunft nicht einmal bemerkte—eine neue, eigentlich verletzende Erfahrung für mich . . ." (*Kassandra* 24). Dieser Dosis an fehlender sozialer Hierarchie und Autoritätsbezeugung ist Kassandra zu diesem Zeitpunkt noch nicht gewachsen, obwohl gerade die gewaltfreie Heterogenität dieser Wohngemeinschaft sie nach und nach doch anzieht. Bei ihrem zweiten Besuch ist sie jedoch nur wenig aufgeschlossener: "Zum erstenmal sah ich die Wohnhöhlen am Steilufer unsres Flusses Skamandros aus der Nähe, das gemischte Volk, . . . unerfindlich, wovon es lebte; durch das ich wie durch eine Schneise des Schweigens ging, nicht bedrohlich, nur eben fremd . . ." (*Kassandra* 54). Ihr Befremden weicht allmählich der Erkenntnis, daß es sich bei dieser alternativen Lebensform eben um ein Negativmodell handelt, das sich in erster Linie abgrenzt von Troia und der königlichen

Zitadelle und mehr und mehr als dessen Negativum sich versteht. "Wieder im Umkreis der Stadt diese Neben-, ja Gegenwelt, die, anders als die steinerne Palast- und Stadtwelt, pflanzenhaft wuchs und wucherte, üppig, unbekümmert, so als brauchte sie den Palast nicht, so als lebte sie von ihm abgewandt, also auch von mir" (*Kassandra* 56).

Diese Gegenwelt bewahrt nun Lebensmöglichkeiten, die systematisch aus der Palastwelt Troias ausgegrenzt werden, veranlaßt durch die fortschreitenden Kämpfe um Troia und der allmählichen Anpassung der troianischen Kultur an die patriarchalisch strukturierte Griechenwelt. Von daher sind auch die Teilnehmer an dieser Gegenwelt zur Formulierung von besseren Lebensansprüchen geradezu moralisch angehalten. Sie erhalten von Wolf diesen besonderen Auftrag des Sprechens für andere aus der Perspektive der Opfer, aber auch aus dem Bewußtsein der besseren Lebensform. Für Kassandra ist dies einer der wichtigsten Impulse, die sie überhaupt zur Erzählung ihrer Geschichte anspornen: sie will ja als Geschichtsschreiberin auftreten, die diese (vorzuziehende) Perspektive der Untergegangenen bewahrt und der Nachwelt tradiert (vgl. Marx 169ff.): "Ich will Zeugin bleiben, auch wenn es keinen einzigen Menschen mehr geben wird, der mir mein Zeugnis abverlangt" (*Kassandra* 27). Im Gegensatz zu den Palastschreibern, die auf Geheiß Geschichte fabrizieren und politische Ereignisse unweigerlich in Triumphe ummünzen, will Kassandra ihre Wahrheit weitersagen: "Schick mir einen Schreiber", möchte sie gerne Klytemnestra bitten, "oder, besser noch, eine *junge Sklavin* mit scharfem Gedächtnis und kraftvoller Stimme. Verfüge, da sie, was sie von mir hört, ihrer Tochter weitersagen darf. Die wieder ihrer Tochter, und so fort. So daß *neben dem Strom der Heldenlieder dies winzge Rinnsal,* mühsam, jene fernen, vielleicht glücklicheren Menschen, die einst leben werden, auch erreichte" (*Kassandra* 93; meine Hervorhebung). Die offizielle Geschichtsschreibung geht nämlich an den wichtigen Aspekten von Kassandras Lebensform glatt vorbei und berichtet nur leere und abstrakte Zahlen und Daten: "So Wichtiges wird nie ein Mensch von uns erfahren. Die Täfelchen der Schreiber, die in Troias Feuer härteten, überliefern die Buchführung des Palastes, Getreide, Krüge, Waffen, Gefangene. Für Schmerz, Glück, Liebe gibt es keine Zeichen" (*Kassandra* 89). Die Tradierung der Historie sollte also, wenn es nach Kassandras Wünschen ginge, auch über die Linie der Opfer möglich sein, die einen besseren Lebensanspruch ausdrücken, denn "als Marxistin", entgegnet Wolf in einem Interview, stelle sie sich "schlicht auf die Seite der Unterdrückten, und lasse [sich] auch nicht einreden, daß Unterdrückung gut ist oder nützlich sein kann—auch nicht die Unterdrückung der Frau durch die Männer" ("Ursprünge des Erzählens" 925).

In einem Aufsatz hat das Wolf im Hinblick auf die Fähigkeit der Frau, bessere Lebensansprüche mitausdrücken zu können, einmal so formuliert: "Ich behaupte nicht, Frauen seien von Natur aus mehr als Männer vor politischem

Wahndenken, vor Wirklichkeitsflucht gefeit. Nur: Eine bestimmte geschichtliche Phase hat ihnen Voraussetzungen gegeben, einen Lebensanspruch für Männer mit auszudrücken" (*Lesen und Schreiben* 220). Brigitte Wartmann hat einen ähnlichen Gedanken einmal in folgende Worte gefaßt: "Frauen haben aufgrund ihrer Verdrängung aus den gesellschaftlichen Lebenszusammenhängen Fähigkeiten bewahrt, die sie vielleicht tatsächlich als die weniger Entfremdeten aus dem Prozeß der historischen Entwicklung hervorgehen ließen, weil sie in den gesellschaftlichen Lebens- und Arbeitszusammenhängen entweder keinen oder nur mühsam einen Platz erobern konnten" (111). In dem oben schon erwähnten Interview mit Jacqueline Grenz beteuert Wolf allerdings ihre Abneigung gegenüber essentialistischen Weiblichkeitsbildern: "Es sind natürlich historisch gewachsene Eigenschaften. Vom Biologismus bin ich weit entfernt", heißt es ganz energisch ("Ursprünge des Erzählens" 924–25). Aber hier scheint doch eine Wunde aufzuklappen zwischen dieser diskursiv behaupteten Position und manchem im Text verankerten Argument. Mir geht es an dieser Stelle darum, diese Position Wolfs einmal genauer nachzudenken und gerade dort Fragen aufzuwerfen, wo sie selbst Verbindungen zu biologisch-essentialistischen Strömungen abstreitet. Gisela Ecker hat neulich in einem anderen Zusammenhang ebenfalls vorgeschlagen, daß wir vorsichtig mit solchen Positionsziehungen umgehen müssen. In ihrem Vorwort zu der englischen Ausgabe einer Sammlung von deutschen feministischen Texten, wo auch die vierte Vorlesung über Kassandra abdruckt ist, heißt es: ". . . there seems to be a general consensus that condemns essentialist thinking. In spite of this explicit consensus there are, I would argue, quite a few fixed ideas about the 'nature of women' still implicitly contained in the discussion of women's art" (15).

In *Störfall* werden Gedankengänge dieser Art mit großer Akribie weitergesponnen. Da wird subjektive Individualität in Analogie zum Atom gedacht: "Woher nun der moderne Zwang zu Spaltungen in immer kleinere Teile, zu Ab-Spaltungen ganzer Persönlichkeitsteile von jener altertümlichen, als *unteilbar* gedachten Person?" (36; meine Hervorhebung) In diesem Text werden dann kulturelle Fehlleistungen biologisch—und eben nicht historisch—interpretiert als Ausläufer von Gehirnfunktionen. Hier zitiert Wolf auch aus der auf Englisch verfaßten Autobiographie einer Freundin den Satz: "We are forced to use our multiple personalities like players acting different plays. We have to hide our *authentic* Self under a mask . . ." (*Störfall* 92; meine Hervorhebung). Die Erzählerin kommentiert dann diese Passage wie folgt: "Schreibend, Bruder—weil du gefragt hast—, haben wir mehr und mehr die Rolle des Schreibenden zu spielen und uns zugleich, indem wir aus der Rolle fallen, die Masken abzureißen, unser *authentisches Selbst* hervorschimmern zu lassen—hinter Zeilen, die, ob wir es wollen oder nicht, dem sozialen Code folgen" (*Störfall* 92; meine Hervorhebung). An dieser Stelle kristallisiert sich zunehmend Wolfs Vorstellung von dem ersten Schritt der Subjektwerdung des

Menschen, der sich als Häutung und Abstreifen der fremden Zuschreibungen gestaltet und zunächst als Herauslösung eines, wie auch immer gedachten wesentlichen Kerns entpuppt. Damit rückt sie weiter ab von der Position, die eine aktive Herstellung eines heterogenen Subjekts in intersubjektiven Prozessen fordert. Wie sich diese zwei Momente zueinander stellen, soll dann in der Zusammenstellung rückblickend entschieden werden.

Das weibliche Mitspracherecht an politischen Entscheidungen wird in Troia zunehmend abgebaut, bis es schließlich ganz zum Ausschluß sogar Hekabes vom Rat kommt. Kassandra findet in einer Gegenbewegung allmählich besseren Kontakt zu der Welt am Skamander und es gelingt ihr, zu einer weniger entfremdeten und bewußteren Einstellung gegenüber sich selbst und vor allem gegenüber ihrem Körper zu gelangen. "Wenn ich die Zeit noch habe, sollte ich von meinem Körper reden" (*Kassandra* 91). Der weibliche Körper ist der Ort, an dem die Einschreibungen von Gewalt in diesem Text am intensivsten erfahren werden. Das Kriegsgeschehen in Troia wandelt sich nämlich von einer Konfrontation mit dem Griechenheer zu einem Kampf zwischen den Geschlechtern. Je länger der Krieg währt, umso mehr bekommen die Frauen Angst vor ihren eigenen verwilderten Männern (vgl. *Kassandra* 21): ". . . auf einmal war es nicht mehr ratsam für uns Frauen, alleine unterwegs zu sein. Wenn man es recht betrachtete—nur traute niemand sich, es so zu sehen—, schienen die Männer beider Seiten verbündet gegen unsre Frauen" (*Kassandra* 119). In dieser Situation bildet sich eine Solidargemeinschaft der Opfer heraus, die auf gegenseitigem Verständnis basiert. Mit Klytemnestra beispielsweise versteht sich Kassandra "wie nur Frauen sich verstehn" (*Kassandra* 118). Frauen werden immer mehr zu Opfern einer destruktiven Zivilisation: "So viele Frauen ich in diesen Jahren schreien hörte . . ." (*Kassandra* 91): Kalchas' Tochter Briseis, die dem Achill übergeben wird, die Schwester Polyxena, deren Leben für Achill eingetauscht wird, die Amazone Myrine und viele andere. Und aus der Einsicht in die Unlebbarkeit dieser Situation gestaltet sich das Experiment der Wohnhöhlen am Skamandros immer eindringlicher, da es eine positive Alternative zur destruktiven Zivilisation Troias darstellt.

Hier wird das gefeiert, was die Griechen und Troianer "zwischen ihren scharfen Unterscheidungen zerquetschen, das Dritte, das es nach ihrer Meinung überhaupt nicht gibt, das lächelnde Lebendige, das imstande ist, sich immer wieder aus sich selbst hervorzubringen, das Ungetrennte, Geist im Leben, Leben im Geist" (*Kassandra* 121-22; meine Hervorhebung). Was ist das nun für ein alternatives Leben, das Geist und Leben gewaltfrei verbindet? Was braucht es für Menschen, die an einem solchen Leben teilhaben können? Wie gestaltet sich deren Identität? Und "bedeutet nun aber die Faszination durch den Mythos, die Wiederaufholung mythologischer Themen, die Ergriffenheit vom Doppelsinn des Wortes 'sacra', das 'heilig' wie 'verflucht' heißen

kann, in der Kunst unweigerlich eine Rückkehr oder auch nur eine Sehnsucht nach früheren, ungegliederten Zuständen?" ("Kleists Penthesilea" 675) "In der tiefsten Tiefe; im innersten Innern, da, wo Leib und Seele noch nicht geschieden sind" hat Kassandra alles erfahren (*Kassandra* 127). Dieser ungespaltene Kern in ihr entpuppt sich dann allerdings als wildes Tier, denn das Ungeschiedene, Ungestaltete, der *Urgrund* droht alles zu verschlingen (vgl. *Kassandra* 138). Eine solche Bedrohung durch die Gewalt des "Urgrundes" erfahren die Frauen in Troia anläßlich von Penthesileas Schindung durch Achilles: "Die Männer, schwach, zu Siegern hochgeputzt, brauchen, um sich überhaupt noch zu empfinden, uns als Opfer. Was soll da werden. . . . Die Frau schinden, um den Mann zu treffen" (*Kassandra* 137). Auf diesen brutalen Racheakt Achills reagieren die frustrierten Frauen mit einem Ausbruch von verzweifelter Gewalt: ein Zug von Frauen bildet sich, ihre Körper winden sich vor Schmerz, manche verlieren die Selbstbeherrschung und berrennen den erstbesten Griechen. Nach diesem Gewaltausbruch konzentrieren die Frauen sich auf die positive Ausgestaltung ihrer Alternative, die die kämpferische und selbstzerstörerische Haltung der Amazonen ausschließt. Mit der Figur der Penthesilea wollte Wolf nämlich "zeigen, wohin Weiblichkeitswahn sich verirren kann" ("Ursprünge des Erzählens" 925, vgl. "Kleists Penthesilea" 673ff., Fuhrmann 81ff.). Kassandra kann sich ja gegen diesen Umschlag des Urtümlichen in nackte Gewalt noch schützen dank der angelernten Verdrängungsmechanismen. Wolf selbst spricht von ihrer Angst vor dem Umschlag ins Archaische, von dem wilden Tier in ihr, gegen das sie sich wehren muß. "Form ist immer auch gleichzeitig Schutz gegen das Unorganisierte, Wilde, Zerstörerische der Konflikte, die mit dem Stoff aufkommen und ausgedrückt werden müssen" ("Ursprünge des Erzählens" 916). Und im *Störfall* heißt es dann zugespitzt: "Ich fürchtete die Abgründe in mir selbst—was heißt: unter meiner Schädeldecke" (46).

Myrine, die Amazone, lebt jetzt unter den Frauen am Skamander wie auch einige Männer, die sich dazu gesellen. "[Aineias] lebte nicht bei uns, wie manche jungen Männer, die an Körper oder Seele durch den Krieg beschädigt waren. Sie kamen wie die Schatten, unser pralles Leben gab ihnen Farbe, Blut, auch Lust zurück" (*Kassandra* 149). In dieser Atmosphäre gedeiht das utopische Lebensexperiment, deren Teilnehmer sich durch Toleranz auszeichnen. "Wir drückten unsre Hände nebeneinander in den weichen Ton. Das nannten wir, und lachten dabei, uns verewigen. Es wurde daraus ein Berührungsfest, bei dem wir, wie von selbst, die andere, die anderen berührten und kennenlernten" (*Kassandra* 150). Hier herrscht Geist im Leben und Leben im Geist, wie vorhin von Kassandra eingeklagt wurde. Natürlich darf man nicht vergessen, daß es sich eben nur um einen "schmalen Streifen Zukunft" handelt, der sich eben nur als Gegenwelt zu Troia versteht und von daher nur Vor-Schein einer verhinderten Zukunft sein kann im Sinne der Philosophie Ernst Blochs (Bloch 122). Als Modell für eine Art von Utopie, wie

Wolf es in den Vorlesungen genannt hat, ist es allerdings nur ansatzweise skizziert, obwohl der dialektische Rezeptionsbegriff, mit dem Wolf arbeitet und der in ihren Texten als Leerstelle angelegt ist, die Brücke schlagen könnte zum produktiven Lesen (Stockinger 133f.). "Es gibt Zeitenlöcher. Dies ist so eines, hier und jetzt. Wir dürfen es nicht ungenutzt vergehen lassen" (*Kassandra* 141, vgl. Hilzinger 95, Romero 26, Pickle 41ff., Köhn 176). Die Erfahrung des Zeitenlochs hat Kassandras Identität wesentlich mitgeprägt und zu einem positiveren Gesellschafts- und Geschlechtsbewußtsein gebracht, wie ich jetzt in einem zweiten Schritt zeigen möchte.

II

Ricarda Schmidts Studie von Kassandras Subjektwerdung hat einige grundsätzliche Fragen aufgeworfen, die ich hier kurz referieren möchte um dann im Anschluß daran auf eine zusammenfassende Diskussion von Kassandras gesellschafts- und geschlechtsbewußter Subjektkonstitution zurückzukommen. Schmidt merkt zunächst kritisch den performativen Widerspruch von relativ geschlossener Erzählweise einerseits und thematischer Offenheit andererseits an. Der Totalitätsanspruch, der nach Schmidt mit jedem geschlossenen Erzählen einhergeht, schlägt dann an einigen Stellen um in Archaik, wie wir auch im Zusammenhang mit der Angst vor dem Wilden und Ungestalteten gesehen haben, die das Projekt der Subjektwerdung Kassandras zunächst als Rekonstruktion eines inhärent wahren Ichs erscheinen läßt (Schmidt 113). Teleologische Sinnstiftung durch Erzählen verleitet Wolf zur ungewollten Darstellung eines "Heldenlebens", zum Exemplarischen Ich-Monolog, der sich gegenüber anderen Stimmen verschließt. Im Gegensatz zu der eher dialogischen Prosa der früheren Texte gestaltet sich hier eine monologisch angelegte Nacherzählung einer Erinnerung. "Die Erzählung ist eine Heldengeschichte", meint Schmidt, und zwar "die einer gewaltfreien Widerstand leistenden Heldin. Ihre geschlossene Form will Sinn widerspiegeln und stiften. Da Ich-Findung vom 'wir' abhängt, erfindet Wolf eine Gruppe von Menschen, in deren Gemeinschaft die Subjektwerdung Kassandras ihre Vollendung finden kann" (118). Die Wohnhöhlen am Skamander gelten Schmidt als der teleologische Fluchtpunkt der Erzählung, wo Menschen in bewußter Selbsterkenntnis friedlich und tolerant zusammenleben. Dadurch, daß aber Wolf die regressiv-archaischen Züge dieser Idylle nicht verschweigt und dazu nutzt, auf die Abwesenheit besserer Modelle hinzuweisen, führt sie doch wiederum ein dialektisches Moment in ihren Text ein. "Insofern bewahrt Wolf trotz und innerhalb der teleologischen Struktur progressive Offenheit und Uneindeutigkeit" (Schmidt 119). Gerade die Unausgeführtheit des schmalen Streifens Zukunft, die ja viele Kritiker sehr gestört hat, wird in dieser Interpretation zum Garant für Offenheit und dialektische Möglichkeiten.

Ich meine nun, daß auch nach einer gründlichen Lektüre dieses Textes in Hinsicht auf die Thematik der Subjektkonstitution keine so eindeutige Antwort gegeben werden kann, wie Schmidt dies versucht. Kassandras Selbstfindungsprozeß ist nicht eindeutig dem einen oder anderen Modell zuzuordnen; einmal scheint es darum zu gehen, daß sie lernt, Fremdes und Anderes in sich zuzulassen und auch auszuhalten; an anderen Stellen wiederum kann sie auf einen, wie es doch scheint, essentialistischen Kern zurückfallen, der ihrer Persönlichkeit immer schon unterliegt und der in einem Häutungsprozeß durch Abspaltung der fremden Zuschreibungen freigelegt werden muß. Ich möchte einmal versuchen, diesen in Wolfs Texten angelegten Widerspruch als zwei Momente eines Erfahrungsprozesses auszulegen, den Kassandra durchlaufen muß. Sie folgt zu Beginn ihrer Erinnerungsreflexion dem eher traditionellen Abspaltungsprozeß fremder Zuschreibungen und verläßt sich auf die Herauslösung eines wahren Kerns unterhalb dieses Fremdbildes. Gegen Ende der Erzählung nähert sie sich jedoch dem anderen Modell von Subjektwerdung an, das auf die erkenntnisstiftenden Ablösungsprozesse verzichten und durchaus auch fremde Ich-Partikel zulassen kann.

Die Erkenntnis des funktionalen Zusammenhangs zwischen Sprache und Herrschaft ist der Ort, wo für Wolfs Kassandra Subjektwerdung und Gesellschaftsbewußtsein zusammentreffen. Die Sprache als Träger von Ideologie leistet dabei eine zentrale Rolle, denn sie ist auf der einen Seite identitäts*stiftend* für Kassandra als Sprache der Prophezeiung wie auch subjekt-*spaltend* in Zeiten der Wahnsinnsanfälle. Identitätstiftung durch Sprache erfährt Kassandra in erster Linie in ihrer Rolle als Seherin. Ihre Seherin-Identität ist allerdings noch sehr stark an das Vaterprinzip und die davon ausgehende patriarchalische Autoritätsstruktur gebunden. Hiervon löst sie sich in einem anstrengenden Prozeß, in dem ihr Priesteramt eine entscheidende Rolle spielt. Solange sie noch im Bann der Zitadelle steht, erlebt Kassandra die Formulierung von fremden Ansprüchen noch nicht als Entfremdungserfahrung, und zwar als Fremdleitung ihrer Wünsche durch andere und in zunehmendem Maße politisch Andersdenkende. Als Lieblingstochter des Königs ist Kassandra nämlich noch völlig unproblematisch integriert in die Wertvorstellungen der Familie und deren Sprachregelungen. Sie macht sich überhaupt nichts daraus, die dort vorgetragenen Werte voll zu akzeptieren, denn am Anfang sind es auch ihre. Das ändert sich erst mit der Zuspitzung der Kriegshandlungen, die sie nicht einfach so unterschreiben will. Erst die Entfremdung von der Herrschaftsideologie ihrer Familie macht es ihr möglich, sich von deren Wertehorizont abzusetzen und die Verbohrtheit der Sprachregelungen als Ideologie zu erkennen. Diese fremden Ich-Anteile gilt es dann abzustreifen, wie an Hand der folgenden Stelle noch einmal verdeutlicht werden soll: "Der Teil von mir, der wieder aß und trank, sich wieder 'ich' nannte, verstand die Frage nicht. Jener andre Teil, der im Wahnsinn

geherrscht hatte, den 'ich' nun niederhielt, wurde nicht mehr gefragt" (*Kassandra* 72). Diese Entfremdungserfahrung durch die Erkenntnis der Fremdgeleitetheit ihrer Werte und Handlungsweisen wird dann im Laufe der Erzählung ersetzt durch eine spaltfreie Ich-Konstitution, die gleichzeitig einhergeht mit einer Befreiung von fremden Autoritäten.

Dieser Prozeß kehrt sich dann in sein Gegenteil, wenn wir Kassandras Subjektwerdung im Zusammenhang mit der Höhlengemeinschaft am Skamander betrachten. Wo sie sich von der Fremdleitung der Zitadelle durch Abspaltungen und Häutungen befreien mußte, geht es hier vielmehr um die gewaltfreie Annahme des Anderen in intersubjektiven Prozessen. Im Gespräch mit Anchises lernt Kassandra überhaupt erst ihre kritische Reflexion auf die troianische Gesellschaft und deren ideologische Sprachmuster in Argumente zu kleiden. Er ist auch einer der wenigen Männer, die aktiven Anteil an dem Sozialexperiment der Frauen am Skamander haben und ist von daher in entscheidendem Maße beteiligt an Kassandras neuer Ich-Konstitution. Seinen Interpretationsangeboten lernt Kassandra sich zu öffnen, obwohl ihr das anfangs sehr schwer fällt. Der Horizont der Interpretationsangebote von Anchises entstammt aber eben der Vorstellung von einer herrschaftsfreien Gesellschaft, die sich ja erst noch entwickeln muß und die in der Erzählung nur durch die knappen Bilder des Zusammenlebens am Skamander angedeutet ist. Diese Bilder müssen dann in einem dialektischen Rezeptionsprozeß Struktur bekommen; sie selbst können nur die Richtung weisen, aus der dieses neue Integrationsmodell sich entwickeln könnte. Mit dieser Perspektive läßt sich dann differenzierter und, ich meine auch, positiver über Kassandras Subjektwerdung und die Rolle der Wohngemeinschaft am Skamander urteilen, denn "es ist einiges, wenn man bedenkt, welch schmerzlich-schonungsloser analytischer Weg bis zu diesen Bildern zurückgelegt werden mußte und welche Chancen sich ergäben, wenn die Rede an diesem Punkt fortgeführt würde und wenn im überregionalen und überparteilich offenen Gespräch eine neue herrschaftsfreie, friedensstiftende, lebensbejahende Sprache gefunden werden könnte, die an die ersten 'zutreffenden' Zeichen anknüpft" (Roebling 231).

Dieses zutiefst paradoxe Projekt der "erinnerten Zukunft", wie es Wolf einmal selbst bezeichnet hat, bedient sich also einerseits—und in erster Linie zu Beginn der Erzählung—einer nostalgischen Rückerinnerung an einen ungespaltenen Zustand, in dem Wort und Sache noch unproblematisch vermittelt sind, und gibt sich andererseits als Vor-Schein einer verhinderten Zukunft aus, die dann im dialektischen Rezeptionsprozeß eingeklagt werden muß. Bei der Entwicklung von Kassandras Subjektkonstitution handelt es sich um eine Ablösung eines Modells, das sich an der väterlichen Autorität orientiert, durch ein neues Integrationsmodell, das Andersartigkeit gewaltfrei ertragen kann und so Subjektivität ganz anders herstellt. Identität, die durch das Vater-

prinzip verbürgt ist, muß von einer gesellschaftsbewußten Subjektivität ersetzt werden, die Heterogenes im sozialen wie auch im individual-psychischen Bereich toleriert. Die Stellen im Subjektwerdungsprozeß Kassandras, die an einen Rekurs an essentialistische Vorstellungen vom ursprünglich ungespaltenen Kern des Individuums erinnern, müssen dann meiner Ansicht nach an die Schaltstelle zwischen diesen beiden Identitätsmodellen plaziert werden. Nur dank dieser Hilfskonstruktion kann Kassandra die Energie aufbringen, von einem Modell zum anderen umzuschalten. Diese Schaltstelle zwischen zwei verschiedenen Identitätsmodellen stellt dann auch die Verbindung her zwischen Kassandras Gesellschafts- und Geschlechtsbewußtsein.

"Der Weg Kassandras zur Autonomie . . . ist ein Weg der Sprache, im Zeichen der Geschlechterdifferenz", schreibt Gerhard Neumann (247). Über Geschlechtscharakteristiken im Kassandra-Projekt ist schon viel gearbeitet worden—allerdings in erster Linie über die Vorlesungen, die das Thema ja direkt anschneiden. Kassandra lernt ihre spezifisch weibliche Identität kennen durch Annahme ihres Körpers. In langwieriger und schmerzreicher archäologischer Arbeit muß Kassandra erst einmal die Zeichen ihres Körpers lesen lernen, die von der troianischen Vaterkultur, die sie im Anfang kritiklos übernimmt, völlig zugeschüttet waren. Diesen Lernprozeß eignet sie sich, wie wir gesehen haben, an über die kritische Selbstanalyse und das sich-selbst-Ausgraben aus den Tiefen des Wahnsinns. Das Kriterium der Selbstkenntnis ist nun für Wolf eine spezifisch weibliche Eigenschaft, die dem männlichen Hang zur Selbstliebe, zur "leeren Selbstbespiegelung" entgeht, wie an Hand der Gegenüberstellung von Panthoos und Kassandra deutlich wurde. Eigenliebe macht die dialogische Ansprache des Anderen unmöglich. Die Freilegung dieser als typisch weiblich erkannten—allerdings nicht auf Frauen beschränkten—Subjektivität und ihrer inhärenten Möglichkeiten zum intersubjektiven Handeln gerät dann zu einem der Hauptthemen der Erzählung. Weibliche Identität entfaltet in dieser Dialogstruktur ihr Spezifikum. Es ist diese Dimension der kritischen Sprachreflexion, die Wolfs Identitätskonstitution Kassandras aus den festgefahrenen Alternativen der subjektphilosophischen Positionen herausführt. Dieser kritische Gebrauch von Sprache eröffnet dann Möglichkeiten, durch die das Nicht-Sagbare versprachlicht und mitteilbar wird. Kassandras Erfahrung in den Wohnhöhlen und insbesondere im Dialog mit Anchises bereiten eine solche offene Subjekt- und Gesellschaftsstruktur vor.

Wolf gelingt es also meiner Meinung nach, die zu Beginn dieses Aufsatzes skizzierten Positionen der philosophischen Durchdringung des Subjektbegriffs zu überwinden mit Hilfe dieser kritischen Sprachreflexion, die sie aus dem Dilemma der philosophischen Reflexion herausführt. Schellings essentialistisch angelegtes Modell vom absoluten und authentischen Selbst, das bereits vor allen Reflexionsbewegungen existiert, sowie Hegels synthetisch gedachtes

Subjekt, das selbstbewußt wird, indem es den Gegensatz zwischen Ich und Welt in der Reflexion aufhebt und das Subjekt so aus dem Zustand der Entfremdung erlöst, wird ein anderes Modell entgegengesetzt, das den Umgang mit dem Ichfremden in intersubjektive und dialogische Prozesse kleidet. Aus den Erfahrungen in den Wohnhöhlen am Skamander sowie aus den Gesprächen mit Anchises resultieret ein neues Selbst-Verständnis, das Kassandra nun in der Lage versetzt, das Andere in sich selbst im Dialog gewaltfrei anzunehmen. Dieses neue Ich-Verständnis, das sich aus "fremden" wie auch aus "eigenen" Ich-Partikeln zusammensetzt, führt sie zu der kritischen Reflexion auf ihre Gesellschaft, die den Text für viele Leserinnen und Leser so wichtig macht.

Bibliographie

Benjamin, Jessica. "A Desire of One's Own: Psychoanalytic Feminism and Intersubjective Space." *Feminist Studies/Critical Studies.* Hrsg. Teresa de Lauretis. Bloomington: Indiana University Press, 1987. 78–101.

Bergelt, Martin. "Emphatische Vernunft: über die Erzählung *Kassandra* von Christa Wolf." *Zerstörung, Rettung des Mythos durch Licht.* Hrsg. Christa Brger, Frankfurt: Suhrkamp, 1986. 111–27.

Bloch, Ernst. *Erbschaft dieser Zeit.* Frankfurt: Suhrkamp, 1977.

Cramer, Sibylle. "Eine unendliche Geschichte des Widerstands: Zu Christa Wolfs Erzählungen *Kein Ort. Nirgends* und *Kassandra.*" *Christa Wolf: Materialienbuch.* 2nd ed. Hrsg. Klaus Sauer. Darmstadt & Neuwied: Luchterhand, 1983. 121–42.

Ecker, Gisela (Hrsg.). *Feminist Aesthetics.* Übers. Harriet Anderson. Boston: Beacon, 1985.

Frank, Manfred. *Einleitung in die Philosophie Schellings.* Frankfurt: Suhrkamp, 1985.

Fuhrmann, Manfred. "Christa Wolf über Penthesilea." *Kleist-Jahrbuch.* Berlin: Erich Schmidt, 1986. 81–92.

Hegel, Friedrich Georg Wilhelm. *Phänomenologie des Geistes.* Theorie-Werkausgabe. Bd. 3. Hrsg. Eva Moldenhauer und Karl Markus Michel. Frankfurt: Suhrkamp, 1974.

Herrmann, Anne. "The Transsexual as Anders in Christa Wolfs 'Self-Experiment.'" *Genders* 3 (1988): 43-54.

Hilzinger, Sonja. "Weibliches Schreiben als eine Ästhetik des Widerstands: Über Christa Wolfs Kassandra-Projekt." *Neue Rundschau* 96 (1985): 85-101.

Köhn, Lothar. "Vergangenheitssprachen: Christa Wolfs Kassandra, Franz Fühmanns *Saiäns-Fiktschen* und *Der Sturz des Engels.*" *Michigan Germanic Studies* 8 (1985): 171-96.

Lersch, Barbara. "'Hervorbringen müssen, was einen vernichten wird': Mimik als poetisches Prinzip in Christa Wolfs Erzählung Kassandra." *Deutsche Vierteljahresschrift* 59 (1985): 145-66.

Love, Myra. "Christa Wolf and Feminism: Breaking the Patriarchal Connection." *New German Critique* 16 (1979): 31-53.

Marx, Jutta. "Die Perspektive des Verlierers—ein utopischer Entwurf." *Erinnerte Zukunft—Studien zum Werk Christa Wolfs.* Hrsg. Wolfram Mauser. Würzburg: Königshausen & Neumann, 1985: 161-79.

Mauser, Wolfram. "Das 'dunkle' Tier und die Seherin: Zu Christa Wolfs Kassandra-Phantasie." *Freiburger literaturpsychologische Gespräche.* Hrsg. Carl Pietzcker. Würzburg: Könighausen & Neumann, 1985. 4: 139-57.

Neumann, Gerhard. "Christa Wolf Kassandra: Die Archäologie der weiblichen Stimme." *Erinnerte Zukunft.* 233-64.

Nicolai, Rosemarie. "Christa Wolfs Kassandra: Quellenstudien und Interpretationsansätze." *Literatur für Leser* 3 (1985): 137-55.

Pickle, Linda S. "'Scratching Away the Male Tradition': Christa Wolfs *Kassandra.*" *Contemporary Literature* 27 (1986): 32-47.

Roebling, Irmgard. "Hier spricht keiner meine Sprache, der nicht mit mir stirbt: Zum Ort der Sprachreflexion in Christa Wolfs *Kassandra.*" *Erinnerte Zukunft.* 207-32.

Romero, Christiane Zehl. "'Weibliches Schreiben'--Christa Wolfs Kassandra." *Studies in GDR Culture and Society* 4 (1984): 15-29.

Schelling, Friedrich Wilhelm Joseph. "Vom Ich als Princip der Philosophie oder über das Unbedingte im menschlichen Wissen." *Ausgewählte Schriften.* Hrsg. Manfred Frank. 6 Bde. Frankfurt: Suhrkamp, 1985. 1: 39-134.

Schmidt, Ricarda. "Über gesellschaftliche Ohnmacht und Utopie in Christa Wolfs *Kassandra.*" *Oxford German Studies* 16 (1985): 109-21.

Stephens, Anthony. "'Die Verführung der Worte'—Von *Kindheitsmuster* zu *Kassandra.*" *Wolf: Darstellung—Deutung—Diskussion.* Hrsg. Manfred Jurgensen. Bern, München: Francke, 1984. 127-47.

Stockinger, Ludwig. "Aspekte und Probleme der neueren Utopiediskussion in der deutschen Literaturwissenschaft." *Utopieforschung: Interdisziplinäre Studien zur neuzeitlichen Utopie.* Hrsg. Wilhelm Vokamp. 3 Bde. Stuttgart: Metzler, 1982. 1: 120-42.

Wartmann, Brigitte. "Die Grammatik des Patriarchats: Zur 'Natur' des Weiblichen in der bürgerlichen Gesellschaft." *Ästhetik und Kommunikation* 47 (1982): 108-32.

Wellmer, Albrecht. "Zur Dialektik von Moderne und Postmoderne." *Zur Dialektik von Moderne und Postmoderne.* Frankfurt: Suhrkamp, 1985. 48-114.

Wilke, Sabine. "'Kreuz- und Wendepunkte unserer Zivilisation nach-denken': Christa Wolfs Stellung im Umfeld der zeitgenössischen Mythos-Diskussion." *German Quarterly* 60 (1988): 222ff.

Wolf, Christa. "Documentation: Christa Wolf." *German Quarterly* 57 (1984): 91-115.

———. *Kassandra: Erzählung.* Darmstadt, Neuwied: Luchterhand, 1983.

———. *Kein Ort. Nirgends.* Darmstadt, Neuwied: Luchterhand, 1979.

———. *Kindheitsmuster.* Darmstadt, Neuwied: Luchterhand, 1976.

———. "Kleists Penthesilea." *Die Dimension des Autors: Essays und Aufsätze, Reden und Gespräche 1959-85.* Darmstadt, Neuwied: Luchterhand. 660-76.

———. *Lesen und Schreiben.* Darmstadt, Neuwied: Luchterhand, 1985.

———. *Nachdenken über Christa T..* Darmstadt, Neuwied: Luchterhand, 1972.

———. *Störfall: Nachrichten eines Tages.* Darmstadt, Neuwied: Luchterhand, 1987.

———. "Ursprünge des Erzählens: Gespräch mit Jacqueline Grenz." *Die Dimension des Autors.* 912-40.

———. *Voraussetzungen einer Erzählung: Kassandra.* Darmstadt, Neuwied: Luchterhand, 1983.

Patriarchy, Memory, and the Third Reich in the Autobiographical Novels of Eva Zeller*

Elaine Martin

Eva Zeller is known in the Federal Republic primarily among readers interested either in women writers or in literature about the Nazi era. In the United States Zeller, whose work has not yet been translated into English, is known only to a handful of German scholars. To address this relative anonymity and introduce an important writer to American readers, I explore in this essay two approaches to Eva Zeller's work: I discuss the major themes of her two autobiographical novels about the Third Reich and the war years, *Solange ich denken kann* and *Nein und Amen,* and also consider Zeller and these two works in the context of other authors who have written about this period. Although Zeller has published a variety of short stories, novels, and poetry since the sixties, I find her two autobiographical novels particularly compelling, and thus have chosen to focus on them here.

One can understand better Eva Zeller's roots as a writer and also get a clearer sense of her writing by briefly viewing her in relationship to two of her contemporaries with whom she has much in common, Ingeborg Drewitz and Christa Wolf. All three come from the same region, around Berlin, and were born within six years of one another (Zeller and Drewitz 1923, Wolf 1929). Drewitz and Zeller were friends from their university days together in Berlin in the 1940s up until Drewitz's death in 1986. A particular link among the women is that each has written autobiographically about the experience of growing up in Nazi Germany: Wolf's *Kindheitsmuster* (1976), Drewitz's *Gestern war heute* (1978), and Zeller's *Solange ich denken kann* (1981) and *Nein und Amen* (1985). Not only does Zeller share a biographical kinship with these two writers, she also shares a literary kinship by virtue of the (self)-reflective element common to all four of these autobiographical novels. Werner Ross wrote in his 1986 *FAZ* review of *Nein und Amen,* "Eva Zeller ist unter den erfolgreichen deutschen Schriftstellerinnen die nachdenklichste." By contrast, many autobiographical works are unreflective narratives, really mere lists of events, uncriticized and uninterpreted.[1]

When I asked Zeller in our interview to identify her *Schwerpunkt:* "Ist das Werk dann eine literarische Autobiographie, oder ist es autobiographische

Literatur?", she emphasized the literary aspect: "Ich würde sagen, es ist autobiographische Literatur, und im Grunde genommen ist jede Darstellung eine neue Schöpfung. Und auch mich selber als das Kind, oder als die Studentin, oder als die junge Witwe . . . —ich mache mich ja schon wieder zur Figur" (48). Zeller is critical of autobiographical literature that explores only one level of consciousness. She herself is able effectively to address multiple *Bewußtseinsebene* through temporal layering: she interweaves the past (events), the future (through foreshadowing), and the present (narrative voice) as different perspectives in her work. On the surface lies the well-told story, but from between the lines arises a social critique that is unmistakable: Zeller indicts ignorance, passivity, willful blindness, injustice, the quest for power, emotional and physical brutality, greed, and hypocrisy. "Ich versuche auf meine Weise—aber eben in meiner Eigenschaft als Schriftstellerin, und durch Sprache—Bewußtsein zu bilden," Zeller explained in our interview (45). Unlike Carola Stern, who has worked in Amnesty International, or others who have been actively engaged in changing society through participation in religious, political, and social organizations, Zeller has preferred to make her contribution through literature.

Like Drewitz and Wolf, Zeller reflects elements of the work-in-progress, or the writer-observing-herself-write. In *Nein und Amen,* for example, she pauses on numerous occasions to check for veracity and verisimilitude: "Habe ich je solche Gedanken wörtlich gedacht? Was dichte ich der Achtzehnjährigen an?" (46), or: "Achtung, Achtung, das ist eine Falschmeldung des Gedächtnisses" (210), or: "*Weiber* hat Großmutter sicher nicht gesagt. Das kann ich ihr nicht in den Mund legen" (198). Sometimes Zeller expands these reflections to address larger topics, such as the relationship between past and present, fiction and truth, history and literature, or the problem of writing autobiography. In one such passage she wonders:

> Ist es statthaft, im Tonfall von damals, zugerüstet mit meinem heutigen Bewußtsein, zu erzählen, wie es gewesen ist? Läuft es nicht auf Beteuerungen hinaus: So ist es wirklich gewesen Ich müßte also mein eigener Zeitgenosse von damals werden, müßte meinem heutigen Welt- und Lebensgefühl entsagen (*Nein* 14).

As is evident in these passages, Zeller, like Wolf, is particularly interested in the role and function of memory in autobiographical writing.

Zeller, as well as Drewitz, Wolf, Luise Rinser, Carola Stern, and numerous others, writes out of a dual compunction: to inform and to warn.[2] Toward the end of our 1979 interview, Drewitz commented upon the persistence of Nazi ideology in the world: "Niemand, der später geboren ist, versteht den Faschismus, wenn er nicht versteht, wie der sich eingeschlichen hat in jedes Leben. Genau deshalb ist er gefährlich, und, wo immer in der

noch immer gefährlich."[3] Wolf, of course, draws "warning" parallels in *Kindheitsmuster* between the Nazi era, the Vietnam War, and the Allende *putsch* in Chile. Zeller also sees parallels, but like Carola Stern in *In den Netzen der Erinnerung,* she locates them between East German Communism and Nazi ideology.[4] In our interview she mentioned the anonymous letter she received from an East German writer who had read from one of her novels at the *Internat* Droyssig she had attended as a schoolgirl, later a *Pionierleiter* school in the German Democratic Republic:

> ... [er] habe einige Seiten gelesen über die Weise, wie wir im Hitlerreich voll programmiert wurden, voll mit einer Ideologie gefüttert wurden, ohne daß es irgendeine Alternative gegeben hätte. Und es sei in diesem Saal ein so betretenes Schweigen eingetreten, weil eine fatale Parallele sichtbar wurde ... dieselbe Situation ... der total Staat ... die ständige Gegenwart des Staates, und die eine Partei, das eine Denken (56).

Zeller is particularly attuned to possible resemblances between National Socialist and East German rhetoric and policies, because she lived in the GDR from the war's end until 1956 when she went to Southwest Africa (Namibia 1956-62).

Zeller published extensively throughout the sixties and seventies, but first came to the attention of a larger segment of the German reading public in 1981 with the publication of *Solange ich denken kann*. She had not originally intended to write a second autobiographical volume because of the emotional stress involved ("ich konnte es nicht mehr"; "das war ein Trauma," Interview 45); however, she ultimately did continue and *Nein und Amen* was published in 1985. The autobiographical novels differ from her other works precisely because of this emotional stress-turned-intensity, which is evident in the complex love/hate relationship with the father in the first volume and in the tender but doomed love relationship in the second volume.

Solange ich denken kann chronicles the first two decades of Zeller's life from 1923 to 1941 and traces within the larger historical context of the Nazi rise to power the personal drama of a child made into an emotional ping-pong ball volleyed between her bitterly divorced parents. This tug-of-war pits country against city (the mother lives in the village of Görzke, the father in cosmopolitan Berlin), art/emotion against science/reason (the mother is a professional pianist of romantic disposition, the father an imperious scientific scholar), and a basic apoliticism and vague patriotism against intellectual skepticism (the mother's family is politically naive, whereas the father is an early and persistent, albeit cautious, opponent of Hitler and is anti-Nazi). Zeller reveals in her portrayal of her father, whose tyrannical treatment of his family contrasts with his own anti-Nazi rhetoric, just how complex, even contradictory, the workings of patriarchy were in the Third Reich.

In our interview, Zeller discussed at some length her father as one of the most important motifs in *Solange ich denken kann*. First symbolized in an incident in which a large and ferocious-looking male turkey traps the five-year-old in a passageway to the garden, the father figure, "dieser bösartige Puter-Vater," to use Geno Hartlaub's formulation, reappears in various guises throughout both novels. Much of the profile of the paternal figure and the dynamics of the daughter/father relationship derive from Zeller's biography: her father was the well-known historian of technology, Franz Maria Feldhaus. This dominating, larger-than-life male is a personal nemesis, at the same time that the daughter/father conflict represents the more universal struggle of women within a context of patriarchal authority. For Zeller as a child the world was simply and clearly divided into good and evil: Everything and everyone in the world of Görzke, including mother and grandmother, was good, and everything in the father's world, the *Halbwelt* of Berlin, was evil. The father was the mother's arch-enemy, so he had to be the child's as well. Relatives of the mother's family refer to him as "ein Satansbraten," "ein unglückseliges Menschenkind," and, according to the grandmother, he is, at best "eine rätselhafte Figur" (*Nein* 198). Later Eva's fiancé calls him her "Lieblingsfeind."

At eighteen Eva still resists her father's anti-Nazi rhetoric, because she rejects him both as a father and as a person: "[M]ein Vater . . . hat seine Macht ausgekostet und alles um sich herum klein gehalten. Mein Vater, der sich dauernd über den Führer aufregt, ist in seinem Reich der unumschränkte Herrscher, Herr über Frauen, Kinder, Mitarbeiter, die alle ihn anbeten sollen" (*Nein* 224). Similarly, in Ingeborg Bachmann's fragment *Der Fall Franza,* the protagonist Franza Jordan comes to realize that fascist beliefs and behaviors are not restricted to political parties and public arenas. Franza, whose psychologist-husband has turned her into a case-study, says to her brother: "Du sagst Faschismus, das ist komisch, ich habe das noch nie gehört als Wort für ein privates Verhalten" (71). The father-daughter relationship in Zeller's novels can be viewed as fascist in so far as the father repeatedly attempts to achieve absolute dominance over his daughter's actions, even her thoughts. At one point he threatens to exmatriculate her from the *Internat,* claiming she has agreed to become a co-worker in his research, and several years later, he sends a letter to the *Rektor* of the first university where she enrolls: "Hiermit beantrage ich, meine Tochter Eva-Marie von allen deutschen Universitäten auszuschlagen" (*Solange* 225). When she becomes engaged, he writes to her fiancé's parents, advising them to oppose the marriage, because his daughter has had surgery for cancer. He never tires of trying to blackmail her into working for him as his secretary.

Zeller's depiction of a female-male relationship that is rooted in both fascism and patriarchy resonates with the work of many feminist or pro-

feminist writers. Numerous twentieth-century writers and scholars, beginning with Virginia Woolf, have made the argument that there is a link between fascism and patriarchy. Susan Bell and Karen Offen summarize Woolf's argument in *Three Guineas* thus: "Woolf recognized that the roots of fascism lay in patriarchy and must be eradicated in the family: no patriarchal society—however liberal—was immune, she argued, from fascist tendencies" (Bell/Offen 255). More recently, the fascism-patriarchy link has been explored by Klaus Theweleit in *Male Fantasies,* especially in the first volume, in which he argues that the fear and revulsion shown toward women by *Freikorps* volunteers is connected to the racism, sexism, and anti-Communism at the heart of the German fascist movement. Bram Dijkstra supports Theweleit's viewpoint by tracing misogynist attitudes inherent in patriarchy back to the turn of the century and linking them on a clear continuum with fascism:

> A blind trust in anything that has been designated as a scientifically obtained finding ... encouraged the development of the aggressively racist and sexist social structures in Europe It can be said without exaggeration that the psychological "gynecide" advocated by the turn-of-the-century male intellectual avant-garde was a first manifestation of the forces which would make the actual genocidal policies of Nazi Germany not only culturally acceptable to the German populace but a logical historical outcome of the extravagant false science of general turn-of-the-century culture. For it was once again inevitable that the dualistic symmetry of nineteenth-century thought should extrapolate from the legitimate theory of the evolution of species the specious theory of potential devolution, the "degeneration" of society. Once again the male mind fastened on woman as the principal culprit (209).

Philippe Lacoue-Labarthe and Jean-Luc Nancy have argued that Nazi ideology grew out of pre-existing German values (which included patriarchal attitudes): "There incontestably has been and there still is perhaps a German problem; Nazi ideology was a specifically political response to this problem; and there is no doubt whatsoever that the German tradition, and in particular the tradition of German thought, is not at all foreign to this ideology" (295). The Italian critic Maria-Antonietta Macciocchi has contributed a viewpoint centered on questions of sexuality, especially of sexual repression: "The body of fascist discourse is rigorously chaste Its central aim is the death of sexuality" (75). Macciocchi further discusses the psycho-sexual relationship of women to "virile puppets" such as Mussolini and Hitler, and concurs with Wilhelm Reich's view of "dictatorial domination in precisely the terms of a huge sexual repression" (69).

Zeller never openly addresses the sexual aspect of her relationship to her father—not once in 727 pages of autobiography—but the references are unmistakable. She describes herself as a young woman in nearly asexual terms: " ... mit meiner blassen Haut ... den farblosen Wimpern und Brauen, den blutleeren Lippen ... ich bin dünn wie eine Bohnenstange" (*Nein* 158).

The contrast of this colorless, corpse-like daughter with the robust, virile father is particularly striking. When she builds a sand castle at the beach, he invades her space. Her narrative reflects acute discomfort at his physical proximity: "Er und ich in meiner Sandburg, die nur für mich gebaut ist. In dem engen Trichter hat nur einer Platz. Noch nie ist er mir so auf den Pelz gerückt, auf die nackte Haut. . . . Halbnackt neben mir in der Sandburg . . ." (*Nein* 43, 70). Even though he is wearing a swimsuit, she perceives him (and herself) as "nackt." Her awareness of her father's body appears later in conjunction with swimming lessons: "Sogar schwimmen lernte ich, weil ich, mich an einer Mole entlanghangelnd, von ihm fortstrebte, weg von seinem nassen behaarten Oberkörper, der aus dem Wasser ragte" (*Nein* 86). She clearly fears both his sexuality marked here by the secondary sexual characteristic of chest hair and his physical power as represented by his large, looming body.

The father's authority derives not only from his sharp tongue, and by consequence from the wit and acerbity with which he attacks both his *Angsthase* daughter and the Nazi regime ("Deutschland, zwei Silben Hysterie" *Solange* 151); it also derives from his virility-as-weapon. A relatively harmonious marriage with his fourth wife does not prevent him from sending his hated ex-third-wife "ein säuisches Buch mit ganz säuischen Bildern, auf denen fette Frauen die Beine breitmachen," and from carrying on "furchtbar viel Affären (*Solange* 54). It is revealed piecemeal that part of the maternal family's scorn for him stems from the fact that he not only forced Eva's mother into an unwanted first abortion, but also impregnated her cousin, "die schöne Ruth," who then committed suicide. On one of her last obligatory visits to her father in Kassel ("noch immer unterstehe ich der väterlichen Gewalt"; *Nein* 115), she observes her father physically: "Er strotzt vor Gesundheit. Er setzt Kinder in die Welt, Töchter. Immer bloß Töchter. Er sagt: kein Kanonenfutter" (*Nein* 118). One of the numerous aunts breaks with the maternal family's solidarity against the father and comments revealingly on Franz's sexual attractiveness: "Nur einmal die Frau dieses Mannes gewesen sein—das reicht für ein ganzes Leben. Tante Elvira" (*Solange* 168). This father is so strong, so potent, it takes groups of women banded together to withstand him. The teen-aged Eva tells her friends at boarding school, "Gott sei gelobt, ich habe nur eine Mutter. Und eine Großmutter. Zu dritt verkraften wir meinen Vater gerade noch" (*Solange* 222).

For Eva, who grows up without her father, but who was both rejected ("hie Goldmarie, da Pechmarie"; *Solange* 61) and dominated by him ("ein Mann im Gegenlicht von kolossalem Zuschnitt"; *Nein* 42), the attraction of a Hitler-figure is strong. In the *Internat* Eva says of her father, "Ich will einen anderen Vater oder gar keinen" (*Solange* 222), and about Hitler, "Wer sind wir? Kleine Mädchen aus einem Provinznest, aus einem Landstrich, den kein

Mensch kennt. . . . Aber der Führer kennt uns" (*Solange* 118-19). Fatherlessness, puberty, idealism, and nationalist ideology make a potent combination. Franz Mennemeier writes of *Solange ich denken kann,*

> Das Aufregendste an Eva Zellers Buch aber ist die ebenso behutsame wie intensive, leidenschaftliche Art, mit welcher sie die Schilderung der gestörten Beziehung zu dem berühmten, intellektuellen Vater . . . mit der Darstellung des Themas des Nationalsozialismus verbindet. Wird das Mädchen deshalb eine so glühende Anhängerin der neuen, positive Werte verheißenden Bewegung, weil es aus Solidarität mit der Mutter und von dieser aufgehetzt, den Vater "haßt—ihn, der kritisch ist, der den Nationalsozialismus durchschaut und negiert . . . ? (29)

I think Zeller would answer Mennemeier's question affirmatively. For her, daughter is to father as father is to National Socialism, and the key concept to both relationships is hostile opposition. Zeller's linking of patriarchal values and attitudes with both sexism and fascism is important, because she indicates the danger inherent in unquestioning acceptance of seemingly neutral values such as *Ordnung, Disziplin, Gehorsamkeit,* and *Treue.* Christa Wolf has noted the same tyranny of inflexibility: "Leichter scheint es, ein paar hundert, oder tausend, oder Millionen Menschen in Un- oder Untermenschen umzuwandeln als unsere Ansichten von Sauberkeit und Ordnung und Gemütlichkeit" (186). Zeller shows how such apparently innocuous social ideals embedded in a patriarchal world view result in familial oppression and permit the rise of totalitarian states.

Ultimately it is both the father with his unrelenting political critique and the protagonist's own search for self in puberty that keep her from total engagement with National Socialism. "Mit einem Fußtritt befördere ich alles, was er sagt, in die dunkelste Ecke meines Bewußtseins," she recalls of her father's lectures, "Darin habe ich Übung. . . . Noch ahne ich nicht, daß diese unaufgeräumten Erfahrungen mit meinem Vater mich vor gelungener Einpassung ins Reich bewahrt haben" (*Nein* 116). As the father's criticisms slowly work on her subconscious, other experiences also interfere with her total nazification. Although the emotions associated with puberty often seemed to lead to enthusiastic and enduring *Bund Deutscher Mädel* or *Hitler-Jugend* membership, this was not always the case, and Zeller was one of these exceptions. In our interview she talked about puberty and how, for her, it conflicted with Nazi ideology: "Der Spruch hieß 'Du bist nichts, dein Volk ist alles.' . . . und man war sich selbst gerade auf der Spur in diesem Alter, man schrieb Tagebücher, man verliebte sich zum ersten mal. Man schmorte im eigenen Saft. Man wollte gerade 'ich' werden; genau das verbot man mir. . . . Und darum habe ich aber nie als BDM Mädchen irgendeinen Posten angenommen . . ." (37-8). It remains unclear what Zeller meant by her "nie . . . irgendeinen Posten angenommen" since she was a BDM *Führerin* as described in *Solange ich denken kann.*

Another experience led to further disenchantment: after her *Abitur* she was assigned to a *Reichsarbeitsdienstlager* in which she perceived herself to be under the total control of another person for the first time in her life, in this case, of a director who did not like her. This experience of *Auslieferung* obliged her to see National Socialism with new eyes. She suddenly remembered people who had disappeared, like the gay waiter at the train station and her father's cook, a Jehovah's witness.

The final factor in Zeller's "non-conversion" was the beginning of a serious love-affair with the man she eventually married, which altered her priorities—as only love-at-eighteen can—from the political to the entirely personal: "Dem Ernstfall Krieg setzen wir den Ernstfall Liebe entgegen" (*Nein* 76). Despite all the forces and accumulated events militating against continued belief in and support of National Socialism, Eva resisted. The emotional stumbling block remained the same: her father. Because of all-consuming hatred for him, she rejected his *Aufklärung* for years, as she explains, "Sich die Parolen meines Vaters zu eigen machen; das paßt mir nicht. Heiß zugeben, daß er recht hat mit seinem Genörgel. Meine leisen Zweifel sind nur erst geahnt, noch lange nicht spruchreif" (*Nein* 33). Her political awakening thus occurred rather late in the war, and was facilitated by her fiancé's apparent acceptance of her father's skepticism and his own doubts about National Socialism and the war.

The basic power relationships change between Zeller's two autobiographical novels. In the second work, the father gradually moves to the periphery as his influence is replaced both by the Nazi policies, which increasingly intrude into Eva's daily life, and by Eva's fiancé. *Solange ich denken kann* centers on the father-related tribulations of a difficult childhood, rather lightly impinged upon by political events. Elisabeth Alexander has called the novel a "father book" and interprets everyone and everything else in the book as "lediglich der Rahmen des Mittelpunktes: Des Mittelpunktes, der Vater heißt." More commonly, however, "father books" refer to those written by daughters in quest of their fathers' identities in general, and of their fathers' roles in the Nazi era in particular, for example, Ruth Rehmann's *Der Mann auf der Kanzel,* Elisabeth Plessen's *Mitteilung an den Adel,* Ingeborg Day's *Ghost Waltz,* or Jutta Schutting's *Der Vater.* Zeller's *Solange ich denken kann* does not fit here, in that her focus is less on understanding the motivation for the father's words and actions and more on their effect on her as a child and adolescent.

Nein und Amen, in contrast to *Solange ich denken kann,* describes a personal life increasingly caught up in the machinery of government ideology and control. The father still plays an important role, but is marginalized emotionally as Eva recenters herself on her fiancé Dirk: ". . . um eine neue

Mitte kristallisiert, [will ich] mich hinfort nur noch nach Dirk richten, ... es gibt nur noch Orte, wo Dirk ist, und solche, wo er nicht ist (*Nein* 130). The astute reader is tempted to criticize Zeller's representation of her love-affair as overly romanticized and idealized, the viewpoint of an adult woman forty years later. But Zeller preempts this criticism by addressing the problem herself: "Dieses Eingetauchtsein in die Zustimmung eines Mannes ist mit nichts bisher Erfahrenem vergleichbar. Und ist durch nichts Späteres zu korrigieren, weil es kein Später für uns geben wird, kein Nach-dem-Krieg. ... keine Gelegenheit für Untreue, Verrat, Wundenschlagen und -empfangen. Eine unversehrte Liebe mangels Dauer. Ich werde weiterleben können mit einem Bild, das gegen Beschädigung gefeit ist" (*Nein* 158–159).

In both novels, Zeller reflects through stylistic choices the emotions she experienced during the National Socialist and war period. She calls everything into question: what actually happened, what she thought was happening, and how one should go about reconstructing and interpreting what happened. She also questions the genre to which her novels, which she sees as a single work, rightly belong: "Roman ist es eigentlich gar nicht, dieser Bericht, diese Rückschau..." (Interview 32). Zeller's writing resembles that of Christa Wolf in its complexity of language and psychological layering. Zeller did not read Wolf's *Kindheitsmuster* when it appeared, however, because, as she explained in our interview:

> [ich] habe Bücher diese Genres nicht gelesen, weil ich nicht wollte, daß ein Vergleich oder eine Art Abhängigkeit entsteht... ich habe deshalb zum Beispiel Christa Wolfs *Kindheitsmuster* nicht gelesen als es erschien, sonder habe abgewartet. [...] Ich habe gesagt, du wirst jetzt keine Kindheitsgeschichten lesen, sondern das, was ich schreibe, soll möglichst von mir sein... (32).

Zeller also discussed her stylistic concerns at some length in our interview. Like Flaubert she is a dedicated seeker of *le mot juste*; quoting from Eichendorff's poem, she observed, "Daß es, im Grunde genommen, eigentlich nur ein Wort gibt, für das, was ich sagen will, und dieses Wort muß ich finden" (8). She somewhat romantically described this search as the quest for the "Zauberwort."[5]

Zeller is all too aware of the limitations of mere words, especially in contrast to visualizations of people or events, "Zurück bleiben Worte. Unzulässig verkürzter Wortsalat, nur ein kleinster Bruchteil dessen, was gewesen war, nicht zu addierende Stichworte zur Auffrischung des Gedächtnisses. Das meiste bleibt unerinnert" (*Solange* 162). She views words as emotionally independent entities that resist the intellect's need to order them so as to provide meaning to life's experiences. Zeller maintains, "Eine zweite Biografie wäre zu schreiben über das Auf- und Ankommen bestimmter Worte"

(*Solange* 196). This recalls Natalie Sarraute's theory of *tropismes,* in which spontaneously arising subconscious thoughts build a subtext to any discourse.[6]

In its more lyrical passages, Zeller's prose reflects her craft as a poet. Zeller often uses triplets rhythmically: "Wieder einmal war das Kind zu feige, zu brav, zu entschlußlos, den roten Handgriff der Notbremse zu ziehen" (*Solange* 62). She also exhibits a preference for lists—of adjectives, of phrases, or even of short sentences. This is certainly in part for the sake of rhythm, but it is also characteristic that she thus offers the reader a choice of interpretations (as in the "zu feige, zu brav, zu entschlußlos" above). This uncertainty of interpretation also reflects the intellectual and moral dilemma—and hence vacillation—experienced by those who had to make decisions without access to complete or reliable information. Uncertainty also characterized Eva's relationship with her emotionally unreliable father.

In some passages Zeller uses this list-approach to intensify the rendering of an experience by piling up images, unrelieved by interpretive commentary. A litany of complaints about his daughter appears regularly in the father's letters to Eva's mother:

> E-M spricht ein Deutsch, das zum Himmel schreit.
> E-M stellt keine einzige Frage.
> E-Ms Wißbegier läßt sehr zu wünschen übrig.
> E-Ms Schlampigkeit ist nicht mitanzusehen.
> E-M soll sich endlich das Nasehochziehen abgewöhnen.
> Taschentücher gibt's wohl nicht in euren Weltgegenden.
> E-M traut sich nicht mal auf den Funkturm hoch.
> E Bindestrich M ist der geborene Angsthase.
> Bangbüchs.
> Umstandskrämer.
> Ganz die Tochter ihrer Mutter.
> Das ist das Ende von weg.
> Das ist das Ende vom Lied (*Solange* 63).

The revealing comment near the end of the negative summary that "the daughter is just like her mother" exposes the father's hidden agenda of an attack on his former wife. Through slight variations à la *nouveau roman,* the repetitions offer different interpretations. In looking back at the war from a contemporary perspective, Zeller observes:

> Man war jung. Ein Satz, den man oft hört, wenn von jenen fatalen Zeitläuften die Rede ist. Man war jung. Ein Satz, der um Nachsicht bittet. Man war jung. Ein Satz, der besagt, jeder meiner Generation habe zwei Leben, eines vor, eines nach 1945 . . . (*Nein* 163).

In this triple repetition of "Man war jung" and "Ein Satz," Zeller constructs a balance between the initial claim and possible intepretations of it, appearing to give equal weight to each, yet emphasizing her generation's youth. She uses the same approach in a larger, ten-page segment in the same novel to heighten the drama of the escalating war while underlining the simultaneity of political and personal events. Each segment begins with the same offset word "Während":

> Während
> Ende Mai Panzerspähwagen in die eroberte Stadt Charkow vordringen und unsere neuen Waffen wie Garben aus der Erde schießen, blühen blau und gelb kilometerlange bienenbeflogene Lupinenfelder auf Usedom. . . .
> [. . .]
> Während
> die Krim erobert wird und unsere Heeresleitung über die geheime, unfaßbare Waldarmee rätselt, . . .
> stehen wir eines abends am Schwanenteich in Greifswald, auf dem wirklich *Die Schwäne im Schilf* schwimmen; . . .
> [. . .]
> Während
> Molotow London besucht, um den Britisch-Sowjetischen Bündnisvertrag zu unterzeichnen, . . .
> redet mit uns kein Mensch über Politik oder über die Ursachen des Krieges, . . .
> (*Nein* 131-133).

This see-saw structure between death and life, between the technology of destruction and life-giving nature, and between war and youthful will to live and to love, reveals the emotional instability of the war years. The narrator explains that one response was cocoon-building: "Der Krieg umschließt uns wie das Wasser den Schwimmer, aber er dringt nicht in uns ein, sonst würden wir untergehen" (*Nein* 134).

The skillful use of repeated elements is a rhetorical device reminiscent both of political speeches and religious sermons. Marriage for many years to a protestant minister may have fine-tuned Zeller's ear to these rhythms of speech.[7] Reviewer Michael Töteberg has also noted Zeller's ability to "hear" and reconstruct the sound of the Nazi era:

> Zu den Vorzügen des Buches rechne ich das genaue Einfangen der Geräuschkulisse jener Jahre, vor allem durch den allerorts laufenden Volksempfänger ständig präsent. . . . [Sie] hat ein Ohr für die Technik der faschistischen Propaganda, die Rituale, Mythologie und auch christliche Frömmigkeitsmuster dazu benutzte, Deutschland heilig zu sprechen und den Gutgläubigen für die Zwecke des Regimes dienstbar zu machen.

Zeller herself notes in retrospect the importance of the radio: "Der Volksempfänger ist nicht wegzudenken, nicht die Erkennungsmelodie des Deutsch-

landsenders. Auf der Berliner Funkmesse habe ich aus Goebbels Mund gehört, daß der Volksempfänger einer der wichtigsten Führungsmittel und Erziehungsinstrumente sei" (*Nein* 83). Zeller uses such *Runkfunkmeldungen*, in addition to other devices such as clichés and sayings ("sich über Wasser halten," "Gold in der Stimme haben"), jokes making the rounds ("Gleich nach dem Krieg gibt's garantiert genug Butter, weil alle Führerbilder entrahmt werden"), and dialect ("Wat peilste mir denn ejalwech an, haik wat jesacht?"), to communicate to the reader a sense of immediacy.

Both Zeller and Melita Maschmann have noted not only the sounds of the Nazi era but also a particular vocabulary, a jargon that reflected an entire *Weltanschauung*. Maschmann comments that as she wrote, "der alte Sprachgeist, genauer Un-Geist, [kam] herauf" (52), and Zeller refers to titles such a "Blockwärter" and "Lagerführerin," specific to this era, and repeatedly cites sayings such as: "Kampf dem Verderb," "Die geringste Arbeit dient dem Ganzen," "Kraft durch Freude," and "Du mußt an Deutschland glauben, als wäre Deutschland du . . ." (*Solange* 376, 374, 396, 372). She also reflects the discourse that her father calls "vormilitärisch" that comprises daily life in the BDM or in the *Reicharbeitsdienst:* "Fahnenappell" (382), "Kolonnenführerin" (373), "Im Gleichschritt marsch" (375), "Ich brülle Antreten, Ausrichten, Durchzählen" (371). The question of how to reconstruct the invasive and comprehensive propaganda and social policies of the totalitarian state in a way that is both authentic and convincing is of concern to many writers, including Zeller. One source of authenticity for her was faithful reproduction of the discourse of the era, and she based it on meticulous documentation.

In our interview Zeller mentioned collecting materials for the book for over fifteen years: "Ich habe angefangen sehr viel Material zu sammeln—ich bin eine ziemlich gründliche und langsame Arbeiterin—und ich habe unendlich viel Aufzeichnungen gemacht . . . [ich] mußte mir ein verlängertes Gedächtnis anlegen, in Form von, nicht Zettel-Katalogen, sondern von Alphabeten" (Interview 31). In addition to maintaining file folders of remembered details about people, places, and events, she also conducted extensive archival resarch, consulted old newspapers, and read "sehr viel Sachliteratur." As she explained, she intended the documentation to support the all-important function of her memory, a memory of which she remained highly skeptical. Referring to it as "das Rüttelsieb Gedächtnis" (*Solange* 11), Zeller compares her memory to "ein schwarzer, speckiger Kasten, in dem ich Bilder verschließe" (*Solange* 413). Zeller, like Christa Wolf who is also very interested in the role and function of memory, questions the memory's reliability and selectivity. "Was für Entscheidungen das Erinnerungsvermögen trifft, liegt nicht in unserer Hand," she realizes, but she worries, "Was aber rückt die Erinnerung NICHT heraus?" (*Solange* 31).

In *Kindheitsmuster* Christa Wolf explores memory from various points of view ranging from psychology to chemistry ("die Speicherung, die Übernahme in das Langzeitgedächtnis [ist] wohl eine Angelegenheit der Chemie"; 48), and she comes to the conclusion that it is a process rather than a body part: "Kein Organ also, sondern eine Tätigkeit und die Voraussetzung, sie auszuüben, in einem Wort. . . . Zu entwickeln wäre also die Fähigkeit des Bewahrens, des Sich-Erinnerns" (15). Similarly, in our interview Zeller referred to her memory as a "muscle" of the body: "Ich habe, weil ich sehr skeptisch war, immer wieder darüber meditiert, aber, ich glaube, daß man sein Gedächtnis trainieren kann, wie man einen Muskel im Sport trainiert. Indem man sich Hilfsmittel verschafft—zum Beispiel die Archive—und ich hatte eine unglaubliche Gedächtnisstütze durch ein Tagebuch meiner Großmutter. . . . Das [war] ein solcher Fund für mich. Ich weiß gar nicht, ob ich ohne dieses noch geschrieben hätte" (53).

When asked what was most difficult for her in writing about this era, Zeller answered: "Einmal Worte zu finden, Form zu finden für dieses Unmaß an Leiden" (49). Zeller describes a highly personal story with non-interchangeable players, yet the events and people are circumscribed by a time and mentality that functioned as common denominators. She criticizes herself and at the same time a nation of women just like her. For example, she describes going to a fashion show and uncritically listening to how women's clothing should show no sign of *Geschlechterverwischung* which, according to the *Modeschau* commentator, stems from "Entartungserscheinungen einer fremden Rasse." She describes being unpolitical to the extent that on the 20th of July, a date fateful to so many of her countrymen and women, she is only concerned that she has "keine Brautschuhe." And, she reveals a different view of Germany's legendary "heroic" women, including many of the women in her own family:

> Hätten diese Frauen nicht so fabelhaft funktioniert, das Dritte Reich hätte sich kaum solange etablieren können. Ihrer Tüchtigkeit, Findigkeit, Brauchbarkeit, ihrem Rückgrat ist es zuzuschreiben, daß das Volk durchmarkt wurde von diesen Tugenden. Sie lebten es vor. Sie meinten es gut. Und wußten nicht, welchem Unheil sie Vorschub leisteten (*Nein* 268).

As one can conclude from this brief introduction, Eva Zeller's two autobiographical novels are rich works of literature that have much to offer both the general reader and the literary scholar. Zeller's narrative abilities are similar to those of Christa Wolf, although on a purely textual level, her less complex sentence structure would make her work accessible to students of German at an earlier stage. Within the context of the Nazi experience she addresses problems of adolescence and of the maturing process that have broad application and would certainly provide an *Anknüpfungspunkt* for many students. Zeller's multi-faceted novels invite further research on a variety of

topics including the father-daughter relationship and the complex grandmother-mother-daughter relationship that I was able to mention only briefly in this essay. Her articulation of the sound of the Nazi era deserves closer attention. New theoretical research on women and autobiography suggests fruitful approaches to Eva Zeller's works. Her other novels, short stories, and poetry remain, to my knowledge, undiscussed. Although I have indicated the implicit connection Zeller makes between patriarchy and fascism, the complexity of her treatment of this theme merits further analysis.

Notes

*I thank Catherine Davis, William Doty, and Ute Winston for reading this essay and offering the benefit of their advice.

[1] Several authors of novels or autobiographies that would fall into the category of unreflective works are Wendelgard von Staden, Marion Yorck von Wartenburg, Christabel Bielenberg, Margaret Boveri, and Margarete Hannsmann.

[2] Luise Rinser writes, for example, in the foreword to the second edition of her *Gefängnistagebuch*, "Um dieses Schweigens willen habe ich mich entschlossen, mein Buch doch wieder erscheinen zu lassen. Viele Stimmen haben gerufen im letzten Jahrzehnt, viele Gewissen sind wachgeworden, viele Versuche des Wiedergutmachens sind gewagt worden. Wir dürfen nicht mehr einschlafen lassen, was wachgeworden ist (9).

[3] This is quoted from Appendix I of my dissertation, *Uncommon Women and the Common Experience: Fiction of Four Contemporary French and German Women Writers*, Indiana University, 1982, 405.

[4] Stern writes of her protagonist, Eka, "Aber sie will bei Kommunisten nicht verteidigen, was sie den Nazis, sich selbst nicht ausgeschlossen, vorwirft: Verbrechen kritiklos hingenommen zu haben. Erklärungen, Entschuldigungen lassen sich stets finden" (149-50). Later she compares her own and her husband's experience: "Doch schmerzt sie beide, daß ihnen so lange keine Zweifel kamen; Eka nicht, als der Terror von den Nazis, Heinz nicht, als der Terror von den Kommunisten kam. Daß sie so stur und so empfindungslos für Unrecht blieben" (254).

[5] The Eichendorff poem to which Zeller refers reads: "Schläft ein Lied in allen Dingen / die da träumen fort und fort / und die Welt fängt an zu klingen / triffst du nur das Zauberwort?"

[6] For additional information about this theory, see Sarraute's *Tropismes* (1932) and the four essays in her *L'Ere du soupçon* (1956).

[7] I thank Ute Winston of the Women Studies Program at the University of Alabama for first bringing this parallel in the case of Eva Zeller to my attention.

Works Cited

Alexander, Elisabeth. "Der Mittelpunkt, der Vater heißt." Review of *Solange ich denken kann*. *Heidelberger Tageblatt* 25 (March 1982).

Bachmann, Ingeborg. *Der Fall Franza* (fragment). Munich: Piper, 1979.

Bell, Susan Groag and Karen M. Offen, eds. *Women, the Family, and Freedom: The Debate in Documents*. V. II, 1880-1950. Stanford: Stanford University Press, 1983.

Dijkstra, Bram. *Idols of Perversity: Fantasies of Feminine Evil in fin-de-siecle Culture*. New York: Oxford University Press, 1986.

Drewitz, Ingeborg. *Gestern war Heute: Hundert Jahre Gegenwart*. Düsseldorf: claassen, 1978.

———. "Personal Interview" (Berlin-Dahlem, 4 July 1979). Martin, Elaine, *Uncommon Women and the Common Experience: Fiction of Four Contemporary French and German Women Writers*. Diss., Indiana University, 1982.

Hannsmann, Margarete. *Der helle Tag bricht an: Ein Kind wird Nazi*. München: Deutscher Taschenbuch Verlag, 1984.

Hartlaub, Geno. "So und nicht anders ist es gewesen." Review of *Nein und Amen*. *Deutsches Allgemeines Sonntagsblatt*, Hamburg (12 October 1986).

Lacoue-Labarthe, Philippe and Jean-Luc Nancy. "The Nazi Myth." *Critical Inquiry* 16 (Winter 1990): 291–312.

Macciocchi, Maria-Antonietta. "Female Sexuality in Fascist Ideology." Michele Barrett, Judy Keiner, Karen Margolis, and Jennifer Stone, trans., eds. *Feminist Review* no. 1 (1979): 67–82.

Martin, Elaine. *Uncommon Women and the Common Experience: Fiction of Four Contemporary French and German Women Writers*. Diss., Indiana University, 1982.

Maschmann, Melita. *Fazit: Mein Weg in der Hitler-Jugend*. München: Deutscher Taschenbuch Verlag, 1979.

Mennemeier, Franz Norbert. "Roman einer Nazi-Jugend." Review of *Solange ich denken kann*. *Neues Rheinland*, Köln (July 1982): 29.

Ross, Werner. "Heldenlied und Gänseblümchen." Review of *Nein und Amen*. *Frankfurter Allgemeine Zeitung* (30 September 1986).

Stern, Carola. *In den Netzen der Erinnerung: Lebensgeschichten zweier Menschen*. Reinbek: Rowohlt, 1986.

———. Personal Interview. Köln, 11 June 1988 (unpublished).

Theweleit, Klaus. *Male Fantasies*. Vol. 1. *Women, Floods, Bodies, History*. Minneapolis: University of Minnesota Press, 1987.

Töteberg, Michael. "Die Anstrengung, sich zu erinnern." Review of *Nein und Amen. Deutsche Volkszeitung, Die Tat,* Düsseldorf (3 October 1986).

Wolf, Christa. *Kindheitsmuster.* Darmstadt: Luchterhand, 1979.

Zeller, Eva. *Nein und Amen.* Stuttgart: DVA, 1985.

_____. Personal Interview. Munich, 15 May 1986 (unpublished).

_____. *Solange ich denken kann.* Stuttgart: DVA, 1981.

Heterosexism, Misogyny, and Mother-Hatred in Rilke Scholarship: The Case of Sophie Rilke-Entz* (1851-1931)

Tineke Ritmeester

Sophie Rilke-Entz from the Perspective of Feminist Scholarship

> Rilke mußte über diese Mutter entsetzt sein (Sieber 51).

> So wurde seine ohnehin schon problematische Rolle als Einzelkind in einer unglücklichen Ehe noch zusätzlich erschwert durch die Weigerung der Mutter, seine Geschlechtsgehörigkeit zu akzeptieren (Leppmann 15).

> The Freudian view of the son is saturated with the Freudian hostility ... toward the mother (Rich 202).

This article examines the extensive misogyny that has shaped Rilke scholarship since the appearance of Carl Sieber's biography of the young Rilke in 1932 by tracing the treatment of Rilke's mother, Sophie Rilke-Entz, and the speculative interpretation of her impact on Rilke. Thus, the subject proper of this study is not the historical Sophie Rilke-Entz but the attitudes of the experts. With very little primary documentation[1] Sophie Rilke-Entz has been consistently depicted in an antagonistic manner as, for example, a "pathological, neurotic," and "unnatural" woman (Hatfield 151), as an "adulterous" wife (Demetz 17), as an unfit, "devouring," possibly incestuous mother (Simenauer 245), or as a combination of these. While Rilke's genius is attributed to divine inspiration, his psychosexual problems are blamed on his mother. We also find her indicted for the crises in her marriage with Josef Rilke, for parental conflicts with their son, and, indeed, for all other problems in the Rilke family. Although the firsthand information available to Rilke scholars is insufficient for a definitive judgment on the mother/son relationship, it does allow for an alternative approach to Sophie Rilke-Entz.

The objective here, then, is to counter the misogynist practices in Rilke scholarship by introducing a revisionary interpretation from a feminist perspective. Feminist analysis of heterosexism, misogyny, and mother-hatred makes visible hitherto invisible aspects of Sophie Rilke-Entz's life and relationships. Her experiences with marriage, motherhood, divorce, and

possibly abuse need to be weighed against the socio-historical context of late nineteenth-century Austria. This approach does not seek to emphasize or favor either the mother or the more famous son, but to bring into relief how mother and son have been pitted against each other at the mother's expense. Much of what has been stated in Rilke scholarship and continues to be echoed on the subject of Rilke and women, or Rilke and love, is based on myths about women, particularly as either the "good" or "bad" mother, that have circulated since Freud. For a corrective assessment of Rilke's mother, attention must also be paid to the role and possible impact of Rilke's father, who has been virtually ignored by Rilke scholars. Excerpts from Sophie Rilke-Entz's *Ephemeriden* (1900) provide evidence that she was an independent and emancipated woman who was fully cognizant of and articulate about her subjugation.

Heterosexism, Misogyny and Mother-Hatred in Rilke Scholarship

> But Rilke's upbringing was so skewed, so perverse, that one wonders how he managed to survive it. His mother and two other relatives were definitely pathological (Hatfield 151).

> Überhaupt eignet dem Gesicht eine fast männliche Entschlossenheit, die sich auch in der Haltung der Arme, der Wendung des Kopfes aus dem Bild heraus ausdrückt (Schneditz 64).

Rilke scholarship that involves Sophie Rilke-Entz—and it almost always does—offers particularly crass examples of heterosexism, misogyny, and mother-hatred. Sophie Rilke-Entz has been referred to as "possessive" and "false" (Demetz 19, 38), "unreal" (Sieber 51), "mentally ill" (Bauer 8), "bigoted" (Storck 16), "superficial" (Buddeberg 1), "detestable" (Bachler 279), "hysterical (Klages 630); "a witch" (Angelloz 14), "an exhibitionist" (Butler 14), and so on. The incriminating myths surrounding her became self-perpetuating and increasingly hostile over the years, as most later scholars followed Sieber's example.[2]

According to the *Dictionary of Feminist Theory,* the term heterosexism "refers to the unconscious or explicit assumption that heterosexuality is the only 'normal' mode of sexual and social relations." Based on this assumption heterosexist practices also reinforce "the suppression and denial of homosexuality" (Humm 94). Not only does the heterosexual imperative mandate that everyone must be heterosexual, it also sets up extremely inflexible standards for the "normal man" and the "normal woman," a system of gender tracking that begins with "the pink and the blue." In Rilke scholarship we find that Sophie Rilke-Entz is judged again and again by how

"feminine" she was, in how "masculine" a manner she reared Rilke, and how "manly" he became.

Thus, a feminist perspective on Sophie Rilke-Entz includes the exposure of implicitly heterosexist assumptions underlying the generally hostile characterizations of Sophie Rilke-Entz. For example, the allegation that she refused to accept her son as belonging to the male sex (Leppmann 15), references to her as having been "manly" and as having had a "deep voice" (Schneditz 1949:64; Graf 227), betray a glaringly heterosexist bias. And again, where her impact on Rilke has been considered "an affliction" (Hass xi) and absolutely disastrous for his development into a so-called normal man or where it is pointed out that she liked to drink wine (Simenauer 243ff.; Graf 227; Demetz 17), we encounter a heterosexist mentality that seeks to evoke incriminating evidence against the person of Sophie Rilke-Entz on the basis of gender transgressions.

René Rilke: Die Jugend Rainer Maria Rilkes, the book that has been the primary source of information about Sophie Rilke-Entz for more than 50 years, was written by Rilke's son-in-law Carl Sieber (1932). In this book, which is generally accepted as the definitive biography of the young Rilke, Sieber created a picture of Sophie Rilke-Entz that amounts to a caricature. It is based on a handful of carefully selected letters, segments from Rilke's unpublished writings, anecdotes, and hearsay. It is worth considering in this context that after the death of Sophie Rilke-Entz in 1931, Carl Sieber and Ruth Sieber-Rilke, his wife, had unrestricted access to the estates of both mother and son. This means they had the power of deciding what to release and more importantly what not to release for publication, and within what context. Sieber's membership in the Nazi party is also relevant; it influenced his editorial politics to such an extent that Rilke's Jewish, anarchist, and communist friends were excluded from the first editions of the collected letters.

It is impossible, given the lack of available historical information, to reconstruct Sophie Rilke-Entz as she really was. It would also be incorrect to conceive of her as beyond reproach or an advocate of women's rights, although her *Ephemeriden,* discussed below, provide evidence that she was not indifferent to the cause of women's emancipation. Although Rilke's relation to his mother remains among the least explored and least accessible subjects, it has nevertheless been a cornerstone of Rilke scholarship. In Rilke studies that appeared in the wake of Sieber's book and that mention Rilke's relation to his mother, Sieber is the most frequently cited author, with Peter Demetz, who again draws on Sieber, a close second. Even scholars—men and women—who have taken issue with other questionable aspects of Sieber's

book repeat and perpetuate the damaging clichés about Sophie Rilke-Entz (Schwarz).

Whenever the influence of Sophie Rilke-Entz is not flatly denied, scholars have regarded Rilke's artistic accomplishments as achievements in reaction to, or in spite of, his mother, but never also because of her. The possibility of reciprocal intellectual influence has been either overlooked completely or assumed to have been one-sided and emotionally damaging to the son (Simenauer 244). Yet, Ingeborg Schnack, author of *Rainer Maria Rilke: Chronik seines Lebens und seines Werkes*, provides numerous citations from letters from the adult Rilke to his mother in which he acknowledges her not only as his intellectual and professional consultant, but also as his confidant.

The Case Against Sophie Rilke-Entz

> Phia Rilke erzählte zwar, René habe sich eine Puppe zum Auskleiden, ein kleines Bett und eine Küche gewünscht und habe stundenlang die Puppe gekämmt, aber wieviel ist hier wohl auf die Suggestion durch die Mutter zurückzuführen? (Sieber 70f.)
>
> Am meisten aber sündigte die Mutter in dieser Hinsicht, wie bei ihrer unausgeglichenen Persönlichkeit zu erwarten war. Ihre sprunghafte Art liess sie René bald mit Zärtlichkeiten überschütten, bald ihn vernachlässigen und ignorieren, um ihn dann wieder wie ein Paradestück aus der Versenkung hervorzuholen, wenn er in seinen neuen Kleidern ihren Freunden vorgeführt werden sollte.
> [. . .]
> Welche schwülstigen und bigotten Gemeinsamkeiten mag diese der Wirklichkeit entfremdete Frau sich erdacht haben, wenn sie ihren René ganz für sich hatte! (Simenauer 245)

The most frequently recurring allegations directed against Sophie Rilke-Entz are based on the way she raised or failed to raise her son to be a "man." To corroborate their case against Rilke's mother, scholars have readily used whatever material could be found in support of Sieber's original assessment: letters, poems, plays, prose, and even rumors.

> Sie ließ ihn in seinen ersten Jahren unverständlicherweise als Transvestiten in Mädchenkleidern aufwachsen, weil sie sich anstatt des Knaben ein Mädchen gewünscht hatte (Schneditz 1947:11).
>
> Denn das versteht sich, René ist gar nicht ein René—sondern er ist in Wirklichkeit eine Renée, die sich Maman so heiss gewünscht hatte (Simenauer 252).

> In the meantime, Rilke's education was in the hands of his mother, such as she was. In keeping with her congenital disregard of reality she brought her boy up as if he were a girl (Graff 13).

It is true that Rilke himself contributed to negative judgments about his mother, for example in some letters to Lou Andreas-Salomé and Clara Rilke-Westhoff.[3] However, it is interesting to note that no letters from his correspondence with Sophie Rilke-Entz have been cited that could substantiate hostility or tension between mother and son. They corresponded with each other over a period of approximately forty years; there must have been thousands of letters and postcards, and yet not one letter has been cited in the literature that would confirm Rilke's disdain for his mother (cf. Schnack). On the contrary, the only letter Sieber cites from this massive correspondence, one that Rilke wrote to his mother on 18 December 1922, when he was almost 47 years old, is very loving in tone. That it was written on the occasion of Christmas does not make it less so. Another such endearing letter is dated 22 March 1899 and was first published in the *Blätter der Rilke-Gesellschaft* (57). In sum, all the letters, either from son to mother or from mother to son, that have been cited by Rilke scholars disclose a relationship that was not at all inimical but reciprocally intimate, trusting, and intellectually stimulating (Schnack).

The letters in which Rilke writes negatively or disapprovingly about his mother to third parties—most of which have not been published in their entirety—do not, in fact, add up to more than a handful.[4] Moreover, one can identify a motive for Rilke's negative attitude toward his mother in each of these letters. For example, in preparing reviews of two books on the topic of children's emancipation written by two of his best friends, Ellen Key and Franziska zu Reventlow (Key; Reventlow), Rilke had to come to grips with his own childhood traumas. The routinely cited letter to Ellen Key reflects that Rilke felt confirmed and validated by her book. Furthermore, the letter to Lou Salomé of 15 April 1904 was written during the time when he had just completed a related detailed two-part questionnaire concerning his childhood and upbringing for Ellen Key (Schnack 180f). Thus, Rilke's obsessive preoccupation with childhood experiences that he felt had damaged him for life makes it plausible that he also scrutinized the impact his mother might have had on his childhood. Yet, references to his mother form only a small part in these recollections and do not weigh as heavily as, for example, his traumatizing experiences in military schools (Kim).

Finally, even where autobiographical connections can be found, the figure of the mother as we meet her in Rilke's dramas, poetry, and prose, remains primarily fictional and does not allow for binding conclusions about the actual Sophie Rilke-Entz. Rilke did not deny that he had felt deprived by his

mother, but he also knew that his fictional mother figures would have been the same with or without a particular maternal influence on him.[5] This corresponds to his conviction that, unlike ordinary human beings, whom he sees as the products of certain conditions, the true artist is "immaculately conceived."[6]

Dresses for Boys?

The way Sophie Rilke-Entz reared her son conformed to the conventions of her culture. When Rilke was born (1875), it was not at all unusual for boys to wear the same clothes as girls, to have long hair and play with dolls, at least until they entered grade school, which in Rilke's case was at about five years old. Thus, Rilke's mother was behaving in accord with prevailing guidelines of pedagogy and fashion. It seems realistic, therefore, to look at Rilke's upbringing as not so terribly different from that of other boys of his generation—with the exception, perhaps, that his mother may have been more emancipated than the average mother. Robert Musil, an Austrian contemporary, wrote in his diary about the girls' clothes he was forced to wear (Musil 613; also see: 418 and 723). Ewing also gives numerous examples of famous men who wore dresses in their early childhood, among them Graham Greene, Osbert Sitwell, and Lord Clark. She found that as late as the 1920s "[i]t was also still customary . . . for boys to wear dresses until they were four or more years old" (Ewing 126). There are numerous illustrations in the *History of Children's Costume* that show "[d]ress, fancy pantaloons and long hair for boys . . ." (Ewing 73). Laven investigated journals like *The Ladies' Gazette of Fashion* from the 1880s and found that "[t]he little boy seems excessively feminine!" (Laven, plate 16).

Rilke's problems have been attributed to his mother, because she had the audacity, it is said, to raise her baby boy as a girl. To save the male genius from this frightful fate of having been treated like a female, the scholars—awed by the advent of Freudian psychoanalysis—were quick to denounce Sophie Rilke-Entz. She is accused of having been an irresponsible mother and an irresponsible wife as well. Rilke's complex gender identity was of course to some extent also related to the domestic circumstances that surrounded his upbringing. But this is not at issue here; more important is that the accusations concerning his upbringing have led to the dehumanization of Sophie Rilke-Entz.

Although Rilke did wear the same clothes as girls, had long hair, and perhaps even played with dolls, it does not necessarily follow that he was raised "as a girl." But even if it did, why should it be considered only

negative? Could not Rilke's greatness be attributed in part to this very upbringing?

Rilke's contemporaries leave no doubt that they denigrated him for his feminine features. After Rilke's death, his friend Kassner testified to his femininity in a sexist fashion: "Für Rilke selbst lag alle Geschichte im mehr Anekdotischen, Legendären enthalten, im Kuriosen, jegliche Pragmatik blieb ihm fern, *was wohl auch dem Weiblichen in seiner Natur* entsprochen haben mag" (Kassner 12; emphasis mine). Carl Burckhardt's homophobic contempt for the feminine in Rilke becomes apparent in a letter he wrote to Hofmannsthal, a mutual friend of Rilke's and his, 30 June 1926: "Der arme Rilke, ihm geht es so schlecht . . . Er liebt und bewundert Valéry über die Maßen . . . , daß er nicht spürt, wieviel Reserve, Fremdheit, ja Kälte *seiner fast weiblichen Hingebung* an den immer höflichen Franzosen entgegenwirken" (Hofmannsthal 217f; emphasis mine). A personal loathing imbued with unrestrained homophobia and misogyny also informs the way Gottfried Benn reviews Rilke: "*[E]ine gute Wärme, Gemisch von männlichem Schmutz* und lyrischer Tiefe, bezärtelt von Duchessen, hergeströmt in Briefen . . . das ist die Größe von 1907" (Benn 195; emphasis mine). It did not surprise Oskar Graf that Rilke, "*dieser beinah unmännliche Mann*" (Graf 182; emphasis mine), was depressed each time he looked into the mirror (Graf 197). Following Graf's thinking, Rilke was "ugly" *because* he was "effeminate." He was a man who had "*feminine Hände*" and who showed "*fast weibliche Pedanterie im Häuslichen*" (Graf 197; the author draws on Simenauer; emphasis mine). Graf, who was involved in revolutionary politics, reveals that his conception of a new humanity would definitely not include feminine men and masculine women, as revealed in his degrading recollections of Sophie Rilke-Entz, cited above. While leaving out the question of morality, and who or what could be held accountable for Rilke's "effeminate" mannerisms, given the deep-rooted contempt for the feminine in a heterosexist and patriarchal culture, his writings bear testimony that his alleged "deficiencies as a man" (Hamburger 15) caused him a great deal of suffering from an early age on.

Ephemeriden

> Als Narziß betrat [Rilke] die literarische Szene—voll versteckter Sinnlichkeit und dekorativer Attitüden, bis zu seinem Lebensende Liebling fragiler wie frigider Frauen, die sich zu dem Dichter in einer tragischen Einsamkeit hingezogen fühlten und ihn mit Fürsorge bedachten (auch wirtschaftlich versorgten) (Glaser 214).

Rilke scholars as well as Rilke himself made his inability to sustain love-relationships with women a function of his relation to his mother (Hatfield 151). Yet, as I will show, Rilke's case was not really as exceptional as it has been made out to be, although he did have a rather extraordinary and

relatively emancipated mother. Sophie Rilke-Entz was oppressed as a woman and she fought against it: sometimes by running away, other times by confrontation, and on still other occasions by seizing paper and pen. Her ideas exhibit parallels to those current in the women's movement with whose rhetoric she seems to have identified, at least to some extent.

Conceivably to control her pain, to deal with the disappointments and the demoralizing behavior of the people around her, to sustain her domestication and probably simply to keep her psychic equilibrium, Sophie Rilke-Entz wrote diaries, notes, poems, and aphorisms. Many of these writings were destroyed or are now not accessible. However, in 1900, when she was nearly fifty years old, a booklet with her aphorisms was published under her name through Rilke's mediation. These *Ephemeriden* constitute a plea for freedom from sexism, violence, domestication, dehumanization, and religious hypocrisy:

> Gar oft wird eine Frau geachtet, verehrt, mitunter angebetet—bis zu jener Stunde, wo sie v e r s a g t (32).

> Es gibt Worte, die einen giftgetränkten Dolch ersetzen (41).

> Man braucht nicht Worte, zuweilen genügt ein Blick, um eine Frau tief zu verletzen (49).

> Eine geistige Mesalliance ist tausendmal schlimmer, als die des Standesunterschiedes (51).

> Verachtung muß sprachlos bleiben (54).

> Das älteste geflügelte Wort ist zweifellos: 'cherchez la femme'... (55).

> Aspasien wird es ewig geben, doch keine Zeit bringt wieder Perikles (11).

> Das Instinkt des Weibes sieht meistens schärfer, als die Vernunft des Mannes (19).

> Die Pflichten der Frauen sind Legion, doch für ihre R e c h t e blieb im Gesetzbuche nur wenig Raum (20).

> Wenn über Frauen gesprochen wird; wo bleibt die O b j e k t i v i t ä t? (58).

Her aphorisms did not alter the views of her critics: on the contrary, they appear to have added more fuel to their fire: "Phia Rilke führte Tagebuch, schrieb 'Ephemeriden', dichtete gelegentlich selbst Glückwünsche und machte Verse auf Familienereignisse—freilich alles ohne Talent" (Sieber 77). Demetz characterizes these aphorisms as "unbezähmbare[n] Ehrgeiz" (Demetz 16f.). He extrapolates three basic thoughts from the booklet that presumably cast some light on why her marriage with Josef Rilke had to fail: first, her "ungebändigte[r] Wille, die Fesseln der Konvention zu brechen"; second, her

"Entschluß auch den Fehltritt niemals zu bereuen"; and third, her "unerfüllte Sehnsucht nach dem ruhmvollen Leben in den blauen Salons des Adels, dem ihre Jugendträume galten" (Demetz 17). Expressions such as "unbezähmbarer Ehrgeiz" and "ungebändigte[r] Wille" imply not a mature woman but a child who is out of control.

It cannot be surprising that the *Ephemeriden* have been ridiculed as much as the woman who wrote them.[7] Yet, in this unique testimonial document of a bourgeois woman we find insights that are poignant and perceptive. We also notice that the woman behind these words has little in common with, in fact contradicts, the clichés that have been created around her. The tone, style, and content of the aphorisms reveal a much closer affinity to the wit and enlightened mind of a Hedwig Dohm than to the caricature that has been accepted by the scholars.

Relations within the Rilke-Family: Sophie's Function as Mother

According to Monique Plaza, "[t]he union between the woman and *her* child . . . this material proximity with the child, was massively imposed on women in the eighteenth and nineteenth centuries" (Plaza 79). Socially ascribed roles began, in Plaza's terms, to be "sociobiologized" by psychoanalysis, which "hid the social character and the exploitation of mothering by denying it, biologizing it, and making it pejorative" while "it affirmed the necessary and fatal prevalence of the paternal system" (Plaza 85).

In her path-breaking study *Mother Love,* the French sociologist Elisabeth Badinter substantiates the case against psychoanalysis even further for having

> greatly contributed to making the mother the central character in the family. After having discovered the existence of the unconscious and shown that it takes form throughout childhood and from even earliest childhood, psychoanalysts formed the habit of questioning the mother, even of challenging her, over the child's slightest psychological problem . . . she quickly came to be seen . . . as the immediate, if not prime, influence on the child's psychic stability. Whether it was intentional or not, psychoanalysis has for many years intimated that an emotionally unhappy child is the son or daughter of a bad mother . . . (Badinter 260).

Feminist scholars have shown that biology is not destiny and "maternal love is not linked to any immutable female nature" (Badinter x). Yet, in the wake of Freud, "mother" can do little or no good.

> What have I heard? That mothers are often suspicious beings, beings with a sort of insatiable instinct which pushes them to smother their children. What have I seen? That traces of this instinct are searched for in their discourse: do they still wash their children at ten years and two months? Do they pick them up at school

at eight years seven months? Did they want them when they were nine months pregnant, seven months? Do they take them into their beds? Do they accept the authority of the father? What have I read? That the madness of a child can be explained by referring to the perversion of its mother (Plaza 75).

The contempt for Sophie Rilke-Entz that so dominates the field and that is shared by scholars who would otherwise make strange bedfellows correlates with the pervasive hatred of mothers that Plaza refers to as "being one of the most prodigious and effective bastions of misogyny" (Plaza 78). "Mothers" have become abstractions, stripped of their personality and intellectual interests. They are reduced to a functional role that has validity only in relation to children. "'Mom' is neither a woman nor an individual . . ." (Plaza 78). Mothers may not be credited with the success of their sons: "Ob [Rilkes] Phantasie ein Erbteil der Mutter ist, erscheint zweifelhaft, wenn man die Nüchternheit der Tagebuchaufzeichnungen kennen lernt, viel eher denkt man an den Urgroßvater mit dem Buche in der Hand," contemplates Sieber (77f.).

Based on the little information available, there is no denying that the relationship between Rilke and his mother was complex; however, what mother/son relationship under patriarchy is not? The question is why the mother was singled out without considering the impact Rilke's father may have had on his son.

The Father

> Keine Wärterin war ihm [Josef Rilke] sorgfältig genug, so daß . . . , nicht weniger als vierundzwanzig im ersten Lebensjahr Rilkes verbraucht wurden (Sieber 68f.).

Josef Rilke, about whom even less is known than about Sophie Rilke-Entz, is described in gender-specific contrast to his wife. Indeed, if we were to rely on the assessment of Sieber et al., we would believe Josef was a better human being than Sophie Rilke-Entz. Scholars inform us that Josef Rilke was "polite," "correct," "charming," "attentive," "uncomplicated," "good hearted," "imposing-looking," etc. "Rilke liebte an seinem Vater [das] im besten Sinne Militärische der äußeren Erscheinung und Lebenshaltung und hat nie an seiner Liebe gezweifelt," pontificates Sieber (44).

As a salaried public servant, Josef did not earn much money. It might have barely sufficed for the maintenance of a small household. We do not know. We *do* know, however, that the family's modest living conditions did not deter Josef Rilke from claiming an extravagant and costly personal life-style. He wore fashionable custom-tailored suits that were certainly expensive and he left much money at outdoor cafés (Demetz 15), where he

could comfortably "watch the girls go by" (Sieber 41), while at home his wife had to make ends meet.

> Das spärliche Beamtensalär reichte nicht aus, die Wünsche einer anspruchsvollen Frau zu verwirklichen (Demetz 12).

> Phia war extravagant, fühlte sich ein exaltiertes Damenleben im Stil eines Markart-Bildes zurecht und schwärmte von Hofbällen (Graf 227).

> Anspruchsvoll und von gesellschaftlichem Geltungstrieb besessen, rieb sie sich an den beschränkten Umständen ihrer Ehe; denn das Einkommen Josef Rilkes war schmal und ihre Mitgift reichte nicht weit (Buddeberg 1).

As Spitzer has pointed out, even if the squandering of money by women was a widespread phenomenon, this would have to be seen as a significant factor in a young woman's marriageability, and, hence, in affecting her future" (Kaplan, Introduction). Sieber indirectly indicates that Sophie Entz brought furniture with her dowry (Sieber 55); however, we can assume that much more, including a considerable sum of cash, was involved. The money a woman brought into the marriage was immediately usurped by her husband (Spitzer 611); she thus forfeited her material independence. After that she had to justify each penny she spent, even of her own money. There is no reason to believe that this was fundamentally different for Rilke's parents.

Few scholars question the stereotypical portrayal of Josef Rilke as presented by Sieber et al. The bias against Sophie Rilke-Entz again becomes manifest. That Josef Rilke evidently misused money is readily excused, accepted, or glossed over, while his wife is blamed for her financial conduct: she has become known as the irresponsible woman who squandered the money and mismanaged the household, two factors that also play a role in the explanations of her separation from her husband. Not only is it ignored that she was economically utterly dependent on her husband but also that her consumer behavior served to enhance her husband's status.

Violence against Women

> Ob [Sophie Rilke-Entz], die dem eigenen Geständnis zufolge "beim Heiraten nicht bedacht hatte, daß ein Mann Socken zerreißen würde," sich nun wirklich, wie sie im Alter gestand, eines Abend beim Strümpfestopfen vor lauter Verzweiflung eine Zigarette anzündete und dem unerwartet nach Hause kommenden Gatten auf die Frage, wessen Besuch sie denn empfangen habe, achselzuckend die Antwort verweigerte und es zur Szêne kommen ließ . . . (Leppmann 26f.)

For men, particularly soldiers, sexist and violent behavior towards women was legally sanctioned and culturally encouraged. Brothels abounded and the

purchase of sex was integrated into boys' socialization from an early age. There is no evidence that Josef Rilke was an exception to a generation of men that routinely sexually exploited and abused women, both physically and mentally. "Aus der Einöde der kleinbürgerlichen Zivilexistenz führte Josef Rilke nur ein einziger Fluchtweg, die Illusion, noch immer—wie einst in den Garnisonsstädten—*ein eleganter Herzensbrecher* geblieben zu sein" (Demetz 14f.; emphasis mine). Expressions such as, "ein eleganter Herzensbrecher," "ein alter Kavalier," and the so-called "Kavaliersdelikt," are the euphemisms used to protect men who exploit women (Schulte and Giesen/Schumann). Even Sieber refers to Josef Rilke as a "coarse soldier" (47) and admits that he was rough in bringing up his son (73). Demetz writes of him as a "Roué" known city-wide (Demetz 5). In other words, Josef Rilke was publicly known as a womanizer. Yet, the Rilke experts have chosen to ignore whether Josef Rilke was an unfit father or how Rilke's personal and artistic development was affected by a womanizing father.

"The Power of Men Is the Patience of Women"[8]

It is reported that over the years, but particularly during 1884, Sophie Rilke made several futile attempts to run away. In one explanation of the separation, Demetz suggests that Sophie Rilke "nicht gewillt [war], in der Ehe mit Josef Rilke die Rolle der unbefriedigten und unverstandenen Frau auf sich zu nehmen" (Demetz 16). There may be some truth in this explanation; however, another explanation is also plausible. In her investigation of what motivated Austrian women of Sophie Rilke's generation to separate from their husbands, Heindl found: "an erster Stelle in der Reihenfolge steht bei ihnen [Frauen] . . . eindeutig Mißhandlungen, Drohungen, Kränkungen und Beschimpfungen. Erst nach Trunksucht und zu geringer Unterhaltungsleistung folgt Ehebruch als Anlaß zur Scheidungsklage" (Heindl 170). Sophie Rilke lived with her husband for nine years, at which point she may have had no other choice but to leave. Given the lack of concrete evidence, to interpret this act as a "selbtsgewählte[s] Los" (16), as does Demetz—and which we find echoed by the majority of Rilke scholars—reveals an insensitivity to the situation. Why is the possibility of abusive behavior by the husband not even considered as a reason for her running away? We find the separation itself (1884) briefly summarized by critics in variations of the following: after she had left her husband, Phia went to Vienna, presumably with a male friend, to be nearer to the courts (Demetz 196). Sophie Rilke-Entz, however, did not move to Vienna until at least seven years after the separation (Schnack 23). And in any case, we can assume that she had more immediate worries than the courts. It appears more plausible that she wanted to be away from peers who would never forgive her "shameful" abandonment of her husband. After the separation she rented a small apartment in Prague. "Nachdem sie ihn

verlassen hatte," according to Demetz, "begann er [Josef Rilke] sich zu einem stadtbekannten Roué zu entwickeln" (Demetz 15). The reversal at work in Demetz's wording of cause (Sophie Rilke's departure) and effect (Josef Rilke becoming a playboy) is difficult to miss.

Even when a separation was legal,[9] Catholics were prohibited from remarrying. Austrian law only provided for divorce on the basis of the "table and bed"-clause (Beth 100; Heindl 176, n. 59). The law stipulated that in the case of legal divorce, the children were to remain in the father's custody. Yet it is known that Rilke stayed with his mother (Sieber 68). This need not mean that Sophie Rilke-Entz actually did "win" a divorce. It does at least mean that if she did win, either aggravating circumstances that did not permit Josef Rilke to keep his son were involved or he declined to have him. Even when "[dem Vater] die väterliche Gewalt entzogen wird, kann die Mutter nur die Stellung eines Vormundes einnehmen. Nur der Vater hat infolgedessen über die Berufswahl des Kindes zu bestimmen" (Beth 99).

Rilke was sent to military school according to his father's wishes and when he wanted to leave school (in 1891), he was also dependent on his father's permission (Sieber 102). Knowing that Rilke believed his experiences in military schools damaged him for life, it is even more astounding that scholars have not considered the impact of Josef Rilke on his son's development to the same extent as his mother's.

It has been widely assumed that Sophie Rilke-Entz caused her marriage to fail by mismanaging the household, and—worse—by allegedly adulterous behavior. There are, however, several indications that contradict this interpretation. If Sophie Rilke-Entz and Josef Rilke were anything like the scholars have portrayed them, it would be reasonable to expect that Josef Rilke would have sought the separation. However, he did not. It was his wife who risked going public with it, which was an unusual and—in view of the contempt that would inevitably follow—also remarkably courageous step for a woman to take.

Conclusion

Rilke's mother is depicted as deviating from a patriarchal norm. And a heterosexist bias enabled friends and foes alike to pity Rilke for his alleged lack of conspicuous virility. Rilke's personal problems are defined as belonging not to him but to his mother. Whether it concerns Rilke's relation to his father, his doctrine of intransitive love, his relationships with women, his concept of "god," his alleged inability to love, his need for seclusion or, his poetic works, the findings are related to Rilke's problems with his mother.

Not only does this imply that an injustice has been done to Rilke, but it has created clichés that are equally dehumanizing to mother and son.

It seems reasonable to assume that besides his mother's influence, other conditions, such as his father's bullying, his parents' separation, the strained relations with other relatives, and perhaps more than anything, his traumatizing experiences in military school, were all contributing factors in Rilke's development.

In some ways Sophie Rilke was typical of her generation, in other ways she was not. Following Chodorow (4–10), one can conclude that, like millions of other women, she had no choice but to comply with the dictates of a capitalist patriarchal state in need of an obliging feminine cultural character.

Notes

* I prefer the name Sophie Rilke-Entz, although in Rilke scholarship other names, such as Sophie Rilke, Phia Rilke, or merely Phia, prevail. Such names, in my opinion, contribute to the erasure of her independent identity.

[1] Crucial correspondences that could shed more light on this early period, such as those with Sophie Rilke-Entz, his wife Clara Westhoff, and his daughter Ruth Rilke, as well as diaries, pocketbooks, and additional correspondences have remained unpublished.

[2] A chronological sampling of some of the most prominent scholars' writings illustrates the problem:

> CARL SIEBER, 1932: "Ergriffen war Rilke von der Gestalt seiner Mutter, aber er war es von einer Gestalt, die nicht so bestand. Rilke hatte seine Mutter seit 1915 nicht wiedergesehen, die Briefe waren die gleichen wie immer, sie war auch in Wirklichkeit nicht anders, als er sie Clara Rilke und Lou Andreas-Salomé schilderte. [. . .] Die Briefe Phia Rilkes dagegen sind bis zum Schluß, wie immer, angefüllt mit Klagen über ihren leidenden Zustand, mit Berichten über Kirchenbesuche und mit Familienklatsch, alles bunt durcheinander. Es ist nicht so, daß im Laufe der Zeit eine vermehrte Zuwendung der Mutter zum Sohne in diesem die Mutterliebe aufrief. Sondern nachdem er ihr jahrelang biographisch sehr interessante, aber nicht vom Gefühl diktierte Briefe geschrieben hat, stellt sich allmählich der innigere Ton ein. Rilke wurde, das ist es vielleicht, die Gestalt dieser unwirklichen Mutter fühlbar, was sie ihm bis dahin nicht gewesen war. [. . .]
> Hat diese Mutter ihm außer der Ähnlichkeit der Gesichtszüge etwas mitgegeben? Konnte eine so äußerliche Frau dem Dichter des "Stunden-Buches" und der "Sonette an Orpheus" irgend etwas vererben? Sie hat ihm vielleicht mehr gegeben als der geliebtere Vater: den Willen. Das ist es ja eben, was uns bei Rilke immer wieder überwältigt: dieser unbeugsame Wille zu seinem Werk, der alle Hindernisse des schwachen Leibes und ihm nicht gemäßer Verhältnisse überwand,— bei ihm der Wille zur Wirklichkeit, bei der Mutter der Wille zum Schein" (52f.).

"Rilke hat seine Mutter unwirklich genannt, und unwirklich war sie tatsächlich in ihrer ganzen Erscheinung..., gekleidet in lange schwarze Gewänder nach einer nicht mehr bestehenden Mode, mit Erinnerungen, die nicht die unseren waren" (45).

"Wie weit sich Josef Rilke damals um die Erziehung seines Sohnes gekümmert hat, wissen wir kaum. Uns ist nur ein ... Zettel erhalten ..., der uns ... fühlen läßt, wie sehr das Versagen Rilkes in der Militärschule auf den Einfluß der Mutter zurückzuführen ist ..." (101).

E.M. BUTLER, 1941: "The mother ..., was the type whose self-dramatisations would earn her to-day the epithet exhibitionist ... She was probably as unreal as Rilke declared her to be in later life she played on his emotions ..." (14).

PETER DEMETZ, 1953: "Phia war es, die René mit ihren trügerischen Briefen und Beschwörungen zur Selbstbespiegelung verführte und aus dem Kreis der Mitschüler riß" (38).

KARL BACHLER, 1955/56: "Sie war ... eine abscheuliche Frau [...] die Ursache der psychischen 'Fehlentwicklung' Rilkes ..." (279).

O.M. GRAF, 1961: "Niemand jedoch wird bestreiten, daß die aus Enttäuschung und glühendem Ehrgeiz zusammengesetzte anomale Mutterliebe das kindliche Gemüt des Knaben Rilke schwer belastete und eine Art unbewußte Hörigkeit erzeugte" (228).

ARNOLD BAUER, 1972: "It can be safely assumed that Rilke's mother was unstable to the point of mental illness. She was a bigoted hypocrite, without religious depth, and she had assumed a role quite fashionable around the turn of the century: that of the misunderstood wife" (8).

JOACHIM STORCK 1975: "Phia Rilke, Temperamentvoll und ehrgeizig, steigerte sich in eine bigotte Religiösität hinein, die auf den späteren Rilke verwirrend wirken mußte" (16)

Also cf. Bassermann 1950; Valentin, 1952; Hendry 1983; Hähnel 1984.

[3] To Lou Salomé in the letter of 4 April 1904 (*Briefwechsel* 145f.). To Clara Rilke in the letter of 3 November 1907 (cited in Sieber 50f.; it is not reprinted in any edition of Rilke's letters).

[4] The letters that are cited most frequently are, in chronological order and according to their first publication: to Valerie David von Rhonfeld of 28 December 1894 (Leppin 27); to Ludwig Ganghofer of 16 April 1897 (*Briefe* 1892-1904); to Ellen Key of 3 April 1903 (ibid.); to Lou Andreas-Salomé of 15 April 1904 (*Briefwechsel* 1952) and to Clara Rilke of 2 October 1907 (Sieber).

[5] Cf. correspondence with Else Hotop (Elya Maria Nevar), 23-26 October 1918 (Nevar 30ff).

[6] [D]er Mensch ist, aus was für Verhältnissen er auch kommen mag, doch immerhin Produkt dieser bestimmten Verhältnissen, selbst dann wenn er sie widerlegt. Den Künstler aus diesen Verhältnissen herausableiten zu wollen, ist falsch; schon deshalb, weil er sich überhaupt nicht ableiten läßt. *Er ist und bleibt das Wunder, die unbefleckte Empfängnis ins Seelische Übertragen: das, wovor Alle staunend stehen, am meisten vielleicht er selbst.* ("Worpswede" [1902] Rilke 1976, 9:56; emphasis mine)

[7] An exception is Donald Prater: "Intellectually [Sophie Rilke] felt and indeed was, superior to her more stolid and humorless husband" (Prater 5).

[8] Cristina Perincioli, Director, "Die Macht der Männer ist die Geduld der Frauen" (Sphinx Filmproduktions-u. Verlags GmbH, i.A. des ZDF: 1978).

[9] There appears to be no evidence that the separation was legal. In fact, indications are against it, for Rilke was allowed to stay with his mother. Although legally not entirely impossible, it was still unusual that mothers were allowed to keep their children after a legal separation. Hedwig Dohm writes about this in her insightful study of motherhood:

> Wer von der zähen, offiziellen Erheuchlung einer Gesellschaft, deren Mund von der Heiligkeit der Mutterschaft trieft, den Schleier ziehen will, mache die Prozeßakten der Ehescheidungen zu seinem Studium. Er wird eine erschütternde Tragik erleben. Mit Entsetzen wird er wahrnehmen, wie oft man erbarmungslos einer Mutter das Kind entreißt, um es aus formalen Gründen dem Vater zuzusprechen. Und die Mutter hat sich vielleicht nichts anderes zu schulden kommen lassen, als daß sie die Gemeinschaft mit einem Gatten, der ihr tödlich zuwider war, nicht ertrug (Dohm 27).

Yet, judging from the language Demetz applies it appears that some legal procedures were probably involved: "René, der neunjährige Sohn, wurde seiner Mutter zugesprochen . . ." (Demetz 12).

Bibliography

Angelloz, J.-F. *Rilke*. Paris: Mercure de France, 1952.

Bachler, Karl. "E. Simenauer *Rainer Maria Rilke*. Bern: Haupt, 1953." *Schweizer Rundschau* no. 55 (1955/56): 279-281.

Badinter, Elisabeth. "Mother Love: Myth and Reality." *Motherhood in Modern History*. New York: Macmillan, 1981.

Bassermann, Dieter. *Der andere Rilke. Gesammelte Schriften aus dem Nachlaß*. Hermann Mörchen, ed. Bad Homburg vor der Höhe: Hermann Grentner, 1961 [1950].

Bauer, Arnold. *Rainer Maria Rilke*. New York: Fredrick Ungar, 1972.

Benn, Gottfried. *Vermischte Schriften: Das Hauptwerk*. Munich: Klett-Cotta, 1980. Vol. 4.

Beth, Marianne. "Die Stellung der Frau im Recht." M. St. Braun, E. Fürth, M. Hönig et al., eds. *Frauenbewegung, Frauenbildung, Frauenarbeit.* Wien: Bund Österreichischer Frauenvereine, 1930. 95–103.

Buddeberg, Else. *Eine innere Biographie.* Stuttgart: Metzlersche Verlagsbuchhandlung, 1955.

Butler, E.M. *Rainer Maria Rilke.* New York: Macmillan, 1941.

Chodorow, Nancy. *The Reproduction of Mothering: Psychoanalysis and the Sociology of Gender.* Berkeley and Los Angeles: University of California Press, 1978.

Demetz, Peter. *René Rilkes Prager Jahre.* Düsseldorf: Eugen Diederichs, 1953.

Dohm, Hedwig. *Die Mütter.* Berlin: S. Fischer, 1903.

Ewing, Elisabeth. *History of Children's Costume.* London: B.T. Batsford, 1977.

Giesen, Rosemarie and Gunda Schumann, eds. *An der Front des Patriarchats: Bericht vom langen Marsch durch das Prostitutionsmilieu* Bensheim: Päd.-Extra, 1980.

Glaser, Hermann. *Die Kultur der Wilhelminischen Zeit: Topographie einer Epoche.* Frankfurt/M.: S. Fischer, 1984.

Graf, Oskar Maria. "Die Besonderheit der dichterischen Erscheinung." *An manchen Tagen: Reden, Gedanken und Zeitbetrachtungen.* Frankfurt/ M.: Nest, 1961.

Graff, W.L. *Rainer Maria Rilke: Creative Anguish of the Modern Poet.* Princeton: Princeton University, 1956.

Hähnel, Klaus-Dieter. *Rainer Maria Rilke: Werk—Literaturgeschichte—Kunstanschauung.* Berlin und Weimar: Aufbau, 1984.

Hamburger, Michael. "Introduction." *Rainer Maria Rilke Poems 1912-1926.* Redding Ridge, CT: Black Swan, 1981.

Hass, R. "Introduction." S. Mitchell, ed. *The Selected Poetry of Rainer Maria Rilke.* New York: Random House, 1982.

Hatfield, Henry. *Clashing Myths in German Literature from Heine to Rilke.* Cambridge: Harvard University, 1974.

Heindl, Waltraud. "Ehebruch und Strafrecht: Zur bürgerlichen Moral in Österreich um 1900." Hanna Schnedl, ed. *Das ewige Klischee.* Wien: Böhlau, 1981. 155-178.

Hendry, J.F. *The Sacred Threshold: A Life of Rainer Maria Rilke.* Manchester: Carcanet, 1983.

Hofmannsthal, Hugo von. *Briefwechsel mit Jacob J. Burckhardt.* Frankfurt/M.: Fischer, 1957.

Humm, Maggie. *The Dictionary of Feminist Theory.* Columbus: Ohio State University Press, 1990.

Kaplan, Marion A., ed. *The Marriage Bargain: Women and Dowries in European History.* New York: Haworth, 1985.

Karasek, Hellmuth. "Elegien gegen die Angstträume des Alltags." *Der Spiegel* 35(47) (1981): 218–231.

Kassner, Rudolf. *Rainer Maria Rilke: Gesammelte Erinnerungen 1926-1956.* Klaus E. Bohnenkamp, ed. Pfullingen: Günther Neske, 1976.

Key, Ellen. *Das Jahrhundert des Kindes.* Berlin: Fischer, 1903.

Kim, Byong Ock. *Rilkes Militärschulerlebnis und das Problem des Verlorenen Sohnes.* Bonn: Bouvier, 1973.

Klages, Ilse. "Rainer Maria Rilke: Psychopathologische Studien zur Persönlichkeit." *Studium Generale* (Berlin), 1964. Vol. 17, No. 1: 628-642.

Laven, James. *Children's Fashions in the Nineteenth Century.* London: B.T. Batsford, 1951.

Leppin, Paul. "Der neunzehnjährige Rilke." *Die Literatur* 29(11) (1926/27): 630-634.

Leppmann, Wolfgang. *Rilke: Sein Leben, seine Welt, sein Werk.* Bern und München: Scherz, 1981.

Mason, C. Eudo. *Lebenshaltung und Symbolik bei Rainer Maria Rilke.* 1964.

Musil, Robert. *Tagebücher.* 2 vols. Reinbek bei Hamburg: Rowohlt, 1983.

Nevar, Elya Maria [Else Hotop]. *Freundschaft mit Rainer Maria Rilke: Begegnungen, Gespräche, Briefe und Aufzeichnungen.* Bern-Bümpliz: Albert Züst, 1946.

Plaza, Monique. "The Mother/The Same: Hatred of the Mother in Psychoanalysis." *Feminist Issues* 2(1) (1982): 75-99.

Prater, Donald. *A Ringing Glass: The Life of Rainer Maria Rilke.* Oxford University Press, 1986.

Reventlow, Franziska Gräfin zu. *Ellen Olestjerne.* München: Marchlewski, 1903.

Rich, Adrienne. *Of Woman Born: Motherhood as Experience and Institution.* New York: N.M. Norton, 1976.

Rilke, Phia [Rilke-Entz]. *Ephemeriden.* Graz: Verlag Jos. A. Kienreich, 1949.

Rilke, Rainer Maria. *Briefe.* Hrsg. vom Rilke-Archiv in Weimar. In Verbindung mit Ruth Sieber-Rilke besorgt durch Karl Altheim. Erster Band 1897-1914. Wiesbaden: Insel, 1950.

_____. *Briefe.* Zweiter Band 1914-1926. Wiesbaden: Insel, 1950.

_____. *Briefe aus den Jahren 1892 bis 1904.* Leipzig: Insel, 1939.

———. *Briefwechsel* (mit Lou Andreas-Salomé). Ernst Pfeiffer, ed. Frankfurt/M.: Insel, 1952.

———. *Briefwechsel* (mit Lou Andreas-Salomé). Mit Erläuterungen und einem Nachwort, hrsg. von Ernst Pfeiffer. Frankfurt/M.: Insel, 1973.

———. *Sämtliche Werke*. Werkausgabe [WA]. Hrsg. vom Rilke-Archiv in Verbindung mit Ruth Sieber Rilke. Besorgt durch Ernst Zinn. Vol. 1-12. Frankfurt/M.: Insel, 1976.

Schnack, Ingeborg. *Rainer Maria Rilke: Chronik seines Lebens und seines Werkes*. Frankfurt: Insel, 1975.

Schneditz, Wolfgang. "Phia Rilke und ihre "Ephemeriden." *Phia Rilke: Ephemeriden*. Graz: Jos. A. Kienreich, 1949. 61–83.

———. *Rilke und die bildende Kunst*. Graz: Jos. A. Kienreich, 1947.

Schulte, Regina. *Sperrbezirke: Tugendhaftigkeit und Prostitution in der bürgerlichen Welt*. Frankfurt/M: Athenäum, 1979.

Schwarz, Egon. *Das Verschluckte Schluchzen*. Frankfurt/M: Athenäum, 1972.

Sieber, Carl. *René Rilke: Die Jugend Rainer Maria Rilkes*. Leipzig: Insel, 1932.

Simenauer, Erich. *Rainer Maria Rilke: Legende und Mythos*. Bern: Paul Haupt, 1953.

Spitzer, Marie. "Zur bürgerlichen Rechtsstellung der Frau in Österreich." *Die Frau*. 1902/03. Vol. 10: 613–616.

Storck, Joachim W. *Rainer Maria Rilke 1875-1975*. Eine Ausstellung des Deutschen Literaturarchivs im Schiller-Nationalmuseum Marbach a.N. Stuttgart: Ernst Klett, 1975.

Valentin, Antonia. "Rainer Maria Rilke (Fragment d'ouvragea paraître)." *Les Temps Modernes* 8(83) (1952): 387–434.

Weber-Kellermann, Ingeborg. *Die deutsche Familie: Versuch einer Sozialgeschichte*. Frankfurt/M.: Suhrkamp, 1975.

Productive Tensions:
Teaching Films by German Women and Feminist Film Theory[1]

Richard W. McCormick

Much of the work done in feminist film theory over the last 15-20 years dealt with the paradoxes that characterize the relation of women to the cinematic medium. Implied in much feminist film theory of the 1970s were formidable questions facing women who wanted to make films: how well could women use a formal language developed by men and oriented toward male psychic needs? How well could women operate within a medium that had been so thoroughly controlled by male-dominated power-structures at all levels of production and distribution? How could women use a medium that, according to basic premises of much feminist film theory, was structured by their absence?

Despite these formidable questions, women filmmakers have succeeded in making more and more films. How does the film theory stand up to the evidence of so much praxis? In many ways they represent different projects—the theory more directed towards criticizing and analyzing dominant patriarchal cinema, the praxis based on a search for alternatives that are more appropriate for giving expression to the concerns and experiences of women.

Moreover, the attempt to resolve contradictions between feminist film theory and the work of women directors whose projects are also feminist is probably undesirable; such contradictions may well represent productive tensions within the overall feminist struggle. Teresa de Lauretis sees as fundamental to the feminist project the tension between the "critical negativity" of its theory and the "affirmative positivity" of its politics (*Technologies* 26). Feminist filmmaking is a form of political intervention. I would like to suggest that the tensions de Lauretis identifies are also productive for the curriculum, and can be discussed profitably when teaching films by women directors.[2] The large number of German-language films made by women directors since the mid-1970s suggests their relationship to feminist film theory.

In this essay, I will first look briefly at some political and pragmatic consequences of feminist film courses in the American university curriculum,

then comment on the historical development of filmmaking by women in West Germany from the mid-1970s to the early 1980s.[3] Then I will trace a shift in feminist film theory from the 1970s to the 1980s. Finally I will discuss some developments over the course of the 1980s in German film, and compare them to some of the above trends in feminist film theory. I hope to provide an overview and an entry-point into some of the debates—and to clarify questions revolving around feminist filmmaking and feminist film theory.

Feminism, Film, and the Politics of the Curriculum

Teaching courses dealing either with women filmmakers or with feminist film theory must be placed within the larger political context of the ascendancy of conservatism in the 1980s, in the U.S. of Reagan/Bush as well as in the West Germany of Kohl. The rise of conservatism in American higher education is epitomized by Allan Bloom's *The Closing of the American Mind*, which has provided major intellectual support for insistence on a "return" to the traditional canon of Western classics. Bloom's best-seller has in Lynne Cheney an important supporter at the head of the National Endowment for the Humanities, and has been a political force within battles over the curriculum all across the United States.

Against this background, the precarious place of courses on feminist films or film theory is clear. Bloom's book is unfriendly to feminism and for that matter to film studies as well. Otherness or difference—class, race, and perhaps most threatening, gender—is to be repressed; education is a process by which everyone, especially the "outsider" who does not want to remain "on the fringe," is to be made into a "universal, abstract being" (30–31). That this "universal" being might actually resemble white middle-class males of Northern European heritage more than other beings is an insight Mr. Bloom rejects; feminism therefore is unwelcome, and is defined as "the latest enemy of the vitality of classic texts" (65).

The "canon" of classic texts has also functioned as an instrument for enforcing "sameness" and relegating others to the fringe. It has also been shaped by the choices of educators, which have rarely been free of political pressures. The situation is further complicated in film studies, since many cultural conservatives would not consider film to be part of the "great Western canon." Film studies is to some extent still struggling to get a fixed place in the curriculum, and thus profits from a loosening or broadening of the traditional curriculum. Nonetheless, there is a "canon" of films that has been selected by film historians and critics during the twentieth century, and it has come to represent what are considered the most significant developments in the young art of the cinema.

Writing specifically about canons and film studies, Janet Staiger suggests that "escape from canon formation will be difficult to achieve. Competition in academics and the film industry reinforces canons and canon-making. . . . For even in revising and decentering dominant canons, new centers appear" (4). The political struggle over a "canon" outside and within film studies is a contradictory one that feminist educators cannot avoid, in spite of the unpleasant associations—and dangers—"canon formation" might involve. For it is a pragmatic struggle within academic institutions over the curriculum, and specifically a battle over a representation of film history. Hence the necessity of building and fighting to build a place in the curriculum for films by women. The films that educators select to teach determines students' perspective on film history. Curricular struggles always center on a "politics of representation": the question is, will the politics be effaced and the process of selection be characterized as merely a "natural" reflection of what the dominant culture considers to be "the beautiful and the true"?

German Women Filmmakers: The 1970s and Early 1980s

The "canon" of New German Cinema cannot be discussed without including films made by women in the Federal Republic of Germany since the late 1960s. The number of German women directors alone is of great significance, as Thomas Elsaesser points out: " . . . West Germany possesses proportionally more women filmmakers than any other film-producing country" (185). There is also probably no other national cinema in which so many women have had the opportunity to make films so independently of the control of commercial interests.[4]

The situation of West German women filmmakers in the late 1970s and early 1980s represented a unique opportunity for women artists, especially when compared to the situation of women not only in relation to the cinema, but to all the so-called "higher" arts. This is not to say it was easy for the women filmmakers in West Germany—on the contrary, what they achieved was the result of their own very difficult struggle on both collective and individual levels for equal access to public funding in a system that ignored them for some time. In the early 1970s, there were few women in a position to make feature-length films—Ula Stöckl had made *Neun Leben hat die Katze* (*The Cat Has 9 Lives*) in 1968, but the critics rejected it, and it would be years before she would get another chance.[5]

By 1980, however, Helke Sander, Helma Sanders-Brahms, Jutta Brückner, Margarethe von Trotta, and Ulrike Ottinger had gained international acclaim—as had the Austrian filmmaker Valie Export; these names were only some of the most prominent. The journal *Frauen und Film*,

founded by Helke Sander in 1974, was already the oldest feminist film journal in the world. The strength of the West German women's movement during the 1970s contributed to growing numbers of women working in independent cinema by the end of the decade, many of them in West Berlin. The women of that community formed the *Verband der Filmarbeiterinnen*, the Association of Women Film Workers, a network based in Berlin but extending to women film workers in West Germany as well. In 1979 the *Verband* demanded that 50% of all public subsidies for filmmaking be given to women—a goal that has not been achieved, but that set the agenda forcefully.[6]

Now, 10 years later, it is clear that while the year 1980 was full of promise for German women filmmakers, the new decade would not be a good one for them—nor for the women's movement. Nor were the 1980s kind to the New German Cinema's male directors. Of the men who once dominated that cinema, only Wim Wenders today is enjoying the same prominence and success as before, and is again making films in Germany.[7]

The films most often used in German Studies courses in the U.S. tend to be from the late 1970s and the early 1980s—a phase in which one could almost speak of a "school" of feminist filmmakers in terms of both thematic and formal similarities. This period is beginning to look like a brief, very productive historical moment. At that time, the feminist autobiographical project of the 1970s intersected with the general interrogation of German history which began in reaction to the "German autumn" of 1977. For this reason, many of these films are especially useful for German studies courses.

From that intersection there emerged some of the best personal reflections on the troubled German past, in a spectrum of cinematic style ranging from von Trotta's "feminist realism" in *Die bleierne Zeit* (*Marianne & Juliane*, 1981) to the "feminist modernism" of Sander's experimental *Der subjektive Faktor* (*The Subjective Factor*, 1981), with Sanders-Brahms's *Deutschland, bleiche Mutter* (*Germany, Pale Mother*, 1979) and Brückner's *Hungerjahre* (*Years of Hunger*, 1980) somewhere in between.[8] Among male directors, the "history films" by Fassbinder (e.g., his "BRD-Trilogie": *Maria Braun*—1979, *Lola* and *Veronika Voss*—1981) and Kluge (especially *Die Patriotin—The Female Patriot*, 1979) are comparable in their confrontation with the German past.[9] Fassbinder's gaudy yet manneristic melodramas and Kluge's witty, essayistic collage have attracted much attention, and deservedly so. However, the women's films are equally inventive, and they achieve a direct, personal confrontation with history, which I find in some ways more honest, even more political than the men's films. Certainly they are worthy of increased attention in discussions of the New German Cinema.

Many of these films are readily and inexpensively available to us.[10] For this reason, the "canon" of German films here in the American university system is a very different one than West German citizens would recognize. It is even possible that more American college students have seen *Deutschland, bleiche Mutter* by Sanders-Brahms and *Hungerjahre* by Brückner than West German viewers have. The commercially oriented tastes of the majority of those viewers characterize West German society in ways that counter-cinema, feminist or otherwise, does not.[11] The dominance of foreign films, especially American blockbusters, at the box office in West Germany is overwhelming, and indeed has rarely been challenged, especially since the early 1960s. This cannot be explained by consumer tastes alone, but also by international political and economic factors hampering the West German film industry since the 1940s (see Elsaesser 8–35, 309–23, etc.). More significantly, none of the above historical films by women or men had a great impact in West Germany. None stimulated the confrontation with the past that the American television mini-series *Holocaust* did (shown in West Germany in 1979; see e.g., Kaes 35–42; Elsaesser 271–72). Still, the less commercial, more independent cinematic reflections on German history are more useful in a German studies context, since they represent almost the only West German reflections on that history.

Not all of the women making films in the late 1970s were interested in autobiographical and historical films. Both Ulrike Ottinger and Valie Export have to be considered in terms of another artistic tradition, the broader European avant-garde in the visual arts. Renate Fischetti has suggested that Ottinger's *Bildnis einer Trinkerin (Ticket of No Return,* 1979) is a filmic example of *écriture féminine*; this not only illustrates a split between Ottinger and other German women directors, but also reflects a split between feminists who advocate an autobiographical project with a political agenda—constructing women's histories and women's identities—and those whose project is deconstruction of dominant, patriarchal systems of language and identity. Even within the group of filmmakers I have labeled as "autobiographical/historical" in the late 1970s, there are great stylistic differences, e.g., Helke Sander's affinity with the Brechtian-Godardian political avant-garde vs. Margarethe von Trotta's predominantly realist aesthetic. While these two very different filmmakers have continued making films in a biographical/ autobiographical and historical vein (e.g., von Trotta's *Rosa Luxemburg,* 1986, and Sander's *Der Beginn aller Schrecken ist Liebe—The Trouble with Love,* 1984), Sanders-Brahms and Brückner have not done so to the same extent.

On Narrative and Visual Pleasure: Feminist Film Theory from the 1970s to the 80s

Precisely such differences and divisions, however, illustrate why films by these women are useful for courses that explore feminist theory and feminist film theory. A number of issues debated in feminist film theory relate to developments in filmmaking by women. In addition to the above-mentioned conflict between the auto/biographical-historical project and deconstruction, one could include the following: premises of psychoanalytic film theory, such as the patriarchal basis of visual pleasure in the cinema, vs. the concern with female desire and the female spectator; conflicts around narrative vs. anti-narrative cinema, genre cinema vs. counter-cinema, the male avant-garde vs. feminist experimental cinema.

Much feminist film theory has analyzed the cinema as a patriarchal discourse, a system of gazes or looks controlled by men and oriented towards satisfying male desire. The many films made by women allow us to evaluate the claims of film theory. Looking at the evidence provided by the German women filmmakers, it is obvious that there is no unified feministic aesthetic, and where there are strong similarities, they seem to have grown out of a specific historical period. Thus, the answer to the question "is there a feminist aesthetic" remains "yes and no" (Bovenschen 1976, de Lauretis 1987). De Lauretis also finds something in the works of more experimental women filmmakers—she includes Export and Ottinger—that is informed by a subjectivity specific to the social position of women and by feminism as well. This is missing from the films of male avant-garde filmmakers, although men's and women's films are tacitly equated in much film theory, based as it is on the valorization of deconstructive, anti-narrative texts (*Technologies* 130–31). However, the difference is *not* solely determined by elements within the text, but is contingent on the historical and gendered position from which the director "speaks," including a familiarity with feminism, and on the specific group of spectators—women—she primarily addresses.

There has been a certain resistance, especially in work influenced by post-structuralism and/or French feminism, to any attempt to bring the actual social experience and practice of women into the theoretical discussion. But a concern for the social practice and experience of women cannot be equated with "essentialism." Indeed, I believe it the height of idealism to disregard the social—what Barbara Klinger terms "textual isolationism" (86). De Lauretis does not call for any recourse to a pre-discursive "essence," but rather for a reading of texts that situates them within the context of social practice, not merely a context consisting of other texts (*Alice* 52).[12]

What distinguishes feminism from so many other theoretical "isms" is precisely its connection to a political movement led by women and its intense concern with the social experience of women. The idea, associated with Jacques Derrida and Julia Kristeva, that modernist writing is "per se feminine" (Huyssen x), allows critics to valorize deconstructive, anti-narrative works regardless of authorship or address, and thus to reproduce still another canon of high modernist texts. In the cinema this means films by an overwhelmingly male avant-garde—and thus another mostly male canon.

Andreas Huyssen has pointed out deeper problems with the equation of the "feminine" with modernist experimental writing. The distinction between experimental and conventional writing is based upon a binary opposition between "high culture" and "mass culture." Huyssen argues that this "great divide" has actually been ideologically "gendered" in the opposite way: modernist "high culture" has most often been seen as "male" and cerebral, and mass culture has been derided as "feminine" and emotional (Huyssen 44–62). This division is thus part of a system of dichotomies that are fundamental to the bourgeois conception of the "feminine"; its simple reproduction should be suspect.

The bias towards avant-garde form in Laura Mulvey's famous 1975 essay "Visual Pleasure and Narrative Cinema" reinforces this tendency. Mulvey's position at that time was very clearly a denunciation of all cinematic strategies for viewer identification, narrative cinema, and "visual pleasure." Her essay was one of the first attempts to develop film theory from a feminist perspective, and it opened up an important dialogue among feminist critics which still continues. In that dialogue the essay has been criticized for postulating a monolithic "narrative cinema" and for its unquestioned valorization of the project of the predominantly male avant-garde (Mayne 1987, 15–16; Williams 303–04).[13] One of the first critics to raise questions about the equation of feminist filmmaking with the formalist agenda of the avant-garde was B. Ruby Rich, in her essay "In the Name of Feminist Film Criticism" (e.g., 355–57).

Mulvey has distanced herself from her original position, in part because by the mid-1980s she felt that the "avant garde was over" ("Changes" 19). Her substantive critique of the position, however, had to do with its tendency to propose an aesthetics of negation that by its dichotomous logic, remains determined by the very system it tries to negate ("Changes" 163–64). Similarly, de Lauretis writes: "The minimalist strategies of materialist avant-garde cinema . . . are predicated on, even as they work against, the (transcendental) male subject" (*Alice* 68).

De Lauretis also suggests that the task of women's cinema "may be not the destruction of narrative and narrative pleasure, but rather the construction

of another frame of reference, one in which the measure of desire is no longer just the male subject" (*Alice* 8). She devotes theoretical attention to the complex interactions of desire and narrative and their implications for female spectators and feminist cinema. A good example of the emphasis on female spectatorship in regard to German cinema can be found in Patrice Petro's excellent book on German films of the 1920s, *Joyless Streets*.[14]

Comedy, Desire, and Film in the 1980s

The ascetic avant-gardist position, refusing all visual pleasure, did not in any case become the model for much filmmaking, feminist or otherwise, in the 1980s (cf. de Lauretis, *Alice* 60). This has also been the case in West Germany during the 1980s. What we call the New German Cinema was never a particularly anti-narrative cinema, although its practitioners saw it as a counter-cinema, as a critical alternative to the commercial industries in West Germany and Hollywood. But in the 1980s, under a good deal of political and economic pressure, West German cinema has tried to survive by aiming toward a more entertaining, commercially viable narrative cinema. Ambitions for a counter-cinema have waned. One reason is the political shift to the right in 1982 when the Christian Democrats came to power. Friedrich Zimmerman, who became Minister of the Interior, a department responsible for some of the public subsidies for filmmaking, attacked the New German Cinema for its immorality and elitism. Another possible reason is the shock to the counter-cinematic aspirations of West German filmmakers that was provided by the resonance the very conventional *Holocaust* found with the West German public. *Holocaust*'s success definitely led to Edgar Reitz's response, the problematic television film *Heimat* (1984).[14]

During the 1980s, making more commercial, genre films, especially comedies, became a trend in West Germany, a development that has had its positive side. Some of the comedies have been both entertaining and progressive: Percy Adlon's *Out of Rosenheim* (*Baghdad Cafe*, 1987) and *Rosalie Goes Shopping* (1989) come to mind; Peter Timm's *Meier* (1986) might also be placed in this category. Helke Sander's film *Der Beginn aller Schrecken ist Liebe* (1984), was in some ways typical of her on-going experimentation with the fusion of personal/autobiographical and political/historical filmmaking, yet at the same time it was a comedy, although a very ironic one.[15]

The most successful comedy so far has been Doris Dörrie's *Männer* (*Men*, 1985), the most commercially successful German film since World War II. How open that film is to a "progressive" interpretation is certainly debatable (see Koch et al.). Dörrie seems to have distanced herself somewhat from the generation of feminist women filmmakers whose success made hers possible.

However, one should not be too quick to categorize Dörrie as "post-feminist" and as a "sell-out." B. Ruby Rich, in a review of woman-detective novels, discusses the loaded terms "postfeminism" and "postmodernism," which she relates to the "shift from the engaged politics of the '70s into the more mainstream modes of entertainment, romance, and upscale empowerment typical of the '80s." Connecting the woman-detective stories to this shift, she does not condemn them, but rather writes about how female detective-story writers have "finessed this shift via the sly appropriation of an overdetermined genre . . ." ("Lady Dicks" 24). Dörrie's work may need to be evaluated along such lines; however, Dörrie is not a committed political filmmaker like Helke Sander.[16]

Along with the recuperation of comedy and narrative has come a renewed interest in visual pleasure and desire. Women filmmakers of the 1980s have explored desire in the cinema in more radical ways than Dörrie's mainstream films. There is interest in the possibility of a specifically female desire in the cinema, something that seemed to have no place at all in most psychoanalytical film criticism—focused as it has usually been on the male psyche. Among the more underground or experimental filmmakers who could be mentioned in this context are Monika Treut, Elfie Mikesch, Ulrike Ottinger, and Valie Export. Jutta Brückner has published some essays on the problem of female desire and the cinema, and on the possibility of pornography for women.[17] More controversial has been Monika Treut's stance in favor of pornography by and for women. She is most interested in pornography for lesbians and is against all attempts—conservative or feminist—to censor pornography of any kind. Her films include *Verführung: Die grausame Frau* (*Seduction: The Cruel Woman*, 1984) and *Die Jungfrauenmaschine* (*The Virgin Machine*, 1988); they are certainly erotic, and they explore issues society usually considers "pornographic" (sado-masochism and a lesbian-oriented "sex industry"). But in my opinion they do not do so in a "pornographic" manner.

Treut's position represents one side of a debate in West Germany that is similar to the general "pro-sex" vs. "anti-porn" debate waged among U.S. feminists.[18] While by no means shared by all German women filmmakers, nor by feminists in general, her views are one measure of how much the debate has shifted since Mulvey's proscription of all cinematic visual pleasure in the mid-1970s. This is not to say that the directions taken by German women filmmakers in the 1980s were a direct reaction to feminist film theory. On the other hand, many filmmakers have been aware of that theory; *Frauen und Film*, for instance, began to discuss the Anglo-American theory as early as the late 1970s (Hake 33).

Austrian filmmaker Valie Export's focus on the discourse of the female body is exemplary of the more experimental work in filmmaking during the 1980s. This focus was already evident in her first film *Unsichtbare Gegner* (*Invisible Adversaries*, 1976); it is continued in her work in the 1980s, including the feature *Praxis der Liebe* (1984) and the experimental short *Syntagma* (1983).[19] Her concern is by no means related to a romanticization or essentializing of the female body, as is clear from her essay "The Real and Its Double: The Body." Her roots are in "actionism" and the Viennese avant-garde of the 1960s. She makes films that are both visually "pleasing" yet challenging, critical yet humorous: the humor often carries the critique. This is evident in her section of the film *Sieben Sünden, Sieben Frauen* (*Seven Women, Seven Sins*, 1986), a collaboration of seven women filmmakers each visualizing one of the seven "deadly" sins. Export's segment, "Wollust," or "Ein perfektes Paar, oder die Unzucht wechselt ihre Haut," examines the commodification of both the male and female body and sexual desire in consumer culture. It reflects her tendency to combine formal experimentation within a narrative framework, in my opinion a postmodernist project, to subvert as it were from within. Yet the feminist sensibility is clear.

The exploration of desire in the cinema parallels developments in feminist film theory that have included a critical revision of psychoanalytical film theory; prominent examples include work by Kaja Silverman, Teresa de Lauretis, and Gertrud Koch. In *The Acoustic Mirror*, for example, Silverman comes to a new reading of the male castration complex and its (distorting) influence on film theory (see Chapter 1, "Lost Objects and Mistaken Subjects"). Both de Lauretis and Koch critique the value of poststructuralist readings of psychoanalysis for feminist film theory. Koch's work is also rooted in the West German feminist film theory debate. With co-editor Heide Schlüpmann, Koch has defined the course of *Frauen und Film* since the early 1980s, during which time it has become the major German theoretical journal engaged in a critical dialogue with Anglo-American feminist film theory.[20]

The various debates among critics and filmmakers in the 1980s provide evidence that feminism is a vital, ongoing discursive process involving many voices. The issues at stake in this discussion are extremely significant: the cinematic representation of female experience and female sexuality, questions of female desire and spectatorship, narrative vs. anti-narrative strategies, and the creation of a "new frame of reference" for desire in the cinema—one in which women filmmakers will play an important role.

The women filmmakers from the German-speaking nations compose no monolithic group, nor do their films comprise a unified body of texts. Yet this group of films represents something unique in both film history and the history of women's art. To be analyzed, these texts need to be placed in various

contexts: the German-speaking cultures and the historical context of their origin, the context of film studies, and, most importantly, the context of feminism and feminist film theory. However, they are not merely passive objects to be analyzed but active contributions to a feminist dialogue that also includes the critical production of feminists working in film theory.

Notes

[1] This essay is an expanded and revised version of a talk given at a workshop sponsored by the DAAD with filmmaker Valie Export, "Teaching Women's Films and Feminist Film Theory in German Studies," U. Minnesota, Twin Cities, November, 1988.

[2] For some practical suggestions on teaching German film from feminist perspectives, see Linda Worley, ed., *frauen/film*, a compilation of syllabi and course materials prepared for the Coalition of Women in German (1989). Forthcoming from Berg Publishers is a volume of feminist essays on German cinema, Frieden, et al., eds., *Feminist Interventions: Gender Perspectives in German Cinema*.

[3] For the situation in the GDR, see Gisela Bahr's "Film and Consciousness: The Depiction of Women in East German Movies." GDR director Helke Misselwitz's *Winter Adé* (1989) is an impressive documentary on women's lives in East Germany, a film that even seems in some ways to have anticipated the changes that would come to that nation in the fall of 1989.

[4] According to Sandra Frieden, the independence of West German women directors from industry control has been a major difference between their situation and that of French women filmmakers. In the U.S. the situation has been much harder for women filmmakers, whether inside or outside the commercial film industry.

[5] On Ula Stöckl, see Möhrmann; Silberman, "Ula Stöckl," "Cinefeminists," and Interview. On *Neun Leben hat die Katze* specifically, see Roswitha Mueller, "Images in Balance," which discusses it and von Trotta's *Schwestern* (*Sisters,* 1979), forthcoming in *Feminist Interventions*. On the history of women filmmakers in West Germany, see e.g., Lenssen; Möhrmann, *Die Frau mit der Kamera*; Silberman (all articles); and the *Jump Cut* special sections in Nos. 27 (1982) and 29 (1984).

[6] On the *Verband der Filmarbeiterinnen,* see Möhrmann, *Die Frau mit der Kamera*. Their original 1979 manifesto appears in translation as "The Manifesto of Women Filmmakers" in Rentschler, p. 5.

[7] According to documentary filmmaker Helga Reidemeister, Wenders acknowledged the influence of German women directors on his work in the 1980s. Formal influence seems evident in *Himmel über Berlin* (*Wings of Desire*), for example, but the film remains problematic from a feminist point of view.

[8] B. Ruby Rich mentions films by von Trotta and Marta Meszaros as examples of "a new feminist cinema of 'corrective realism'" ("In the Name" 354). She uses the term "feminist modernism" for Sander's work in her discussion of Sander's *REDUPERS* (1977) ("She Says, He Says" 45).

[9] *Deutschland im Herbst* (*Germany in Autumn*, 1978) was the collective response of an almost exclusively male group of West German filmmakers to the events of Autumn 1977, an attempt to explore the contradictions and historical context of that polarized moment in recent German history; this was the immediate impetus for Kluge's and Fassbinder's "history films," and those of other directors as well. On the topic of the history film, see Anton Kaes's *Deutschlandbilder: Die Wiederkehr der Geschichte in Film* (in English translation: *From Hitler to Heimat*).

[10] West Glen Films distributes many films basically free of charge for the Embassy of the Federal Republic of Germany. To request catalogue and information and/or order films: West Glen Films, ATTN: German Feature Films, 1430 Broadway, New York, NY 10018. Tel: (212) 921-2800.

[11] *Dallas* has been much more popular in Germany—East as well as West—than any German counter-cinema.

[12] "Essentialism" is a concept that, as Jane Gallop suggested at MMLA in 1988, is used now mostly to denounce other feminists' positions; no one ever seems to assert such a position. The attempt to define an essential "femininity" is a dangerous one, since often it reproduces patriarchal conceptions of the feminine.

[13] Besides these two excellent overviews of developments in feminist film theory by Judith Mayne, I am indebted to Andrea Staskowski's "Is Feminist Film Theory a Theory of Women's Cinema?"

[14] For an introduction to the critical controversy about Reitz's film, see *New German Critique*, No. 35 (1985).

[15] Sander's latest film, *Die Deutschen und ihre Männer* (*The Germans and Their Men*, 1989) is a return to the experimental political documentary with which her career started. It is often quite funny, but it is not a comedy, rather a resolutely political film with a clear feminist agenda. A fictional character carries on documentary interviews with West German men, many of them politicians in Bonn, and discovers that while most can problematize their national identity, hardly any can problematize their gender identity.

[16] Dörrie remains problematic. Her comedy *Ich und Er* (*Him and Me*, 1988), filmed in New York with an American cast, seems such a sexist male fantasy that it is hard to imagine a woman made it. On the other hand, *Geld* (*Money*, 1989) is a comedy that arguably demonstrates some feminist consciousness, and it actually contains some female bonding.

[17] In the article "Ich sehe was, was du nicht siehst," Renate Möhrmann discusses Brückner's essay on Saura's *Carmen* as exemplary of the overall shift in attitudes with regard to visual pleasure on the part of women filmmakers and critics in West Germany.

[18] See the special section on this debate in *Spiegel*, No. 44, 1988: 254–74, which begins with the article "Die erotische Gegenkultur muß her."

[19] These three films—plus *Menschenfrauen* (1980)—by Export are now available on film from Foreign Images, 1213 Maple, Evanston, IL 60202, and on video from Facets Multimedia, 1517 W. Fullerton, Chicago, IL 60614.

[20] A volume of Koch's essays in the original German has appeared: "*Was ich erbeute, sind Bilder.*" On the early history of the journal *Frauen und Film,* see Möhrmann, *Die Frau mit der Kamera*; Silberman, "frauen und film." More recent overviews of its history that take into account its theoretical direction during the 1980s include Sabine Hake's "Focusing the Gaze: The Critical Project of *Frauen und Film*" and Ramona Curry's "Yet Another Ten Years After: A Decade of *Frauen und Film.*"

Works Cited

Bahr, Gisela. "Film and Consciousness: The Depiction of Women in East German Movies." Frieden, et al.

Bloom, Allan. *The Closing of the American Mind.* New York: Simon & Schuster, 1987.

Bovenschen, Silvia. "Über die Frage: Gibt es eine 'weibliche' Aesthetik?" *Ästhetik und Kommunikation* 25 (September 1976). 60–76.

Brückner, Jutta. "Carmen und die Macht der Gefühle." *Ästhetik & Kommunikation* 53/54 (1983): 227–32.

———. "Sexualität als Arbeit im Pornofilm." *Der Sexuelle Körper. Ausgeträumt?* Thomas Ziehe, Eberhard Knödler-Bunte, eds. Berlin: Ästhetik & Kommunikation, 1984.

Curry, Ramona. "Yet Another Ten Years After: A Decade of *Frauen und Film.*" Frieden, et al.

de Lauretis, Teresa. *Alice Doesn't: Feminism, Semiotics, Cinema.* Bloomington: Indiana UP, 1984.

———. *Technologies of Gender: Essays on Theory, Film, and Fiction.* Bloomington: Indiana UP, 1987.

Elsaesser, Thomas. *New German Cinema: A History.* New Brunswick, NJ: Rutgers UP, 1989.

"Die erotische Gegenkultur muß her." *Der Spiegel* no. 44 (1988): 254–74.

Export, Valie. "The Real and Its Double: The Body." *Discourse* 11.1 (1988–1989): 3–27.

Fischetti, Renate. "*Écriture Féminine* in the New German Cinema: Ulrike Ottinger's *Portrait of a Woman Drinker.*" *Women in German Yearbook,* 4 (1988): 47–67.

"frauen und film." Editorial excerpts trans. by Marc Silberman. *Jump Cut* 29 (1984): 50.

Frieden, Sandra. "Contemporary French and German Women Filmmakers: Cross-Currents?" Unpublished paper, presented at MLA, New York, Dec. 1986.

Frieden, Sandra, Richard McCormick, Vibeke Petersen, and Melissa Vogelsang, eds. *Feminist Interventions: Gender Perspectives in German Cinema* (working title). Forthcoming from Berg Publishers, Providence, RI.

Hake, Sabine. "Focusing the Gaze: The Critical Project of *Frauen und Film*." *Women in German Yearbook* 5 (1989): 19-39.

Huyssen, Andreas. *After the Great Divide: Modernism, Mass Culture, Postmodernism.* Bloomington: Indiana UP, 1986.

Kaes, Anton. *Deutschlandbilder: Die Wiederkehr der Geschichte in Film.* München: edition text & kritik, 1987. (In English translation: *From Hitler to Heimat.* Cambridge: Harvard UP, 1989.)

Klinger, Barbara. "'Cinema/Ideology/Criticism' Revisited: The Progressive Genre." Barry Keith Grant, ed. *Film Genre Reader.* Austin: U. Texas Press, 1986. 74-90.

Koch, Gertrud. "Exchanging the Gaze: Re-Visioning Feminist Film Theory." *New German Critique* 34 (1985): 139-53.

_____. "*Was ich erbeute, sind Bilder.*" *Zum Diskurs der Geschlechter im Film.* Basil: Stroemfeld/Roter Stern, 1989.

_____, et al. "Bei neuestem Licht besehen. Ein Streitgespräch über *Männer* und *Tarot.*" *frauen & film* 41 (1986): 84-89.

Lenssen, Claudia. "Women's Cinema in Germany." *Jump Cut* 29 (1984): 49-50.

Mayne, Judith. "Feminist Film Theory and Criticism." *Signs* 11.1 (1985): 81-100.

_____. "Feminist Film Theory and Women at the Movies." *Profession 87* (1987): 14-19.

Möhrmann, Renate. "Ich sehe was, was du nicht siehst. Überlegungen zu den Darstellungs- und Wahrnehmungsformen weiblicher Kinofiguren im westdeutschen Frauenfilm." Conference paper, Austin, Texas, May 1983.

_____. *Die Frau mit der Kamera. Filmemacherinnen in der Bundesrepublik Deutschland. Situationen, Perspektiven. Zehn exemplarische Lebensläufe.* München: Hanser, 1980.

Mueller, Roswitha. "Images in Balance." *Gender Perspectives in German Cinema.* Frieden, et al.

Mulvey, Laura. "Changes." *Visual and Other Pleasures.* Laura Mulvey, ed. Bloomington: Indiana UP, 1989. 159-76.

_____. "Visual Pleasure and Narrative Cinema." In *Visual and Other Pleasures.* 14-26.

Petro, Patrice. *Joyless Streets: Women and Melodramatic Presentation in Weimar Germany.* Princeton: Princeton UP, 1989.

Rentschler, Eric. *West German Filmmakers on Film: Visions and Voices.* New York: Holmes & Meier, 1988.

Rich, B. Ruby. "In the Name of Feminist Film Criticism." First versions 1979, 1980. Latest version: Bill Nichols, ed. *Movies & Methods*. Vol. 2. Berkeley: U. California Press, 1985. 340–58.

———. "The Lady Dicks: Genre Benders Take the Case." *Voice Literary Supplement* (June 1989): 24–26.

———. "She Says, He Says: The Power of the Narrative in Modernist Film Politics." *Discourse* No. 6 (1983): 31–46.

Silberman, Marc. "Cine-Feminists in West Berlin." *Quarterly Review of Film Studies* 5 (1980): 217–30.

———. "From the Outside Moving In." Introduction to Special Section: "Film and Feminism in Germany Today." *Jump Cut* 27 (1982): 41–42.

———. Interview with Ula Stöckl. *Jump Cut* 29 (1984): 55.

———. "Ula Stöckl: Now Women See Themselves." *New German Filmmakers*. Klaus Phillips, ed. New York: Ungar, 1984.

———. "Women Filmmakers in West Germany: A Catalog." *Camera Obscura* 6 (1980): 124–52.

Silverman, Kaja. *The Acoustic Mirror: The Female Voice in Psychoanalysis and Cinema*. Bloomington: Indiana UP, 1988.

Staiger, Janet. "The Politics of Film Canons." *Cinema Journal* 24.3 (1985): 4–23.

Staskowski, Andrea. "Is Feminist Film Theory a Theory of Women's Cinema?" Unpublished paper given at "A Workshop with Valie Export: Teaching Women's Films and Feminist Film Theory in German Studies," U. Minnesota, Twin Cities, November, 1988.

Williams, Linda. "'Something Else Besides a Mother': *Stella Dallas* and the Maternal Melodrama." Christine Gledhill, ed. *Home is Where the Heart Is: Studies in Melodrama and the Woman's Film*. London: BFI Publishing, 1987. 299–325.

Worley, Linda Kraus, ed. *frauen/film: new approaches to teaching film*. Lexington, KY: Coalition of Women in German, 1989.

Women in the GDR: Will Renewal Pass Them By?

Hildegard Maria Nickel

In the past, work has been not just a duty in the GDR, but also a right. Despite all the problems it entailed, that right gave women a certain social protection, maybe no dolce vita, but a least a chunk of financial independence, legal autonomy, and a chance to make their own demands on life. In 1989, 91% of women of working age were involved either in paid employment or else in study or training. Women in the GDR took it for granted that they could learn a trade, pursue a career, and hold down a secure job. That was a part of their identity.

Rationalization, postponed for far too long and now well overdue, has claimed its first victims in the GDR. There are no retraining programs or social strategies to deal with the situation, as if nobody foresaw that what has happened elsewhere would ever happen here. There is widespread fear of the market economy, especially among women. How many will keep their jobs, and how secure will those jobs be? In recent years, 30% of babies in the GDR were born to single mothers. 50,000 marriages ended in divorce each year. How are the multitudes of single mothers to earn their bread in the future? Up to now they have been able to count on getting a childcare place. 94% of children aged 3 and over were cared for this way. Companies have begun to go on crash diets, and they are cutting back. The first company kindergartens have closed down.

One thing is certain: as we take off into the market economy, conditions for women are tougher than for most men.

Patriarchal Egalitarianism, Not Social Equality

About half the labor force in the GDR is still female. Formal gaps between men and women in levels of occupation skill had gradually narrowed. For those under 40, the gap had virtually disappeared. In 1988, 82% of working women had completed some kind of job training. Before November 1989, this was presented by politicians and ideologues, in the media and in official statements, as evidence that equal rights had been achieved in the GDR. In fact, a lot of women were so convinced by the mythology of equal

rights that they were blind to the very real disadvantages that beset them in daily life and that will continue to handicap them as they seek to start anew. It was taboo, particularly from the early seventies, to suggest that formal equality by no means erased the social inequalities between the two genders, or that new kinds of discrimination and disadvantages were created by social policies based top-heavily on reconciling motherhood (rather than parenthood) with employment. It was mainly women who were supposed to perform the work of reproduction and servicing in both society at large and the family.

An Opportunity Shared Is an Opportunity Halved

By the end of the sixties at the latest, economic and occupational structure in the GDR was polarizing according to gender. Women were over-represented in the social services (91.8%), in the health services (83%), in education (77%), in commerce (72%), and in postal jobs and telecommunications (68.9%). They were under-represented in industry, craft trades, construction, agriculture and forestry, and transportation. Women occupied barely a third of all management positions, although this fluctuated greatly from one sector to the next, and the proportion diminishes rapidly with rank. We can see how precarious the situation is when we consider that 60%—almost two-thirds—of the girls who left school in 1987 were channeled into 16 out of 259 available non-college training options.[1] Jobs that are more or less exclusively entered by girls include keyboard or data entry specialist,[2] shop assistant (the training involves a specialization), sales and finance clerk, and skilled textile worker. The same applies to jobs requiring college training, such as nursery and primary school teacher, nurse, and paramedical technician. There is one common denominator to all these jobs: they are the worst paid.

Might this segmentation of the labor market turn out to be a "home advantage" for women? The service sector is likely to expand. Over two-thirds of managerial positions in commerce are held by women. Will they be strong and astute enough to assert themselves? Restructuring means taking risks, reacting fast, seizing chances, and competing for the front seats. A widespread reaction was a kind of rabbit syndrome—rigid paralysis in the face of the unknown viper—that rendered many women incapable of action. That very quickly gives the initiative to those men who have long since recognized the new openings offered by the service sector.

It pays better to work in industry, where women account for 40% of the work force. When girls take up training in this sphere, they usually concentrate on a few branches, such as textiles and clothing, or certain areas of the electronic and electrotechnical industry that value women's sensitive,

nimble fingers. Since 1975, in the wake of conservative social policy, there has been a downward trend in jobs for girls at the *heart* of technology design and control: maintenance engineer for data processing and office equipment (from 30.1% down to 18.4%), electrical engineer (7.9% to 3.9%), automation control technician (25.9% to 8.4%).[3] Meanwhile, women have been a growing force on the *periphery* and on the finishing lines of manufacturing: chip production, data processing (currently 71.2%), chemical production (82.1%). Women have had the unattractive jobs in industry. Even when they operate the most up-to-date machines, as in the textile industry, they are often assigned to jobs that isolate them from communication with others. They are also exposed to poorer labor hygiene. Their occupations allegedly call for fewer skills and are therefore rewarded in industry with lower income.

For a number of years, training schemes have been subjected to quotas: women were systematically excluded from male occupations and men from female ones. Girls' career choices were narrowed for the most part to traditional women's work. Often, a girl was obliged to accept "contingency options" or "transitional solutions." In other words, she would train for an occupation knowing that she would not pursue it once she qualified or, at the latest, after her first baby. Company managers consistently reduced the proportion of female trainees in technical jobs crucial to the future to allow in more male applicants. As reasons they identified greater absenteeism among women due to social policy, such as secure maternity leave, mothers looking after sick children, etc.; high rates of fluctuation among female employees; lack of interest in technical matters on the part of girls; and inadequate social and sanitary facilities in male domains.[4]

A Job Is Just One Side of the Female Coin

Employment outside the home is one side of the coin; housework is the other, and that is still women's business. Even though households have progressively acquired more technical appliances and an extra-domestic service sector has grown, the time and energy devoted to housework has hardly changed over the last 25 years. In the average family, it is about 10 hours a week. That amounts to a second shift. Three-quarters of housework has been done for the most part by mothers with jobs of their own that kept them outside the home for 40 to 43.75 hours per week. Women were responsible for the family atmosphere, something that cannot be measured in units of time. Women perform countless little unpaid labors of love to make family routine function smoothly. Individual strategies have been necessary to compensate for poor consumer supplies: sewing, knitting, shopping, standing in line, improvising, and cultivating relationships based on reciprocal benefit. Men, on the other hand, have been the main family breadwinners, earning 25-

30% more than women. This division of labor has consequences for the next generation.

A good quarter of working women have held part-time jobs, but the demand for a shorter work week and more flexible hours was actually much higher. Inge Lange, who was in charge of women's policies in the old power apparatus, believed she could handle the problem administratively. Part-time work was permitted only in exceptional cases, and in many occupations not at all. For decades Inge Lange saw it as her task to help "the next generation of young women to realize that the manner and mode of their employment and their lives as mothers pertains under fundamentally better conditions than in the case of previous generations of women, and that part-time work by women not only diminishes society's labor asset but also exerts a negative influence on their career prospects."[5] Equality thus degenerated into a series of slogans. The criterion was formal equality within standard work shifts, and the yardstick was the male time schedule, purged of domestic ballast. In propaganda terms it was a success, but in their day-to-day lives most women experienced a yawning gap between propaganda and reality. They discovered—physically and through the disintegration of the family—just who had to bear the burden for this formal equality decreed from above. It was an equality that stretched women to the limits, and yet did not touch men or move them to relinquish their traditional privileges. Instead of rebelling, women paid the price for their exclusion from key decision-making processes both at work and in politics. They left the hubs of power, labor organization, and science to the menfolk and settled for the periphery. Sociological studies have shown just how vulnerable the periphery is to rationalization[6] and how rapidly men can expel women from any periphery that subsequently is transformed into a hub.[7]

Even before the political changes began, the Sociology Institute at Berlin's Humboldt University had published new research on the introduction of modern information and communication technology among office workers. Areas with a predominance of female labor, such as insurance, commerce, and industrial administration, were compared with essentially male domains of production and construction. The inquiries showed that, although the social effects of the new technology varied according to social categories based on occupation and level of skill, there was no sign of an end to the division of labor between the sexes.[8] In fact, new hierarchies were developing quietly—hierarchies that left women in the back seat again.

For years, there were stumbling blocks to the development of a critical awareness of these problems. For one thing, they were taboo, and for another, they were effaced by rosy statistics. This delayed awareness applied above all to women themselves, particularly because they are permanently

exposed to the tremendous stress of a double burden. The trade union has not been a force likely to help women analyze their situation and develop counter-strategies. In those areas addressed by the research, for example, there was clearly an urgent need to encourage greater participation in automation processes in order to free new potential for shaping society. This would mean enabling those concerned to recognize, articulate, and defend their own interests and engage in the appropriate conflicts. However, new democratic structures have yet to take shape and to prove their worth, so that the universal trend is to cling to old, "tried and tested" structures.

Women must learn again to take matters into their own hands and act assertively. They have been numbed by a centralized planned economy and a company policy of pseudo-democracy that functioned over the heads and behind the backs of the workers, and ignored women's concerns altogether. Ultimately, many of them accepted that decisions came from above and had to be accepted. But women felt ambivalent toward the slogan "Uns wurde es gesagt und wir müssen uns damit abfinden." On the one hand, it was functional, because in a way it suited women's circumstances, saving them from having to develop too much commitment and responsibility at the workplace. And yet, on the other hand, they felt excluded from decisions that concerned them and to which they could have made a valuable contribution. All the more reason to place hope in the East German's women's movement, but it is still in its infancy and must find ways to reach these women.

Practicing Gender Roles: Socialization

Almost as if there were some "secret syllabus," spontaneous everyday experience trains girls and boys quite casually in the structures of the prevailing division of labor, teaching them to accept these as "natural."[9] Schools are co-educational, with girls and boys studying the same curriculum, often for more than ten years. Most of them went to nursery school, even day care, before starting school. Sociological investigations conducted over the past few years show that these formally equal conditions did not erode gender differences, but actually consolidated them in particular respects, and were experienced by the boys and girls differently. Girls, for example, did not on the average receive worse marks in mathematics and natural sciences than boys. In fact, their marks were often better. And yet they distrusted their abilities in these spheres, regarding boys as more naturally gifted. In computer courses, girls perceive boys to be "better" and "faster." Typically, at the first sign of difficulty, girls voluntarily relinquish the already inadequate places, leaving the boys to delve deeper into programming and technology and to master them. Why are the girls so quick to retreat? Why are they so ready to accept the terrain as a male preserve without resisting? The reasons are

complicated. One, however, is that girls discover early and repeatedly that they can get by in life without these skills. And the girls know almost instinctively that they do not exactly improve their chances on the sex market if they display too much ambition in technical fields. It does not make them more desirable and attractive to the sex that still holds the power of definition, the men. The two-way traffic in desirability and the latent sexuality in relationships between the genders seem to exert a fundamental influence on attitudes to achievement and formation of interests and skills. That would be one way to explain why girls perform less well at school as they get older, while boys improve.

Boys and girls start school with different experiences behind them, and so they are already socially different. Any approach to education that abstractly ignores these differences will inevitably strengthen them rather than ironing them out. Co-education calls for back-up measures, especially for girls, who must defend themselves against once again becoming society's underdogs.

Since the late sixties we have had no social strategies that consciously question traditional gender relations, notably in education policy. As a result, much was left to run its own course in public education. The wording and illustration of textbooks and syllabi are an eloquent expression of this. The imparting of gender stereotypes and traditional male/female clichés begins already in nursery school. No attempt has been made to encourage sensitivity to these processes and their consequences, let alone develop a critical awareness of them. This can only change through discourse, the kind of open public discussion that first began in autumn 1989. There is a need for a feminist sociology and for women's research that will transcend the limitations of traditional GDR research on women.

Women's Studies, Not Studies of Women

Why have traditional studies of women run up against limitations? Because

- women have been looked at *functionally,* and thus one-sidedly. They were reduced to their economic, biological, and/or political function. Women were not interesting as subjects in the full complexity of their concrete circumstances, but as members of the labor force, political office-holders, managers, childbearers, and/or mothers;

- the aim in "objective," i.e., androcentric, analyses was to consider the "optimum" distribution of women among skill categories, occupations, or positions of leadership, often with the view that women were tackling one thing "quite nicely" but still had to learn something else. Consciously or not, the yardstick was always male. From this point of view, much research was concerned with *deficiency* rather than *difference,* focusing on deficiencies "still" displayed by women (as compared to men), which they would have to overcome in order to achieve "higher," usually economic, goals, in most cases by working harder and exerting themselves more. Less attention was devoted to social deficiencies and objective inequalities in the available resources, such as money, time, social, and cultural opportunity;

- this traditional research on women was *committed* not so much to women as to the dominant ideology and apparatus. There was no independent women's movement behind it, but there was the Women's Department of the SED Central Committee breathing down its neck. It was expected to *legitimate* policy, and thereby contributed to the growth of myths about equality marching triumphantly ahead in the GDR and helped place taboos on discussing the real conditions under which women were living. As a result, it bears part of the blame for the atrophy of women's consciousness and for the society's growing insensitivity to gender issues;

- gender was reduced to a statistical category rather than analyzed as a structural factor. The gender gap was trivialized as a *subcontradiction* in a world of primary contradictions.

To overcome these limitations, women's studies must:

- make women visible as subjects, both in history and in the present. They are half the human race!

- evaluate the work that has been conducted in this field *internationally* for more than a decade to discover where it is useful for us. International women's studies have generated some important theoretical foundations and also a different perspective on the context of social reproduction. They have set in motion a debate about the concept of work, criteria for efficiency, and the interaction between private, individual chores, and productive labor that has just begun in our country. It is necessary to address the value of work, both the paid variety and the personal, but it is also

necessary to prevent women from being forced back into their homes and kitchens by a "tacit" re-evaluation of values;

- understand that gender is a *structural factor*. That is the only way to grasp the ambiguity of gender (R. Becker-Schmidt), i.e., the organization of gender relations as a structural phenomenon on the one hand and the subjective establishment of gender stereotypes in the individual on the other;

- make the discussion about *patriarchy* productive. In other words, we need to find out why the world is still organized around two gender categories (cf. Carole Hageman-White). We must also explain how and why power structures are mediated through the relationship between the sexes;

- conduct a debate about *androcentrism* from the methodological perspective and ask how male the foundations of our scientific disciplines are.

This program cannot be carried out *ad hoc,* and it is bound to meet with resistance. But women's studies are on their way, I am sure. The women's movement in our country will make sure of that.

Notes

[1] "Studie zur beruflichen Orientierung der Mädchen und Frauen" (Berlin: Zentralinstitut für Berufsbildung, 1989).

[2] The official job designation is usually male, even in predominantly female occupations.

[3] "Studie zur beruflichen Orientierung der Mädchen und Frauen" (Berlin: Zentralinstitut für Berufsbildung, 1989).

[4] "Studie zur beruflichen Orientierung der Mädchen und Frauen" (Berlin: Zentralinstitut für Berufsbildung, 1989).

[5] Inge Lange, "Frauenpolitik der SED in Verwirklichung der Beschlüsse des XI. Parteitages," Inge Lange, ed., *Die Frauen—aktive Mitgestalterinnen des Sozialismus: Ausgewahlte Reden* (Berlin, 1987): 500.

[6] C. Unterkirchner and I. Wagner, eds. "Die andere Hälfte der Gesellschaft," Österreichischer Soziologentag, 1985 (Vienna, 1987).

[7] U. Hoffman, *Computerfrauen* (Munich, 1987).

[8] Research reports: "Die soziale Realität der Einführung neuer Technologien—Vier Fallstudien aus Berliner Betrieben" (Berlin: Humboldt University, Institut für Soziologie, 1988); "Computerisierung der Büros," (Berlin: Humboldt University, Institut für Soziologie, 1989).

[9] H.M. Nickel, "Geschlechterziehung und Arbeitsteilung," *Weimarer Beiträge* 4 (1988). Cf. also readers' views on the subject of "My Dream Partner," in the newspaper *Junge Welt* (1989).

Feminist Germanistik after Unification
A Postscript from the Editors

In our postscript for Volume 5 of the Yearbook, we struggled with the question of theory and its role in feminist teaching and research. Now, looking back over all that has happened in the past year, we—like everyone else—are astonished by the sudden transformation in the GDR. Our discussion of the role of feminist theory in the academy seems dwarfed by the challenges presented to feminist *Germanistik* by German unification. The very pace of change and the tumult of *die Wende* have made it difficult to assess what the changes mean for our work as feminist teachers and scholars. As we write this, unification day is only weeks away. What can we say that might still be relevant six months from now?

At the outset we want to express our own ambivalence at the enormous gains and losses incurred by the dissolution of the GDR. We have gone from anticipation and pride at the visible role women played in the initiation of political events—the courage of Bärbel Bohley, for example, and the eloquent tenacity of Christa Wolf—to disappointment at patriarchal politics as usual, with women playing prescribed roles inside the structure. Those who inspired the movement toward democratic reforms have been relegated to the margins of mainstream politics. In addition, as Hildegard Nickel points out in her essay, unification threatens rights and advantages that East German women have enjoyed: unhampered access to abortion, child care, the undisputed right to work, generous maternity leaves. The prospect of "one breadwinner families" and the reestablishment of conservative social patterns is disheartening. The strength of conservative politics in both Germanys suggests the absolute necessity of concrete political engagement by feminists. At the same time, we need to acknowledge the necessity for feminist politics to confront the disadvantages of GDR socialism for women—not only the persistence of stereotyped roles and the double burden, but also the *Entmündigung* of GDR citizens, which in the case of women perniciously reinforced traditional patriarchal behaviors, despite the GDR's ostensible intent to liberate women from such social patterns.

Certainly, the independent women's movement in the GDR represents a crucial step. We want to express our solidarity with East German women as they begin to find their own feminist voices. We hope that their struggle

against conservative policies will inspire us in Women in German to renew and strengthen our commitment to feminist politics, and to a feminist scholarship that does not exploit women less privileged than we. What can, or should, the role of American, West German, and other Western scholars be in articulating a feminist analysis of changes wrought by unification, for example, or in promoting the emergence of women's studies from the perspective of East German feminists? However we decide to answer such questions, we believe we must respect the uniqueness of the East German feminist project, and find ways to support it even after unification may appear to have obliterated differences.

Unification also forces us to reexamine our role as feminist teachers of GDR literature. Regardless of where we locate ourselves on the political spectrum, *die Wende* cannot help but have an impact on our teaching of the GDR women writers who have nourished us for years. For many of us, the works of Irmtraud Morgner, Christa Wolf, Helga Schütz, Christine Wolter, Brigitte Reimann, and Helga Königsdorf, to name just a few, were a primary source of information about GDR women's attitudes toward GDR policy and daily life. These writers' insights complemented our own; we felt a kinship with them and their sense of what values are necessary for a livable world. Their critique of the GDR and of the capitalist West, grounded in utopian socialism, allowed us and our students to discuss feminist values within a framework different from the one we inherit traditionally in the United States. With the rejection of the East German regime has come an undifferentiated discrediting of socialism and an ambiguous status for artists and intellectuals who espoused a "third alternative." We must now find ways to teach East German women's literature in a new context and to articulate why our commitment to the values we found expressed in that literature has not weakened.

To do this, we will have to face some difficult issues, not least the question of our own self-interest and compromises we may have made because of it. Debate about the extent to which literature critical of the GDR also helped to legitimate the system, particularly in the eyes of those outside of East Germany, cannot fail to touch us as well. We are likely to find ourselves reading our own lectures notes or articles "against the grain," to discover how our approaches to teaching and interpreting GDR literature may have participated in that paradox of simultaneous critique and legitimation, and to determine which approaches we can use now. The altered political situation forces us to reassess our positions as feminist Germanists, a task that may seem formidable but can also be viewed as an opportunity for growth. We are optimistic that WIG members will have the energy and creativity to formulate new orientations for teaching and research that address the complexities of feminist *Germanistik* after unification. We hope that the WIG

Yearbook will play an important role in this process, and we want to encourage members to submit articles sharing their insights on this crucial issue.

<div style="text-align: right;">
Helen Cafferty

Jeanette Clausen

September 1990
</div>

ABOUT THE AUTHORS

Helen L. Cafferty is William R. Kenan, jr. Professor of German and Humanities at Bowdoin College.

Jeanette Clausen is an associate professor of German and Director of Graduate Liberal Studies at Indiana University-Purdue University, Fort Wayne.

Dagmar C. G. Lorenz, born in Goslar, West Germany, in 1948, studied Germanistik and Anglistik at the University of Göttingen. She received her MA in German from the University of Cincinnati in 1970, her PhD in 1974, and her MA in English in 1975. She is Professor of German and member of the Executive Board of the Melton Center for Jewish Studies at the Ohio State University. She specializes in modern German and Austrian literature, particularly Jewish German Literature, Holocaust literature, and women's literature. Her publications include *Martin Luther: Vom ehelichen Leben und andere Schriften über die Ehe* (1978), *Ilse Aichinger* (1981), *Franz Grillparzer—Dichter des sozialen Konflikts* (1986), and numerous articles and book chapters. Her current research project is a book on Holocaust discourses in German: "Verfolgung und Massenmord: Aus der Sicht der Verfolgten."

Richard W. McCormick is the author of *Politics of the Self: Literature, Film, and the Postmodern in West Germany,* and a co-editor of *Feminist Interventions: Gender Perspectives in German Cinema* (working title), both forthcoming. He teaches courses on film and literature in the German Department at the University of Minnesota.

Elaine Martin, Assistant Professor of German and Women Studies at the University of Alabama, has edited a forthcoming collection of essays on women's writings on the Nazi era and has written articles on the female quest, women and madness in literature, and memory and autobiography. Her current project is a book based on interviews with women who have written autobiographically about the Nazi era.

Hildegard Maria Nickel, born in 1948, studied Humanities and Sociology, with specializations in family sociology and gender socialization. Since 1987 she has been a lecturer in the Institute for Sociology at Humboldt University, Berlin, also serving as Acting Director of the Institute. Her research interests include new technologies and the gender-based division of labor, and the future of employed women.

Tineke Ritmeester teaches Women's Studies and International Studies at the University of Minnesota, Duluth. She is currently working on a book entitled *The Heterosexualization of Rilke* and on the compilation of an anthology called *Feminist Perspectives on Rilke.*

Sabine Wilke is an assistant professor of German at the University of Washington where she teaches courses on critical theory and contemporary literature. She currently holds an NEH Fellowship for her book on myth in contemporary German culture. Her essays on critical theory and contemporary authors have appeared in *MLN, The German Quarterly, German Studies Review, Telos, boundary 2,* and others. She has collaborated on the translation of Manfred Frank, *What is Neostructuralism?* (Minnesota).

NOTICE TO CONTRIBUTORS

The *Women in German Yearbook* is a refereed journal. Its publication is supported by the Coalition of Women in German.

Contributions to the *Women in German Yearbook* are welcome at any time. The editors are interested in feminist approaches to all aspects of German literary, cultural, and language studies, including teaching.

Prepare manuscripts for anonymous review. The editors prefer that manuscripts not exceed 25 pages (typed, double-spaced), including notes. Follow the second edition (1984) of the *MLA Handbook* (separate notes from works cited). Send one copy of the manuscript to each coeditor:

Sara Friedrichsmeyer	**and**	Jeanette Clausen
Foreign Languages		Modern Foreign Languages
University of Cincinnati, RWC		Indiana U.-Purdue U.
Cincinnati, OH 45236		Fort Wayne, IN 46805

For membership/subscription information, contact Jeanette Clausen.